Media / Art / Politics

The **series in Media / Art / Politics** stimulates cutting-edge research in the fields of media, arts and politics, focusing on transformations in technology, cultural expressions and political processes, and their intertwinement, in our everyday, increasingly media-saturated and globalised world. We welcome publications that address the myriad ways in which media-technological developments frame, shape and transform our (current) socio-cultural and political order, and give rise to new political ecologies, identities and communities, as well as to novel forms of cultural expression and communication. We seek to publish research that is case-based and theory-driven. However diverse the cases addressed, the studies in this series converge, in that they all take a specific set of cultural phenomena as a focal point to broach the larger socio-cultural and political issues from the perspective of a critical (media) theory in development. Art probes the implications of such changes, offering an excellent starting point for critical reflections that seek to untangle the pivotal role of media in our world today.

Series editors

Pepita Hesselberth (Centre for the Arts in Society, Leiden University)
Yasco Horsman (Centre for the Arts in Society, Leiden University)

Editorial Board

Herschel Farbman (French and Comparative Literature,
 School of Humanities, UC Irvine)
Cissie Fu (Emily Carr University of Art & Design, Vancouver)
David Gaultier (Netherlands School of Cultural Analysis,
 University of Amsterdam)
Frederik Tygstrup (Department of Arts and Cultural Studies,
 University of Copenhagen)
Pasi Väliaho (Department of Philosophy, Classics, History of Art and Ideas,
 University of Oslo)
Kristin Veel (Department of Arts and Cultural Studies,
 University of Copenhagen)

Other titles in this series:

Inge van de Ven Big Books in Times of Big Data, 2019

Place:
Towards a Geophilosophy of Photography

Ali Shobeiri

LEIDEN UNIVERSITY PRESS

Credit cover: ESA/Rosetta/MPS for OSIRIS Team MPS/UPD/LAM/IAA/SSO/
INTA/UPM/DASP/IDA – CC BY-SA 4.0. © European Space Agency (ESA)

Cover design: Ieva Verikaite
Lay-out: Friedemann Vervoort

Every effort has been made to obtain permission to use all copyrighted illustrations reproduced in this book. Nonetheless, whosoever believes themselves to have rights to this material is advised to contact the publisher.

ISBN 978 90 8728 358 2
e-ISBN 978 94 0060 400 1 (e-PDF)
e-ISBN 978 94 0060 401 8 (e-PUB)
NUR 652

This book is distributed in North America by the University of Chicago Press (www.press.uchicago.edu).

Place is not the content
of a definite representation.

Edward S. Casey,
The Fate of Place

Contents

Introduction

The medium of photography has a long-lasting engagement with the nebulous concept of place, ranging from actual places captured in photographs to fictitious ones constructed by photographic software. This engagement can be traced back to the photograph taken by Nicéphore Niépce, *View from the Window at Le Gras* (1826/1827), which is believed to be the oldest surviving camera photograph in the history of the medium. Niépce's photograph stands as the earliest example of how photography can transmute physical places into photographed places. While in Niépce's time capturing photographs would require several hours of patience, in the present day almost anybody equipped with a photographic camera can, in less than a second, eternalise a physical place in the form of a photograph. Not only has the relationship between photography and places been preserved since the advent of the medium, but it has also been continually consolidated owing to the omnipresence of photographic images and cameras. For example, because of hectic working schedules or economic constraints, not everyone has the spare time to visit remote places. As a result, a great number of us have our first exposure to physical places through seeing them in photographs, before physically visiting those places in the world. Thanks to the medium of photography, we can observe a variety of geographical locations from vast distances away, glimpsing the orient from the occident and vice versa, thus circumnavigating the world photographically through images. Photography not only helps us to "pre-visit" physical places that we can later see during our lifetime, but it also allows us to arrive at places that we would not have otherwise. Owing to the recent technological advancement of photographic apparatus, for instance, we can observe images of far-flung places around the cosmos, places from which we are millions of light years removed. Imagine photographic images taken by cutting-edge cameras owned by The National Aeronautics and Space Administration (NASA) or the European Space Agency (ESA); these images make evident how photography can transmute a piece of space into a more familiar place: a photograph. Examples such as these serve to show the extent to which our very conception of place is constructed by photography, a medium that has been unremittingly utilised to discover and document new places around the world. In fact, my own pensive reflection upon the concept of place was also initiated by photography, while I was attempting to discern the topographical features of the physical world through my camera.

Several years ago, when I started studying photography with a view to becoming a photographer, I had an inexplicable proclivity for places as my subject matter. Both behind my camera's viewfinder and before my very own eyes, places became my way of being in the world. I henceforth set off on a journey to understand places in both the real and the representational worlds of photography. As a topographer with a fervid penchant for places, I was commissioned to make photographs of diverse geographical locations across the globe, a process through which my insatiable desire for learning about different places was amplified. Being fascinated, or rather haunted, by places I travelled to many countries across different continents to capture places with my camera, desiring to revisit them later through my photographs. However, being a topographical photographer not only gave me insights into morphological features of the world, but also made me realise that places were not necessarily limited to that which I was capturing in photos. They were not merely an assemblage of materialised things at which I could aim my camera; they were more elusive, inscrutable and unknown. At some point in my career, while taking topographical photographs of some vast terrain, I became aware of my own bodily presence as a place within the landscape I was attempting to seize with the camera. This realisation of my corporeal existence as something constituting another place in the landscape cast doubts on my conviction that I could capture and, in turn, fix places in photographs. Consequently, I decided to delve deeper into the concept of place through photography in order to examine how this medium could account for place as something that resists being rendered inert and static in time and space—as was the case with my own lived body in the aforementioned landscape. In other words, instead of simply regarding place as that which a photograph is of, as an image that is permanently fixed and circumscribed within the frame, I started to view place as philosopher Edward S. Casey does: as something "*at work*, part of something ongoing and dynamic, (being) ingredient *in something else*".[1]

In his seminal book on the concept of place, *The Fate of Place: A Philosophical History*, Casey argues that during the last two hundred years of philosophical and geographical inquiry place has been gradually reduced to a fixed location, suggesting that places have a permanent essence in time and space. One of the main reasons for the reduction of places to fixed locations is that they have been steadily subordinated to space and time, causing each place to cease to exist as a dynamic entity in the era of "temporocentrism": an epoch that signifies the belief in the hegemony of time.[2] Because of the spread of electronic technology and the resulting inclination towards an acceleration of time, Casey argues, place has been shrunk to a fixed location, whereas time and space have consistently remained processual. An obvious token of the dominance of space over place in contemporary academic discourse can be found in the prevalence of the adjective "spatial", derived from "space", whereas no English dictionary offers an adjective derived from "place".[3] However, through his unprecedented approach, Casey proposes and uses the adjective "placial" to address

the dynamic, processual and indeterminate account of place, contending that place is never a "fixed thing: [and] it has no steadfast essence".[4] By investigating the work of a multitude of thinkers, ranging from Foucault, Benjamin and Arendt to more contemporary ones, such as Soja, Irigaray and Nancy, Casey argues that each of them has "rediscovered" the importance of place as an unfixed and abstract entity in a different field of study.[5] In other words, he argues that, despite the fact that places have been gradually reduced to fixed locations, as if they are unaffected and unvarying, thanks to particular scholars, their indeterminate aspects have been preserved in different discourses. If Casey suggests that specific scholars have "rediscovered" the concept of place, it is because they have given meticulous and studious attention to place as something that remains equally indeterminate as time and space. It is also the intention of this book to revive the spatiotemporal dispositions of place, but this time by carefully examining the architecture of photography.

Although the processual and indeterminate accounts of place have been discussed in relation to particular discourses—such as those by Doreen Massey, who proposes a "progressive sense of place" that provides mobility in cities, and Yi-Fu Tuan, who observes place as a pause in a movement that transforms a location into place— it is Casey's reading that does not favour any particular discourse from which the indeterminacy of places can be fleshed out.[6] Instead, he looks at the pliancy and elusiveness of place in a variety of fields, ranging from architecture to phenomenology, arguing that the discussions of placial qualities cannot be confined to any particular domain, but can manifest themselves unconstrainedly in all possible arenas. In the words of human geographer Tim Cresswell, "geography is about place and places. But place is not the property of geography—it is a concept that travels quite freely between disciplines and the study of place benefits from an interdisciplinary approach".[7] That is precisely why Casey asserts, "since there is no single basis of the primacy of place, there is no monolithic foundation on which this primacy could be built", because "what is at stake is a polyvalent primacy" of place.[8] In other words, Casey is putting forward the idea that places can be identified as such through a variety of methods and discourses, and therefore there cannot be a single discipline that can claim to be able fully to explain, thus own, the notion of place. Moreover, he contends that place is not necessarily seen as a location, such as a room in a building, which can be captured and fixed in a photograph, but is to be regarded as that which continually resists permanent embodiment. That is to say, for Casey, a place is never identified by the location at which it is situated nor by the material construction that has constituted it, since it is not to be regarded as a localisable entity at all. He instead conceives of place as that which continually evades a finalised representation. Strictly speaking, for Casey, and likewise for this book, a place is never delimited to what it is, where it is, and to when and how it subsists in time and space.

In this book, by embracing Casey's understanding of place and giving precedence to this concept over that of space, my primary aim is to indicate how photography can

substantiate his dictum that "place is not the content of a definite representation".[9] I will discuss how the medium of photography can make clear that a place is never simply presented or fixed, but exists as something that is endowed with indeterminacy regarding its presence in space and time. To do this, this book will be triangulated by the fields of photography, philosophy and geography, as its title suggests. By adopting this approach, I hope this book will contribute not only to the burgeoning theoretical research on the concept of place in relation to photography,[10] but also to broader interdisciplinary research that probes into this notion, culminated in works such as: *Place and Experience* (1999); *Getting Back Into Place* (2009); and *The Memory of Place* (2012).[11] To achieve its goal the book breaks down the participatory elements of photography into six tropes: the photographer, the camera, the photograph, the image, the spectator and the genre. As a result, each one of its chapters will be devoted to discussing these themes. This division, however, is by no means intended to establish a "new theory" of photography or corroborate an ontological claim on behalf of photography, as numerous theorists have attempted to do over the past decades.[12] Instead, by reading photography through the above prisms, I want to make clear that discussions of place vis-à-vis photography do not need to be necessarily about, or end up in/around, the photographic image, as if place can only be the subject matter of photographs. But such debates need to acknowledge the processual, omnilocal, mutating and lived manifestations of place by bringing the other partakers of photography into the discussion. This hexa-part division, therefore, is my methodological strategy to avoid reducing place to a mere representation, i.e. the photograph. In other words, by breaking down the constitutive elements of photography into six tropes, this book intends to show how this medium is comprised of places, each instilled with latent temporal and spatial features. Rather than considering a place only to be the subject matter of photographs, it will study all the partakers of a photographic act as places, thereby trying to draw out their placial characteristics. To this end, it will explore how each participant of photography, viewed as a place, interacts with and interferes in different spaces and times, thus viewing spaces through places rather than the opposite. In doing so, this inescapably transdisciplinary book aspires to put forward what I call "a geophilosophy of photography", which incontrovertibly privileges places over spaces, through a medium whose history has been intertwined with place since its very conception.

The first chapter provides a phenomenological reading of the photographer's body, viewing it as both a lived body (*Leib*) and a physical body (Körper) in space. While as a lived body the photographer can actively project the schema of space by merely taking an upright position, as a physical structure the body is a thing among other things, which requires indirect localisation through kinaesthetic experiences that are felt within it. Cognizant of the double characteristics of the body, this chapter looks at the photographer through the lens of "lived place". This concept not only endows the body with porous boundaries and open orientations, viewing it

as something that can actively interact in its environs, but also acknowledges that, as a physical object, the body is co-localised amongst other objects in space. To make this point palpable, I foreground the banal act of walking as practised by landscape photographers, in which they constantly oscillate between keeping still as a physical body and keeping in operation as a lived body. For such a phenomenological body, I suggest, the landscape cannot be considered a predefined image, idea or way of seeing, but a confrontation with the materiality of the world. The chapter exemplifies this point through comparing a landscape photo taken by Ansel Adams, which embodies an anthropocentric landscape conjured up from the imagination, with a landscape photo taken by Gary Metz, which features the landscape as an unnameable encounter with the materiality of the world as a conglomerate of things. Finally, in my first step towards reading photography through the lens of place, I show that the photographer's body is never reduced to a fixed location or null point in space, but is always in a constant process of entanglement and disentanglement, belonging and disruption, and inactive intervention with the space of which it is a part.

The second chapter moves away from the photographer to investigate how the camera as a place complicates space and time, by considering it as a non-living agent in a photographic act. By surveying several thinkers who have mulled over the photographic camera, such as Derrida, Flusser, Kracauer and Barthes, this chapter proposes that the camera does not literally cut off or slice out a section of space and time, which would make it an active tool that can interfere in the physical world, nor is it entirely a passive agent in a photographic act. Instead, it suggests that the camera functions as a place that forever eternalises the spatiotemporal dimensions to which it is exposed through a passive intervention, a mechanism that allows it to be passively active as an apparatus. To illustrate this point this chapter examines a photograph taken by contemporary artist Susan Collins, showing that, despite the camera's passivity in recording the exposed reality, the photographed subject never remains passive, waiting to be hunted by the camera. Here I also expound on several enduring concepts in the photographic discourse, such as the "punctum" of time and detail and the crucial distinction between the photographic "referent" and "reference"; notions that have been indefatigably discussed, applied and quite often misinterpreted over the past decades. Finally, in my second effort to read photography through places, not only do I show how the camera as a place grants a temporal dimension to the spatial configuration witnessed by its lens, but also how it imbues the photograph with a spatial dimension caused by the suspension of the photographed subject into an irrevocable past.

In the third chapter I will shift my focus from the camera to the photograph itself, considering it as a thing that travels through different spaces, to show how it can be seen as a place that is identified neither by its constituents nor by the location at which it makes an appearance, but by its movability. To clarify this, I focus on the pliability of the photograph as a thing that has been continually altering and transforming

through different modes of reproduction and channels of distribution. Underlining reproducibility as a capacity instilled in each photograph, this chapter shows that photographs are simultaneously marked by the conflicting forces of domiciliation and dispersion, whereby they resist being permanently localised in any time and place. To exemplify this, this chapter looks at a photograph constructed by conceptual artist Joan Fontcuberta through spatial concepts proposed by Michel Foucault and Gilles Deleuze: a photo that lays bare the temporary localisation of photographs in space and time. Having been converted into reproducible immaterial information subjected to mass proliferation in cyberspace, here I propose that photographs are no longer distributed via a fixed itinerary, which can be traced and localised, but rather they unboundedly drift into unspecified directions and locations in the internet space. Consequently, in my third step towards reading photography geographically I discuss how the photograph as a material or immaterial thing cannot be restricted to the space in which it temporarily rests, but instead it becomes a vagabond flyer whose spatial movements and provenances remain radically open.

In my fourth attempt to examine photography through places I shift my attention from the body of the photograph to its surface, in order to look at the spatial features of what I call "photographic place": a perceptible place that is embedded in the photograph as an image. To do this I consider the photographic frame as an edge to examine the spatial features that lie inside, outside and at the photograph's frame. One of these spatial facets is the so-called "blind field": a spatial dimension that could be included but has been left out of the photograph. This chapter dives deep into the significance of this usually overlooked spatial element of the photographic place. To foreground the gravity of the blind field I first examine a photograph taken by the European Space Agency (ESA), showing how a maximised blind field can not only strip off the spatial nexus between the in-frame and off-frame, but also destabilise the spatial scales within the frame, thereby manifesting a defamiliarised photographic place that seems to have come into existence ex nihilo. Then, by looking at another photograph constructed by the National Aeronautics and Space Administration (NASA), I show how the radical minimisation of the blind field can help us to visualise the spatial fabric of the universe, thus creating a familiarised photographic place wherein our perceptual distance towards what remains physically far removed is reduced. Having looked at the spatial features that lie inside and outside the frame through ESA's and NASA's photographs, this chapter probes into the spatial qualities that lie at the photographic frame itself, where the implied existence of the blind field is buried. To do this, it discusses how the enshrouded existence of the blind field allows mental projection and spatial protension beyond the frame, thereby making liminal what is kept in the frame. Therefore, in my fourth approach to reading spaces through places I show not only how the liminal existence of the blind field can affect our spatial reading of a photographic place, but also how this tertiary element can project itself as an extra-spatial dimension onto its edge.

In the fifth chapter I elevate my view from the ground to, as it were, hover above the photographic act by including the spectator in my geophilosophical reading of photography. This chapter contends that a place is neither necessarily embodied through its location, locale or sense of place; nor can its significance become palpable by combining these three aspects into a unity whereby it becomes a place. Instead, it proposes that places can also be viewed as moments of encounter that yield transitory appearances in time. To tie this evanescent conception of place to photography I deploy Azoulay's formulation of "the event of photography", as that which occurs not only as an actual confrontation in relation to the camera or the photograph, but also as a potential encounter in relation to their hypothetical existence. Like the concept of "the event" espoused by Alain Badiou as an effect that exceeds its establishing causes, here I argue that "the event of photography" can surpass its founding structures and come about without heralding its arrival time; in that it is an additional possibility immanent within the structure of photography, awaiting the time of its maximal appearance, thereby providing a retroactive sign of recognition of its emergence. As a result, in my fifth step towards reading photography through places, I show that the very perdurable encounter between the spectator and the photograph can be viewed as a place, instilled with the possibility of eternal resumption thanks to the vacant space of the spectator.

Having already looked at each partaker of photography through the lens of place, in the last and longest chapter I look at the genre of aftermath photography to see how this representational scheme translates physical places into photographed places to communicate a content. In this genre the photographer visits an empty physical place which has invariably witnessed a tragic event and, irrespective of its physical features, considers it a place instilled with meaning. In doing so, the aftermath photographer aims to direct the spectator to the concomitant histories of physical places in the world by putting an undeniable emphasis on their specificities in the world of photography. First, by looking at physical places in the world, this chapter considers landscapes to be localities that are inherently interlaced with, and comprised of, places, foregrounding the inextricable affinity between landscape and place. Then, I put forward that physical places in the world, such as landscapes, can acquire agency by intra-acting with people through their intermediary non-human elements. Later, by shifting from the physical world to the world of photography, here I argue that aftermath photography utilises the landscape genre to create a temporal suspension in the act of looking. I exemplify this point through examining an aftermath photograph taken by contemporary artist Gert Jan Kocken, showing how aftermath photography uses landscape images to prolong the act of looking, thereby creating a ghostly effect in the viewer. Here, however, I propose that the ghostly effect or spectral presence of aftermath photography originates not only from the image but also from its accompanying text: the caption. To clarify this point I delve into the multi-layered means of interaction between text and image by inspecting how a caption operates

vis-à-vis a photograph. Accordingly, this chapter suggests that in aftermath genre the meaning resides neither in the image nor in the text but in their point of convergence or site of struggle: the spatial juncture in between the two. Finally, by drawing on the philosophy of Giorgio Agamben, this chapter proposes that, if aftermath photography entangles the viewer in between the text and the image, it is to conjures up the exigency of the photographed place: an urgent demand to remember what remains unexpressed yet haunting within the photograph. Therefore, in my final approach towards reading photography through the concept of place, I show not only how the space in between the photographer and a physical locality coagulates the agency of place, but also how the lacunary space in between the text and the image begets the exigency of place.

Taking together all six approaches that were shortly introduced above, in this book I am going to embark on a journey to rediscover the spatiality and temporality of places through photography. As Casey has contended, what is irrefutable about the concept of place is its "polyvalent primacy": the fact that places can exhibit their indeterminate features in a multitude of discourses and practices. To unearth the effervescent existence of place, I single out the medium of photography in order to unravel how this medium can bring the indeterminate qualities of places to the forefront. Consequently, by closely examining each constitutive element of photography in the coming chapters, I am going to flesh out the inactive, contingent, unlocalisable, liminal, evental, agential and exigent features of places, with the aim of proposing a geophilosophy of photography that regards the aforesaid dispositions as the prerogative of places. I hope that my theoretical trajectory comes to fruition for an avid reader who bears with me throughout the book, where my geophilosophical lexicon finds its place.

CHAPTER ONE

The Photographer:
A Corporeal Place in the Phenomenal World

> Phenomenology is ... a philosophy for which the world
> is always "already there" before reflection begins—as an
> inalienable presence; and all its efforts are concentrated upon
> re-achieving a direct and primitive contact with the world.
>
> —Maurice Merleau-Ponty, *Phenomenology of Perception*

To begin my analysis of the notion of place in relation to photography I will look at the usually unheeded partaker of a photographic act: the photographer's body. By employing a phenomenological scheme that pays significant attention to human lived experiences and perceptions in the world, this chapter regards photographers as both affecting and affected beings in space. As philosopher Vilém Flusser suggests, a photographer is "a person who attempts to place, within the image, information that is not predicted within the program of the camera".[1] By actively engaging in the world through their bodies, photographers are constantly in search of the information that is not provided by their cameras. Otherwise, they are reduced to some "functionaries" whose existences are restricted to their apparatuses.[2] Through discussing the bodily engagements of photographers, this chapter aims to foreground the significance of the photographer's body as a place instilled with lived experiences. As geographer John Wyile suggests, paying attention to the lived experiences of humans can allow us "to move away from a description of subjectivity in terms of rational, distant observation, towards an alternate understanding of human beings", which is based on "expressive engagement and involvement in the world".[3] To foreground how our lived experiences affect our engagement in, and perception of, the world, this chapter will hence treat the photographer's body as a place: a corporeal place that is continually perfused with and entangled in the phenomenal world.

However, it is true that the spectators of a photograph cannot access the lived experiences of the photographer at the moment the photograph was taken. Instead, they can only observe the outcome of a photographic encounter, that is,

the photograph. That is why for philosopher Hubert Damisch a phenomenological reading of photography is fundamentally problematic. The hesitancy we have when a series of phenomena results in what we consider to be photographs, Damisch notes, "is a revealing indication of the difficulty of reflecting phenomenologically... on a *cultural* object".[4] Cognizant of this difficulty, this chapter does not aim to elicit the interpersonal experiences of photographers, nor to speculate on their first lived-contacts with the world. Instead, it aims to highlight that the act of photography begins when the phenomenological body of a photographer involves in the world, when the body as a place engages with its surrounding space, aspiring to reflect the given experiences in the representational form of a photograph. By focusing on the photographer's body as a place, I intend to underline that photography is a medium of dynamic and indeterminate places, the first of which is the lived body of the photographer, a place that usually goes unnoticed. As art historian Hans Belting has put forward, in the triad of picture, medium and body it is usually the body that is overlooked.[5] As he notes:

> Photography, although it remained confined to a framed visual field, fed on its opposition to the concept of painting. It was not a medium of the gaze, for it replaced the gaze with the camera, but rather a medium of the body, which itself produced its own shadow. This shadow was arrested, held still at the moment of exposure, and so soon as it took shape in the print, *the body was lost.*[6]

By looking at the way in and through which a lived body experiences the world, in my first approach towards reading photography vis-à-vis the concept of place I enquire how the photographer's body can be seen as a place and how such a place interferes with its surrounding space. To do this this chapter will first discuss how the human body can be considered a place with bilateral features, being both a physical and a lived body at the same time. Then, by discussing the work of two American landscape photographers, Ansel Adams and Gary Metz, it will exemplify how such a place can inhabit spaces in the physical world. While both of these visual artists were working as landscape photographers, due to their divergent approaches to their subject matter their works reflect different methods of engaging with their surrounding space. Finally, having foregrounded the characteristics of the photographer's body as a bilateral place, through discussing philosopher Jacques Rancière's conception of aesthetics, this chapter suggests how such a place deals with space while retaining its duplicitous characteristics. To begin my study, in the following section I will explain how the photographer's body can be seen as a place that continually deals with its surrounding space, exemplified by the act of walking as practised by landscape photographers.

Going for a Walk with a Lived Body

> One knew of places in ancient Greece where they led down into the underworld. Our walking existence likewise is a land which, at certain hidden points, leads down into the underworld.
>
> —Walter Benjamin, *The Arcade Project*

For Tim Cresswell, spaces transform into places when they are invested with "human meaning", that is, when humans impart meanings to a portion of space it becomes what they consider to be a place.[7] However, not only do humans create places out of infinite space, humans themselves can be considered places in which meanings and images transpire. The provenance of images, Belting argues, is to be found not in the natural world but in the bodies of individuals.[8] As he puts it, "the body is a place in the world, a locus in which images are generated and identified".[9] For Belting, it is through human bodies and the corporeal activities thereof that their perceptual system makes sense of the world and, in turn, constitutes images. Consequently, he defines visual perception as "an operation by which we—our bodies—take in visual data and stimuli and analyse them. But the final outcome is not an analysis but a synthesis".[10] In the process of taking in visual data from the world, the human body is not merely a passive recipient, but one that actively constructs and reconstructs the sensory data received from its surroundings. That is why Casey notes that "we must realize that the perceiver's body is not a mere mechanism for registering sensations but an active participant in the scene of perception".[11] However, by having a direct contact with the world, the human body is not only an active participant in the process of perception, but also directly in charge of its unification.

As philosopher Alfred North Whitehead notes, "we have to admit that the body is the organism whose states regulate our cognizance of the world. The unity of the perceptual field therefore must be a unity of bodily experience".[12] For Whitehead, humans' corporeal activities are not only the primary source of perception, but also the means of their unification. "You are in a certain place perceiving things. Your perception takes place where you are, and is entirely dependent on how your body is functioning", states Whitehead.[13] One of the constructive instances whereby bodily functionality can become palpable is the way in which a human body orients itself in the world, thereby determining objects' locations by means of its direction with respect to them. Although we usually think of orientation as a purely mental activity, hence disregarding our bodily intervention in this process, it is the human body that mainly determines our very sense of direction. That is why Casey contends that "things are not oriented in and by themselves; they require our intervention to *become* oriented. Nor are they oriented by a purely mental operation: the *a priori* of

orientation belongs to the body, not to the mind".[14] For instance, a photographer can project orientation onto their surroundings by his/her mere bodily presence, because the human body is a living organism that can hold an upright position. As human geographer Yi-Fu Tuan underlines, one of the unique features of the lived body of humans is that it can stand up, allowing space to be constructed in its surroundings.[15] In an upright position, he writes:

> man is ready to act. Space opens out before him and is immediately differentiable into front-back and right-left axes in conformity with the structure of his body... In deep sleep man continues to be influenced by his environments but loses his world; he is a body occupying space. Awake and upright he regains his world, and space is articulated in accordance with his corporeal schema.[16]

According to Tuan, the lived body that can hold an upright position immediately "imposes a schema on space", which determines orientation according to the position of the body, and the person notices this spatial coordination only when he/she is lost.[17] This means by simply moving into an upright position the photographer's body instantaneously projects the coordinating schema of space onto its surroundings, thereby engaging in the perceptual world with, and through, a corporeal activity.

Nevertheless, as Casey reminds us, a person's body is not only a lived body (*Leib*) that can move and determine orientations, but also a physical body (Körper) that appears to be still and inert.[18] Seen as a physical construct, the human body has its own interior mechanisms by which it senses itself, which are premised on the body's kinaesthetic experiences. While we can habitually see the spatial movements of a lived body, we cannot observe kinaesthetic experiences and the way in which receptors in smaller body parts (e.g. muscles, tendons and joints) constitute our perceptions. As Casey explains, kinaesthesia is "the inner experience of the moving or resting body as it feels itself moving or pausing at a given moment".[19] To be clear, kinaesthetic experiences are the internal corporeal movements of the human body whereby it constitutes itself, which are not visible in the way that spatial movements are, but are nevertheless felt through movements and stoppings of internal body parts. Although we can observe the exterior spatial movements of our body parts when they move, such as a moving leg or an arm, according to philosopher Edmund Husserl, the "holding sway" of our physical bodies is felt only indirectly in bodily movements.[20] The imperceptible holding sway of the body is a clear instance of kinaesthetic experience. As Husserl explains this point:

> All such holding-sway occurs in modes of "movement," but the "I move" in holding-sway is not in itself the spatial movement of a physical body, which as such could be perceived by everyone. My body—in particular,

say the bodily part "hand"—moves in space; the activity of holding sway, "kinesthesis," which is embodied together with the body's movement, is not itself in space as a spatial movement but is only indirectly co-localized in that movement.[21]

Despite being a place that can actively project the coordinating structure of space by its mere presence, Husserl suggests that the human body has its own internally co-localised movements as well, i.e. the indiscernible activities through which a moving or resting body holds sway. Accordingly, when a lived body (*Leib*) moves in space it imposes the schema thereof through orientation and, being also a physical body (Körper), it actively and internally co-localises itself in that movement. For this reason Casey puts forwards that the human body, being both a lived body that externally moves and a physical body that internally holds sway, "resists direct localization"; that is, the human body cannot ever be viewed as a location fixed in space.[22] Geographically speaking, the term location "refers to an absolute point in space with a specific set of coordinates and measurable distances from other locations. Location refers to 'where' of place," states Cresswell.[23] The human body, which moves spatially as a lived body and kinaesthetically as a physical body, cannot be reduced to an absolute point in space. In other words, calling the human body a location is to announce its death, turning it into a null point in space, therefore disregarding both its spatial and kinaesthetic activities. Given that the body of a photographer is at the same time a lived and a physical body, it cannot ever be reduced to a location in space. Instead, a photographer's body embodies what Casey calls a "lived place".[24] As he sets out, lived places are

> regarded not as the mere subdivision of an absolute space or as a function of relationships between coexistents but as loci of intimacy and particularity, endowed with *porous boundaries* and *open orientations*. They are experienced and known through customary bodily actions.[25]

The human body, seen as a "lived place", is not delimited to the spatial movements that can be perceived by the naked eye (such as a moving hand), nor to the interior kinaesthetic experiences of our body parts. Casey's notion of lived place, instead, refers to the conflation of the lived body, which spatially moves in and through space, *and* the physical body, which is constantly co-localising itself amongst other objects in that space. As Husserl suggests, the coalescence of the physical and the lived body in one place—or, as Casey calls it, a lived place—can be best exemplified by the banal act of walking. In walking, Husserl points out, "my organism constitutes itself: by means of its relation to itself … the kinesthetic activities (of the physical body) and the spatial movement (of the lived body) stay in union by means of association".[26] In walking, the physical body, which is in charge of inter-bodily experiences, and the lived body, which is in charge of bodily spatial movements, forge one coherent

organism. That is why for Husserl walking becomes an oscillation between "keeping still" as the physical body and "keeping-in-operation" as the lived body.[27] By simply walking in the landscape, therefore, the photographer's body is not in it just as a fixed location, but is actively constituting itself as a physical body and reconstituting itself as a lived body, thereby inhabiting its environment as a lived place.

As philosopher Merleau-Ponty puts it, "our body is not primarily *in* space: it is of it", referring to the fact that our body, or rather the body as a lived place, is not a fixed location in space.[28] As he further writes, "we must therefore avoid saying that our body is *in* space, or *in* time. It inhabits space and time… I belong to them, my body combines with them and includes them".[29] For Merleau-Ponty inhabiting a space is not merely being present in it as a location, but being a part of that space as a lived place, through corporeal porosity and perviousness. For photographers, the act of walking becomes, to a certain extent, a way of phenomenologically inhabiting the world through internal kinaesthetic and external spatial dynamism, not as locations, but as lived places. As anthropologist Tim Ingold notes, "it is through being inhabited, rather than through its assimilation to a formal design specification, that the world becomes a meaningful environment for people".[30] However, as Merleau-Ponty has underlined, inhabitation is not merely being *in* space and time, but including and combining them with our bodies, just as humans inhabit their houses. Yet, even to be in a house is not to be fixed in it as a location, but, as Casey succinctly states, it is

> to feel oneself to be in the centre of things without, however, necessarily being literally at the centre. The difference is that between a strictly geometric centeredness (being a location) and an inhabitational being-centred-in (a lived place) that is as thick as it is porous.[31]

Through the practice of walking, photographers not only resist being reduced to a simple location which has specific geometrical boundaries, but are also being inhabited as lived places in the world. Because, as I have discussed with regard to walking, the photographer's body viewed as a lived place is continually in the active process of integration (as a lived body) and reintegration (as a physical body) into its surrounding space, thereby inhabiting the space with and through a somatic place. In other words, being capable of spatially moving through and kinaesthetically co-localising itself in the world, the photographer's body is not in but *of* the space.

Although it is true that having access to the inhabitational experiences of the body of a photographer is inconceivable, the way photographers choose to embody their lived experiences in photographs can be suggestive. Therefore, having argued that the photographer's body can be seen as a lived place, which oscillates between keeping still as a physical body *and* keeping in operation as a lived body, I will next look at the work of two landscape photographers to examine the extent to which their work reflects the conflicting aspects of this lived place.

Inhabiting the World as a "lived place"

> Landscape, in short, is not a totality that you or anyone else
> can look *at,* it is rather the world *in which* we stand.
>
> —Tim Ingold, *The Perception of the Environment*

Taken in 1942, *The Tetons and the Snake River* (fig.1) is one of the most widely acknowledged photographs of American landscape photographer Ansel Adams (1902-1984). Adams' fascination with the American landscape prompted him to walk to the remotest areas of the US to visualise the splendour of American nature. Describing Adams' landscape work, photography theorist John Szarkowski once wrote, "for Adams the natural landscape is not a fixed and solid sculpture but an insubstantial image, as transient as the light that continually redefines it".[32]

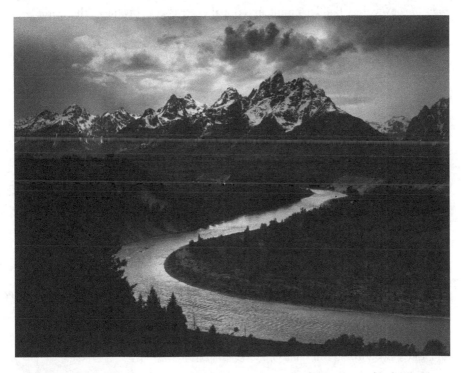

Figure 1: Ansel Adams (1942). *The Tetons and the Snake River, Grand Teton National Park, Wyoming, 1942.* Collection Center for Creative Photography, University of Arizona. © The Ansel Adams Publishing Rights Trust.

Figure 2, however, shows a photograph from a lesser known landscape photographer, Gary Metz (1941-2010). This photograph is included in a landscape series entitled *Quaking Aspen: A Lyric Complaint,* which was published posthumously.[33] While Adams' photograph presents a spectacular view of the landscape where all the visual elements are in a paradisiacal arrangement, Metz's photograph foregrounds a more commonplace facet of the landscape.[34] Irrespective of their approaches to the landscape, both images aim to convey the lived experiences of the photographers in their surrounding space. Referring to his work, Gary Metz notes that the concept of landscape is habitually conceived as a "pictorial one", and that is why most of the American landscapes are "visited but not lived in".[35] It is true that photographs cannot make tangible the lived experiences of landscape photographers, but to some extent they can put the spectator in relation to those experiences. As sociologist Rob Shields rightly states, "photographic 'shooting' kills not the body but the life of things, leaving only representational carcasses".[36] Evidently, photographs do not contain the phenomenological experiences of a lived body, and are merely "representational carcasses". However, through looking at them, we can comprehend how photographers *chose* to convey their bodily and inhabitational experiences of being in the world.

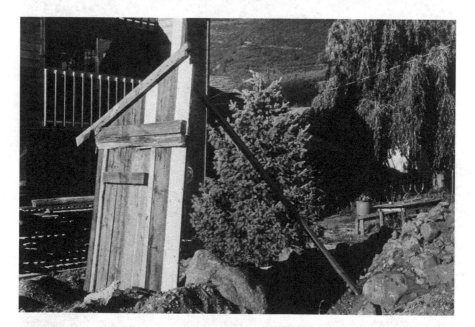

Figure 2: Gary Metz (circa 1970). Untitled, from *Quaking Aspen Series.* © Gary Metz Estate.

As I have already discussed, the human body as a lived place inhabits space not merely by being in it, but through the constant integration and reintegration of the body with its environs, which do not necessarily originate from a fixed standpoint that can be localised. This is because the human body as a lived place constantly oscillates between keeping still and keeping in operation, and therefore it resists becoming a fixed location. In Adams' landscape, the photograph's central perspective features a dazzling river, a lush forest and a majestic mountain in the background; a scenery wherein all the visual components are in divine congruence with each other. By positing the spectator at a bird's eye vantage point, Adams offers a localised landscape where the spectator is obliged to look at the landscape in its totality. However, in a landscape phenomenology, Wylie points out, "the landscape ceases to define a way of seeing, an epistemological standpoint, and instead becomes potentially expressive of being-in-the-world itself", which is "a milieu of engagement and involvement".[37] That is, from a phenomenological perspective one cannot look *at* the landscape from a fixed stance, since a lived body is never fixed as a location in the landscape, but inhabits it through constant corporeal involvements. In other words, in Adams's photograph we can anticipate that the photographer is in the centre of things in the landscape, whereas Casey suggests that inhabitation is not enacted through a "strictly geometric centeredness", but in an "inhabitational being-centred-in" which is "as thick as it is porous".[38]

Contrary to Adams' landscape, Metz's photograph indicates a landscape in which everything is out of place, as if it has just been wreaked to ruins by a thunderstorm. In the foreground, the photograph features scattered rubble and debris lying on the ground below a damaged wooden façade and a single tree. Behind the wooden façade lies a residence on the left-hand side, and in the background one can observe the flattened piece of the mountain constituting a small part within the frame. In short, in Metz's landscape nothing seems to be *in situ* within the photographic frame. However, the damaged wooden figure resembles the façade of a house that has been cut into two pieces, propped up by a wooden stick placed in the middle of the frame. As philosopher Gaston Bachelard puts forward, the house is the quintessential example of bodily inhabitation; it is "one of the greatest powers of integration for the thoughts, memories and dreams of mankind".[39] Through the lived experiences of human bodies with the houses they are born in, Bachelard suggests, the first houses of humans are somewhat embedded in their bodies as "a group of organic habits".[40] As he puts it:

> The house we were born in has engraved within us the hierarchy of the various functions of inhabiting. We are the diagram of the functions of inhabiting that particular house, and all the other houses are but variations on a fundamental theme.[41]

For Bachelard, the first house of every human being is the primary source of inhabitation, because it is therein that the lived experiences of the human body are enacted in space for the first time. Introducing his landscape photographs, Gary Metz writes, "I want the work to be a metaphor of all inhabited places", the first of which, according to Bachelard, is the house we are born in.[42] Even though there cannot be any access to the inhabitational experiences of the photographer when the photo was taken, such experiences can be metaphorically conveyed through photographs. Figuratively speaking, the broken wooden façade in the photo reflects the formation of a house, the very place where humans' inhabitational experiences of being in the world originate. Similar to the inhabitation of a lived place, which is as thick as it is porous, the broken wooden house can serve as a visual metaphor of bodily inhabitations, since they are both as unfinished as they are porous in their surrounding space. Inhabitation, Bachelard suggests, is not a matter of the size of a dwelling, nor is it necessarily to be in a house guarded from the outside world, but it is to feel "an intensity of being, the intensity of a being evolving in a vast perspective of intimate immensity"; that is, it is to feel inhabited *from within* the body through its "intimate immensity".[43] In other words, for Bachelard, to inhabit a place is not to be limited to its physical boundaries nor to be located in it, but, rather, inhabitation is marked by the degree of intimacy and familiarity that human beings feel towards places within their bodies; towards places that are not necessarily constructed fully, since our lived bodies are never finished per se, but are in a constant process of integration and reintegration with their surrounding space. As Ingold notes, in a phenomenological understanding the landscape "is never complete: neither 'built' nor 'unbuilt', it is perpetually under construction".[44] Accordingly, from a phenomenological perspective, one cannot inhabit the landscape by simply being *in* it, but, to use Merleau-Ponty's terms, one should be *of* the landscape in order to inhabit it.

As Casey explains, for Bachelard "the 'in' ingredient in inhabitation is a fluid focus, one that is in constant communication with the 'out': for instance, by means of doors and windows, whereby the outside world becomes part of the being of within".[45] In the same vein, Metz's wrecked house makes manifest the fact that one cannot simply be in it without being a part of the outside world. It shows a house that offers inhabitation only through porosity and inclusion, mirroring the inhabitation of the lived place that is continually under construction and reconstruction in its surrounding space. While Metz's house suggests the possibility of a landscape that resonates with the phenomenological operations of the human body, Adams' transcendental view embodies a landscape that is finished in and of itself. This is mainly because Adams was a photographer who would pre-visualise the final landscape he wanted to appear in his photographs, and therefore always had an expectation regarding the final work. As media theorist Sean Cubitt remarks, Ansel Adams

> is working not only with a memory (of the landscape) but with an
> expectation concerning what the final project should look like... his
> field work is undertaken in the expectation of finding the landscape
> that is *already there in imagination*. His darkroom practice is not only a
> revision of the exception he brought to the landscape but also a prevision
> of the prints that as yet do not exist.[46]

As Adams famously said, "you don't take a photograph, you make it", since for him
a landscape photograph results from the pre-visualisation thereof, a prevision that is
always before him in the imagination.[47] Thus, instead of reflecting the inhabitational
experiences of the photographer's body as a lived place, Adams' photograph foregrounds
a previsaged and thus *uninhabited landscape* conjured up from Adams' transcendental
imagination. Nevertheless, as Belting argues, "imagination is a corporeal activity" as
well, but in the manner of "leaving the body" and not through the body.[48] For instance,
by means of imagination Chinese poets could construct utopic and "imaginary places"
in their literature, "places to which one could journey, but not places one could live".[49]
Similarly, Adams' transcendental view of nature indicates a landscape whose divine
dispositions allow only an imaginary inhabitation (i.e. a journey in the mind), and
not a landscape that reflects the inhabitational experiences of a phenomenological
body. As Belting further writes, Chinese poets "went in search of uninhabited nature
... they contemplated nature from a distance as 'landscape', that is, as an image",
and by doing so they superimposed a cultural image of the landscape onto a real
geographical site.[50] Adams' landscape photograph, too, reflects the cultural image of
the landscape, a view of an uninhabited countryside, resulting from the projection of
an image of the landscape onto a geographical site.

As cultural geographer David Crouch puts forward, although landscape is usually
regarded as the countryside, it also includes "the assemblage of landforms, concrete
shapes, fields, gutters, designed spaces and serendipitous collection of things".[51]
Crouch suggests that the landscape should not be viewed as a way of seeing, as a
cultural image, or as a perspective projected onto the world. Rather, it is an encounter
with the materiality of the world as an assemblage of things. As Tuan notes, the main
"curiosity about places is part of a general curiosity about *things*, part of the need to
label experiences so that they have a greater degree of permanence and fit into some
conceptual scheme".[52] By identifying a view, scenery or countryside as landscape,
humans make intelligible and thus conceptualise their confrontational experiences
with the world, disregarding that their lived body is also a thing in the phenomenal
world. Within a phenomenological scheme, Merleau-Ponty points out, the "body is a
thing among things; it is caught up in the fabric of the world, and its cohesion is that
of a thing".[53] Although humans' spatial movements suggest that their bodies are always
fluid in space, thereby dominating it, as physical bodies humans also need to be located
along with other objects in the world; however, not necessarily in an anthropocentric

way. According to Tuan, "we more readily assume a god-like position, looking at the earth from above, than from the perspective of another mortal living on the same level as ourselves".[54] Advancing this argument by commenting on humans' inclination to think of themselves in a superior position in the world, Merleau-Ponty proposes that all spatial prepositions in human language are essentially anthropocentric. He writes:

> When I say that an object is *on* a table, I always mentally put myself either in the table or in the object, and I apply to them a category which theoretically fits the relationship of my body to external objects. Stripped of this anthropological association, the world *on* is indistinguishable from the world "under" or the world "beside".[55]

Assured of their anthropocentric ascendency, humans utilise spatial prepositions in relation to the ways their bodies are situated, or could be mentally situated, towards objects. For instance, people tend to say that the book is *on* the table and not the table is *under* the book, since the former corresponds better to their bodily and mental placements. On the one hand, by choosing a ground level view, Gary Metz has abstained from placing his body in a god-like vantage point, thus implying an elevated position for the photographer's body from which a cultural image of the landscape could be projected onto the site. On the other hand, through paying non-hierarchical attention to the material world Metz has, to a certain extent, undermined spatial prepositions that can be used to describe a traditional landscape photograph.[56] Strictly speaking, due to the visual equilibrium and the absence of an elevated perspective, the constitutive materials in the photograph do not gain any superiority in relation to one another, nor are they situated according to the anthropocentric location of the photographer's body. Instead, they are an encountered collection of things, and not a previsaged idea of the landscape projected onto the world. As critic Leo Stein once put it, "things are what we *encounter*, ideas are what we *project*".[57] While Adams' photograph features a cultural idea of the landscape projected onto an uninhabited countryside, Metz' photograph offers a landscape constituted of the body's encounter with an assemblage of things, reflecting that the body is, too, a thing among things.

As theorist Bill Brown describes, the word "thing" tends to "index a certain limit or liminality, to hover over the threshold between the nameable and unnameable, the figurable and unfigurable, the identifiable and unidentifiable".[58] Being a thing among things, or a physical place in the world, for the photographer's body the landscape cannot be a predefined image, idea or way of seeing, but an unnameable encounter with the materiality of the world. For Crouch, the materiality of our surroundings and the way in which we relate to them and with them take shape in our "holding on" and "going further" in the world. In light of this, he asserts that "landscape resonates a capacity of belonging, disorientation and disruption. Landscape is not perspective and horizon".[59] Consequently, for the photographer's body seen as a lived place, which

needs to hold on as a physical body (Körper) and go further as a lived body (*Leib*), landscape is not something to project, but to encounter as a conglomerate of things in the phenomenal world.

At this point, having discussed how a lived place inhabits space not by simply being in it but by being *of* the space, and not by being in the centre of things but by being a *thing* among things in the world, I will look further into the bilateral aspects of the lived place. As I have already discussed, Casey's understanding of a lived place refers to the conflation of the lived body, which actively meanders through space, with the physical body, which appears to be passively located among other objects in the world. While by moving through space the lived body appears to be active in it, by constantly co-localising itself as a physical body it appears to be spatially passive in its environs. In the following section, to shed more light on the conflicting aspects of the body, both as an active lived and seemingly passive physical body in space, I will draw on philosopher Jacques Rancière's formulation of aesthetics. In so doing, I will discuss how the encounter of a lived place in the world can be simultaneously active and passive, akin to the ways in which the bilateral body operates in space through a concurrent integration and reintegration, construction and reconstruction, belonging and disruption.

Confrontational Aesthetics of Corporeality

> The sentence-image reins in the power of the great parataxis and stands in the way of its vanishing into schizophrenia and consensus.
>
> —Jacques Rancière, *The Future of the Image*

As Rancière has proposed, "photography is exemplarily an art of aesthetic ideas", since it can provide a way to merge the two incongruent elements of arts. That is, it combines "the intentional production of art", which implies the active participation of the photographer, with "the sensible experience of beauty", which implies the passivity of the photographer in a photographic act. That is why he suggests that the greatest achievement of the photographic medium is that it provided a way with which "artistic purity" and "aesthetic impurity" could link together.[60] While "artistic purity" suggests that the photographer merely functions as a vehicle of communicating the experience of beauty from the world, as if directly and unaffectedly, "aesthetic impurity" suggests that the intentionality of the photographer always alters and influences the content of this communication. And for Rancière the medium of photography has the capacity of merging these two seemingly incompatible elements. In other words, he argues

that photography has offered us a means whereby the intentionality of an artist, or "aesthetic impurity", can be aligned with the direct experience of beauty in the world, or "artistic purity". The key to this troublesome alignment, Rancière proposes, can be found in the "inactivity" of photographers towards the subject matter, that is, "the suspension of the opposition between activity and passivity".[61] In that, a photographer who adopts an inactive approach is neither actively constituting the subject matter with a set of predefined ideas thereof, nor completely passive in a photographic experience. Instead, an inactive approach towards the subject matter results in "a pure instance of suspension", which is established in what Rancière calls "the aesthetic regime".[62]

According to him, the aesthetic regime departs from the mimetic barrier that "distinguished ways of doing and making", which had caused the hierarchical order of the subject matter. Because, by means of classifying different tiers and ranking them accordingly, the mimetic principle "defines *proper* ways of doing and making as well as means of assessing imitations".[63] To clarify this point through exemplification, within the aesthetic regime there cannot be a proper image of the landscape based on which other landscape images can be forged and evaluated; that is, the landscape photograph cannot be a copy assessed with regard to its model. Having departed from the mimetic principle, hence in the aesthetic regime the landscape cannot be an image that can be sublimated and refined in order to resemble its original model. Alternatively, the aesthetic regime "simultaneously establishes the autonomy of art and identity of its forms with the forms that life uses to shape itself", states Rancière.[64] In other words, within the aesthetic regime there cannot be a predetermined form, image or conception with which the subject matter (e.g. the landscape) can be constituted, classified and eventually evaluated. As Rancière explains, it is because

> in the aesthetic regime, artistic phenomena are identified by their adherence to a specific regime of the sensible, which is extricated from its ordinary connection and is inhabited by a heterogeneous power, the power of *a form of thought that has become foreign to itself:* a product identical with something not produced.[65]

Instead of utilising a set of pre-defined forms to constitute the subject matter, the aesthetic regime alienates the conventional relations between forms, and creates a subject matter that is "foreign to itself" (e.g. it creates a landscape that does not correspond to the common conceptions of the landscape). Consequently, within the framework of the aesthetic regime, writes Rancière, "the ordinary becomes beautiful as a trace of the true. And the ordinary becomes a trace of the true if it is torn from its obviousness".[66] Strictly speaking, the aesthetic regime does not aim at making the unknown known for the spectator, as in the case of Adams' photograph. Instead, by alienating the subject matter the aesthetic regime renders the familiar world uncanny

and foreign to itself. In the aesthetic regime, as Rancière succinctly puts it, "the anonymous became the subject matter of art that the act of recording such a subject matter can be an art".[67]

Therefore, within the framework of the aesthetic regime there cannot be a landscape that can be copied or envisaged prior to a photographic experience, or refined and sublimated after a photographic shooting. Instead, the landscape can only be confronted as an assemblage of things that are foreign to themselves. To put it differently, under the light of the aesthetic regime, a photographer confronts his/her subject matter when it is torn away from its obviousness, when it is stripped of its conventions; that is, when it has become the anonymous. Consequently, in this situation the photographer neither actively creates an imitation of the landscape from imagination, nor passively passes by it. Instead, as Rancière would say, the photographer *inactively* confronts the landscape as "a product identical with something not produced", invented out of the suspension between activity and passivity. According to philosopher Jacques Derrida, the uncertainty about the active or passive intervention of the photographer in the subject matter is rooted in the bifurcated denotations of the word "invention". As he explains this point:

> The photographic experience is situated right at the internal edge of a division that divides the two senses of the concept of invention: *on the one hand*, invention as a discovery or a revelation of what is already there… *on the other hand*, invention as a technical intervention, as the production of a new technical apparatus that constitutes the other instead of simply receiving him.[68]

Nevertheless, for Derrida, a photographic experience cannot be reduced to simply discovering what is already there, nor to the constitution of the subject matter from a productive imagination. Taking landscape as the subject matter, a photographic experience cannot be limited to confronting the landscape and capturing it as it is (a discovery), nor can it be the creation of a landscape that does not exist in front of the camera (a production). Instead, as Derrida notes, in a photographic experience "the two senses of invention constantly parasite off one another".[69] That is to say, a photographic experience vacillates between a complete passivity towards the subject matter (a discovery) and an active intervention in establishing the subject matter from imagination (a production). It takes place at the suspension of both. For Rancière, likewise, this situation refers to the inactive confrontation of the anonymous in the aesthetic state. To illustrate this point, while Adams' photograph is susceptible to becoming a production shaped from imagination, Metz's photograph, by confronting a collection of things as the landscape, has confronted the subject matter as the anonymous. In other words, Metz has not *produced* a landscape nor *discovered* one, but rather montaged a landscape that is foreign to itself.

As Rancière defines it, montage is "a measure of that which is measureless or as the disciplining of chaos".[70] That is, montage is the very conflation of the chaotic world into a new order. In Rancière's understanding of aesthetics, montage, as a means of remaining at the boundary of activity and passivity, manifests itself best in the idea of the "sentence-image". According to him, the "sentence-image" is not only the conflation of "a verbal sequence and a visual form", but can also be expressed in terms of "the relationship between the said and unsaid in a photograph". For Rancière, the sentence-image addresses the very link by which the "disruptive" power of art can be sustained without falling into "schizophrenia or consensus".[71] To be clear, the sentence-image is the suspension through which a work of art retains its disruptive forces while remaining passive; it is as if the sentence-image stitches passivity onto the explosive forces of art, thereby sustaining activity in a passive mode. Rancière epitomises the suspension of passivity and activity in the sentence-image by describing Harpo, the mute character from one of Marx Brothers movies. As he explains:

> At the beginning of *A Night in Casablanca*, a policeman looks with a suspicious air at the strange behaviour of Harpo, who is motionless with his hand against a wall. He asks him to move on. With a shake of the head, Harpo indicates that he cannot. The policeman then observes ironically that perhaps Harpo wants him to think that he is holding up the wall. With a nod, Harpo indicates that that is indeed the case. Furious that the mute should make fun of him in this way, the policeman drags Harpo away from his post. And sure enough, the wall collapses with a great crash. This gag of the dumb man propping up the wall is an utterly apt parable for making us feel the power of the sentence image, which separates the *everything hangs together* of art from *everything merges* of explosive madness or consensual idiocy.[72]

By holding up the wall, the character of Harpo represents the passive but active force of the sentence-image, highlighting its inactive intervention in the act. Although he seems to be passive in the scene, the entire construction of the wall is premised upon his inconspicuous activity. Returning to Metz's photograph, by looking closely at the centre of the photograph, one can see that the entire uniformity of the frame is hinged upon the wooden stick that is propping up the wooden façade. One can say that the wooden stick in Metz's photograph resembles Harpo's function in the movie: by holding up the walls, they both sustain the disruptive forces through their inactivity, manifesting how activity can be retained as a dormant force within passivity, in a state of interminable suspension.

This suspension, which is visually reflected in Metz's photograph, resonates with the concurrent passive and active operations of a lived place. In that, as I have shown before, the photographer's body as a lived place is comprised of porous boundaries and open orientations, constantly oscillating between keeping still and keeping in operation. It is simultaneously a lived body that can dominate its surrounding space through orientation *and* a physical body that is dominated by the space that it is a part of. While the former suggests that it can determine the coordinating scheme of space in an activity, the latter suggests that it also needs to co-localise itself in space in a passivity. Given its bilateral facets, therefore, the photographer's body features a corporeal place held in abeyance between active and passive intervention in its circumambient space: a *lived place* that is unremittingly stitching passivity to its active spatial presence in the phenomenal world. In other words, being simultaneously a physical body (Körper) that needs to hold together kinaesthetically and a lived body (*Leib*) that can go further spatially, a lived place is both orientative and disruptive, still and moving, static and dynamic, passive and active: it is inactive.

Having argued that the photographer's body is a lived place comprised of imperceptible internal and perceptible spatial experiences that operate together in an inactive mode, I will next shift my focus to another place in the act of photography. After all, the photographer's body is not a seismograph that directly receives waves from the world, but it sees the world indirectly through the camera, which has its own way of dealing with space. The seismograph, Cubitt notes, "describes the way the world points at an instrument, the photograph at the way we point an instrument at the world. Both rely on the distance between subject and object, but with different weighing and a different direction".[73] In other words, the photographic experience cannot be reduced to what Derrida calls a "discovery" of the other by simply receiving it, but is always on the verge of becoming a "production".[74] That is why Flusser describes photographers as "functionaries" whose existences are restricted to their apparatuses.[75] In the following chapter, therefore, I will zoom out from the position of the photographer as a lived place to the second partaker of the photographic encounter, the camera, in order to examine how this mechanical place deals with space and time.

Chapter Two

The Camera:
A Place That Spatialises Time and
Temporalises Space

> Photography is a monster with two subjects,
> with a double body (human) and a single, cavernous head
> whose one eye blinks on and off.

> —Jean-Luc Nancy, *The Ground of the Image*

In the previous chapter I looked at how the body of a photographer can be considered as lived place replete with internal and external dynamisms, and how such a somatic place inactively deals with space. But, as Derrida has reminded us, the act of photography cannot be simply reduced to a mere discovery of what is out there, as if unaffected, since it also implies the intervention of the camera in the act. Although there are photographs that are produced in the absence of the camera, such as "cameraless photographs", photographic production is habitually undertaken with a mechanical apparatus, which brings it close to becoming a production.[1] In debates surrounding the history of photography, Damisch notes that even the medium's conception is usually referred to as a discovery, whereas the photographic image that the early photographers were seeking to attain was "in no sense naturally given".[2] Damisch highlights the fact that the camera should not be regarded as a neutral element in a photographic act, since photographic images are never given, but mechanically constructed. In this chapter, to show how the camera leaves its agential trace in a photographic act, I will discuss how it interferes with the space at which it is pointed, thereby affecting the possible result of a photographic encounter, i.e. the photograph.

As I have previously shown, the photographer's body can interfere in space by its mere corporeal presence, by projecting its spatial schema, and thus becoming a part of its surrounding space. The camera, too, engages with space, but through

a different mode of involvement: it neutralises the space in between itself and the photographed subject, and in turn forever preserves that space in photographs. As leading geographer Nigel Thrift points out, seemingly all the theorists of place seem to agree that the idea of "place consists of particular rhythms of being that confirms and naturalizes the existence of certain spaces".[3] In a photographic act, I would like to argue that the camera can be deemed as a place that, by aiming at and capturing a subject in the world, neutralises the space to which it is exposed, thereby eternalising this in-between space in the photograph.

However, in a photographic shooting the camera not only aims at space, but deals with time as well. As cultural critic Susan Sontag pointed out in *On Photography*, the photographic camera is a "predatory weapon", which is as "automated as possible, ready to spring". For Sontag, the predatory function of the camera would not result in the literal death of the photographed subject, but in the spatiotemporal transgression of the subject's territory, indicating how the camera deals with space and time. That is why she said, "to take a photograph is to participate in another person's mortality, vulnerability, mutability. Precisely by *slicing out* this moment and freezing it".[4] For Sontag, the photographic camera influences the outcome of a photographic encounter precisely by slicing out a segment of space and a moment in time, that is, by its spatial and temporal interventions in the act.

In this chapter, given the importance of the way in which the camera deals with space and time, I will shift my focus from the role of the photographer to that of the camera to examine the spatiotemporal aspects of this mechanical place. To do this I will firstly foreground how the camera deals with space and time by discussing how different theorists have reflected upon this matter. Then, by examining a photograph that magnifies the intervention of the camera, I will discuss how the optical device confers a temporal dimension to the space in front of its lens. Lastly, by deploying Roland Barthes' and Jacques Derrida's conception of time in photography, I will argue how the camera grants a spatial dimension to the time at which the photograph is taken. After all, photographers do not perceive the world directly through their bodies, but they see the world with the aid of the camera, which has its own obscurities, complexities and contingencies. According to Flusser, "the world is purely a pretext for the realization of camera possibilities" and "no photographer, not even the totality of all photographs, can entirely get to the bottom of what a correctly programmed camera is up to. It is a black box".[5] In the following section, I will begin my analysis of the camera by explaining the active role it plays in engaging with space and time, not with an aim to get to the bottom of it, but to indicate the extent to which a photographic act is hinged upon this black box of photography.

Seeing through the Camera

> With the help of a new optical device one could finally see sight,
> one could not only view the natural landscape, the city,
> the bridge and the abyss, but could view viewing.
>
> —Jacques Derrida, *The Principle of Reason*

In his now classic essay "The Ontology of the Photographic Image", originally published in *What is Cinema* between 1958 and 1962, film theorist André Bazin acknowledged the agency of the camera in a photographic act.[6] For him, the authenticity of photography in comparison with painting lies in its "objective character", referring to the way in which a camera can apparently mechanically reproduce reality in an accurate way. As he argued, the advent of photography shows that "between the originating object and its reproduction, there intervenes only the instrumentality of a *nonliving agent*. For the first time the image of the world is formed automatically, without the creative intervention of man".[7] In this essay, Bazin celebrated the exactitude of mechanical reproduction in photography, arguing that it not only granted a credibility to the camera that was absent in the other media, but it also manifested the camera's agency: the fact that photography's realism was fundamentally hinged upon the mechanical functionality and existence of the camera in a photographic act.

Moreover, Bazin proposed that the automaticity of photographic production compelled the viewer to accept that the photographed subject assuredly existed in time and space. In his terms, by some kind of "embalmment" or "mummification" of time and space the camera could immortalise them in photographs as if by moulding them, keeping them unaffected from future alterations.[8] Reforming the mould argument, philosopher Stanley Cavell notes that the camera cannot function literally as a physical mould, but instead it is a "mould-machine, not the mould itself. Photographs are not hand-made: they are manufactured".[9] By naming the camera a "mould-machine", Cavell underlines that photography, unlike painting, does not require the direct engagement nor the presence of the photographer, because it is a machine that can manufacture photographs even in the absence of a human agent. As Bazin famously argued, "while all arts are based on the presence of man, only photography derives an advantage from his absence".[10] For Bazin, the automaticity of the camera's engagement with time and space fashioned a new way of seeing, which not only differed from the old media, but also conferred an advantage to photography. Accordingly, he claimed that "photography contributes *something* to the order of natural creation instead of providing a substitute for it".[11] That is to say,

through its optical and mechanical contributions to the arts, Bazin proposed that the photographic camera could unveil a new way of seeing the world that the other arts, such as painting, were trying only to imitate.

However, philosopher Walter Benjamin had given particular attention to the optical contribution of photography long before Bazin, by coining the term "optical unconscious" in 1931. Aligning the optical advancement of photography with the discovery of the unconscious in psychoanalysis, Benjamin argued that the camera, through "stop motion" and "enlargement", could display spaces that were hitherto impossible to see with the naked eye. He exemplified the optical unconscious of the camera with an example of a person's walking as follows:

> It is another nature that speaks to the camera than to the eye: other in the sense that a space informed by human consciousness gives way to a space informed by the unconscious. Whereas it is a commonplace that, for example, we have some idea what is involved in the act of walking, if only in general terms, we have no idea at all what happens during the fraction of a second when a person steps out.[12]

As Benjamin notes, by means of slow-motion the mechanical eye of the camera enabled humans to see the precise distance between one's footsteps for the first time, the spatial arrangement that was not previously observable to the naked eye. His instance of the optical unconscious could substantiate Bazin's claim that photography liberated painting "from its obsession with realism", by featuring what the naked eye could not see.[13] Because, having the aid of a mechanical device at its disposal, photography could offer new ways of embodying reality which fundamentally altered the old realism of painting. The main reason for this shift in the perception of reality stems from the fact that painters and photographers have essentially different methods of engagement with space. Benjamin exemplifies this difference in his seminal article "The Work of Art in the Age of Its Mechanical Reproduction" by drawing an interesting comparison between the cameraman as a surgeon and the painter as a magician. He contends that while the painter (as magician) maintains a natural distance from reality, "the cameraman (as surgeon) penetrates deeply into its web".[14] In Benjamin's example, it is as if the photographer, like a surgeon who dissects a patient, utilises the camera as a knife to cut through space and time in order to preserve a piece of them in photographs.

Similar to Benjamin's example, film critic Christian Metz elaborates on the tool-like function of cameras by stating that they can "striptease the space" at which they are pointed, referring to the way cameras can reveal spatial configurations that cannot be seen with the naked eye.[15] For Metz, whereas film induces a "stream of temporality where nothing can be *kept*", the power of photography lies precisely in its "silence and immobility" through which it can preserve time and space.[16] In other words, thanks

to the mechanical aid of cameras, photography can preserve time and space by, in a sense, slicing up a piece of them in photographs. In all photographs, Metz states, "we have this same act of *cutting off* a piece of space and time, of keeping it unchanged while the world around continues to change".[17] Even though the metaphor of cutting off a piece of space or, as Sontag put it, slicing out a moment in time seems to account for how cameras function, it is undeniable that cameras are neither knives nor surgical razors that can physically interfere with space and time. That means that, although cameras seem to fall under the category of tools, the way they engage with space and time is more intricate than that of tools.

As Flusser contends, cameras should not be reduced to the category of tools (e.g. a needle or a knife that can change the form of an object), nor are they to be regarded as machines, which result from the addition of technical advancements to the empirical functions of tools. Instead, cameras should be subsumed under the category of apparatuses.[18] Here, the crucial point is that cameras do not literally slice out or cut off a piece of what they are exposed to, but they alter the signification process of the world by the way they engage with time and space. As Flusser puts it, "tools and machines work by tearing objects from the natural world and informing them … but apparatuses do not work in that sense. Their intention is not to change the world but to change the meaning of the world".[19]

Flusser not only grants agency to the camera, as Bazin did by calling it a non-living agent, but, more notably, argues that the "automaticity" of the camera can exceed human intentionality. Thus, for him the camera becomes capable of altering the meaning of the world according to its own intentionality, resulting from its pure automaticity as an apparatus. That is why he argues that photographers should fight against the automaticity of the camera, because it is a "plaything", otherwise they become some "functionaries" who "control a game over which they have no competence".[20] Regardless of the photographer's intention, Flusser proposes that the automation of an apparatus may lead to unforeseen conditions that may not be entirely anticipated by the photographer. In addition, he draws attention to the etymology of the word "apparatus". As he notes, alongside the Latin verb *apparare*, which the noun "apparatus" is derived from, exists the verb *praeparare*, which means to prepare. Consequently, he submits that an apparatus "would be a thing that *lies in wait* or in readiness for something, and *preparatus* would be a thing that waits patiently for something".[21] As this etymological analogy suggests, the automaticity of the camera, or its very force to supersede the photographer's intention, is in part intertwined with its capability to wait in readiness. In other words, considering the camera as an apparatus means that taking a photograph not only refers to when the camera cuts a piece of space and time, but also to when its automaticity interferes with the photographed subject through waiting. Because, as Flusser has suggested, the camera is not a tool or a machine but an apparatus that patiently lies in wait, preparing to override the photographer's intention through its mechanical automation.

Although after the shift from analogue to digital photography the optical device has undergone substantial changes, leaving us in what media theorist William J. Mitchell referred to as the "post-photographic era", the camera still functions as a mechanical agent that severs a segment of time and space through its sheer mechanical automaticity.[22] At this point, having discussed the potency of the camera in cutting off or slicing out a piece of space and time *and* the possibility of interfering in that process through passively waiting, I will next examine a seascape photograph to foreground the camera's agency in a photographic act. That is, in the following section I will exemplify how the camera can become what Flusser calls an apparatus: that which lies in wait to take over photographers' intentions through its mechanical intervention with time and space.

An Apparatus that Lies in Wait

> Photographing is essentially an act of non-intervention.
>
> —Susan Sontag, *On Photography*

> Photograph ... has no before or after:
> it represents only the moment of its own making.
>
> —Graham Clarke, *The Photograph*

Between March and October 2008, British photographer Susan Collins exhibited a series of photographic prints alongside their real-time images, which were recorded from five different locations on the south-east coast of England: Margate, Folkestone, Bexhill, Pagham and Stokes Bay. These images were captured by five high-resolution cameras each recording one pixel at a time, a meticulous process that allowed for a one-to-one relationship between the cameras and their pictorial output. Eventually, by capturing one pixel approximately every 0.25 second, each of these cameras was able to build up an image after a period of seven hours. The result was called *Seascape*, an assortment of images that magnified how the camera deals with space and time in a conspicuous way.[23] If Collins' real-time images showed how the camera could instigate a stream of temporality, their photographic prints revealed how it could encapsulate time into the immutable moment of the photograph. Figure 3 features one of the photographic prints, called *Seascape, Pagham, 13th February 2009 at 11:25am*. The photograph displays a distorted and pixelated view constructed of several horizontal lines with different shades of colours, which in their totality can be

conceived as a seascape scene. By extending the time exposure and leaving the camera to record the seaside, Collins has captured a photographic seascape that, above all, forefronts the mechanical intervention of the camera in the production process. The best photographs, Flusser remarks, are those in which photographers "subordinate the camera to human intention", that is, when a photographer's intention takes over the automaticity of the camera.[24] If that is the case, Collins' photograph has seemingly achieved the contrary, since it is an attempt to diminish the photographer's intention as much as possible in order to foreground the agency of the camera in the photographic process. By replacing the human agency with that of the camera, Collins' practice reflects what media scholar Joanna Zylinska calls "insignificant photography": referring to the photographic approach that allows "us to see things that have been captured almost incidentally and in passing, with the thematic 'what' not being the key impulse behind the execution of the images".[25] That is, by means of removing the photographer from the inscription process and underscoring the camera's automaticity, this photograph features the passive intervention of the camera in the photographic production.

Figure 3: Susan Collins (2009). *Seascape, Pagham, 13th February 2009 at 11:25am*. © Susan Collins.

As Flusser notes, on the one hand, the camera is "a prototype of apparatuses" that can lie in wait and preparation, suggesting the passivity of the camera in a photographic act.[26] On the other hand, due to the automaticity of the camera that cannot be

entirely anticipated by the photographer, the camera is also a "plaything" that changes the meaning of the world, implying the active intervention of the camera with the photographed subject.[27] As I have already discussed, the camera cannot literally cut off a piece of space and time, which would mean it is an active tool that can literally interfere with the physical world. Nor is the camera utterly passive, since it can change the signification of the world through its automaticity and agency. Instead, as Derrida has pointed out, the very moment technics enter into the photographic act it becomes a question of "an auto-affection, at once passive and active".[28] Derrida essentially refrains from defining the camera as either a passive or an active agent in the photographic act, and instead he proposes that the photographic apparatuses function through a different structure. As he puts it:

> If technics intervenes from the moment a view or shot is taken, and beginning with time of exposure, there is no longer any pure passivity, certainly, but this does not simply mean that activity effaces passivity. It is a question of another structure, another sort of *acti/passivity*, … Even when technics intervenes in a more and more complicated and differentiating way, it continues to treat passivity in a certain way; it continues to *deal with* it, to negotiate with it.[29]

For Derrida, the intervention of a photographic apparatus lies within an "acti/passivity", because, irrespective of the active or passive role of the camera, the photographed subject in front of the lens cannot be "reduced to a given substance" that is inertly waiting for the camera's intervention. Therefore, according to him, the camera can "deal with" the photographed subject only in an active/passive way, since the "photographed thing" is never passively waiting to be intruded upon by the photographer's intention.[30] In fact, as Flusser argues, an apt criticism of apparatuses should not "call up on the last vestiges of human intention behind apparatuses", but should manifest the "unintentional, rigid and uncontrollable functionality of apparatuses".[31] That is to say, regardless of the photographer's intention, the mechanical functionality of the camera overrides the intention of humans by passively recording everything that is exposed to its lens. For Derrida, this is precisely the moment when photography goes beyond art, since it passively and unintentionally records the photographed subject, turning it into an indivisible present time in the photograph. As he explains:

> however artful the photographer may be, whatever his or her intention or style, there is a point where the photographic act is not an artistic act, a point where it *passively records* … it captures a reality that is there, that will have been there, in an undecomposable now.[32]

This passive recording of the camera, which can surpass the photographer's intention, not only reveals the unintentionality of the camera in capturing the exposed reality, but is also an instance in which the camera is both active and passive. For, as Derrida reminds us, even though the camera "passively records" the photographed subject, the subject is never simply passive and inert in front of the lens. Returning to Collins' photograph, looking on the lower part of the sea the viewer can observe some rather unidentifiable pixels inscribed on the photograph which are distinct from the sea in terms of their colour and lack of continuity.[33] These unidentifiable pixels, Collins notes, could represent "a busy waterway of passing ships, yachts, people and windsurfers" or a "violent lightening" appearing as an incongruity of pixels on the surface of the sea.[34] In any case, due to the "pastness" of the medium of photography, the real identity of these pixels cannot be known by the viewer. Although these pixels might not have much significance at first sight, they can indicate the unintentional functionality of the apparatus, foregrounded by the passive recording of the seaside over seven hours. The existence of these pixels signifies that the photographed subject is not passively waiting to be hunted by the camera, but it is the camera that unintentionally lies in wait, recording the exposed reality heedless of the photographer's intention. Despite all the possible conjectures that can be made about these pixels, their real identity remains inescapably unknown, since there is no way to go back in time and ascertain what they depict. They simply remain as a few contingent pixels on the surface of the photo that can attest to "an undecomposable now", manifesting the acti/passive intervention of the camera in a photographic act.

According to media scholar Tom Gunning, what characterises the realism of photography is its very "resistance to significance ... as well as its uniqueness and contingency".[35] Despite the prevalent tendency for increasing the exactitude and accuracy of photographs through technological advancement, Gunning argues that the very realism of photography is still marked by its contingency and resistance to meaning. For him, it is the "inexhaustible visual richness" and "excessive quality" attached to a photograph that makes it surpass the function of a sign.[36] As he argues, even for Bazin the photograph was not a sign of something, "but a presence of something, or perhaps we could say a means for putting us into the presence of something".[37] The existence of the unidentifiable pixels in Collins' photograph may underpin Gunning's claim by the very fact that they cannot be deciphered as a sign, but only defined as contingent pixels that resist signification. Although these pixels can take on countless identities, such as passing ships, yachts, people and windsurfers, their real identity remains conjectural and indefinitely indecipherable for the viewer. These pixels, without signifying what they are, merely bear witness to the presence of the reality that they conceal, thereby situating the spectator in relation to, or in the presence of, something that is not in the photograph. In other words, instead of presenting the world to the spectator, the contingent pixels in Collins' photograph (to use Gunning's terms) "put us into the presence of" the world.

What painting was aiming to achieve before the conception of photography, Cavell argues, "was a sense of *presentness*", but "not exactly a conviction of the world's presence to us, but our presence to it".[38] While painting preserves humans' presence towards the world (since it constructs a timeless world to which they have access on demand), photography does precisely the opposite by confronting us with the past. Strictly speaking, by constructing a new world in their pictures, Cavell argues, painters presented humans to the world, whereas photography presents the world to humans by embedding a sense of pastness in each photograph. As he puts it:

> Photography maintains the presentness of the world by accepting our absence from it. The reality in a photograph is present to me while I am not present to it; and a world I know, and see, but to which I am nevertheless not present (through no fault of my subjectivity), is a world past.[39]

The contingent pixels in Collins' photograph not only show how the camera passively records the exposed reality into an indecomposable now, but they also feature the "presentness of the world" by reminding the viewer that they belong to an irreversible past. These pixels retain the presentness of the world through persistently reassuring us of our absence from the moment of their making, and by informing the spectator that they are too late in time to identify what these pixels are. Although it is true that these pixels cannot embody the reality that is concealed behind them, they can testify that what they hide once existed in the space in between the camera and the seaside. Rather than representing the visual appearances of the moving objects they mask, these pixels give evidence to their existence in time and space in front of the camera. In other words, the contingent pixels are irrefutable testimonies to the *spatial existence* of the moving objects they perpetually bury in the past, without ever revealing what these objects are.

For cultural critic Siegfried Kracauer, the singular spatial existence of the photographed subject in front of the camera was the defining marker of photography. In his essay, written in 1927, he suggested that "photography does not preserve the transparent features of an object or a person but records it from whatever position as a spatial continuum".[40] For Kracauer photography does not aim to imitate or maintain the appearances of the subject; instead, it merely records the space in between the camera and the photographed subject as a spatial continuum. He elucidates this point by contrasting painting with photography. As he argues, while in painting "the meaning of the subject becomes a spatial appearance", in photography "it is the spatial appearance of a subject that is its meaning".[41] That is to say, while painters, by deducing the meaning of the subject, visualise its spatial appearance in paintings, in a photograph the mere spatial existence of the photographed subject in front of the camera becomes its meaning. For Kracauer, photography does not necessarily cut

off the spatial appearances of a subject, but its significance lies in its eternalisation of the space continuum once confronted by the camera. He explains this point in a revealing passage where he describes the experience of looking at the photograph of his grandmother in her youth:

> We are held in nothing, and photography gathers fragments around a nothing. When the grandmother stood before the lens, she was for a second present in a space continuum that offered itself to the lens. But what was made eternal was just this aspect, instead of the grandmother. The viewer of old photographs feels a shiver. For they make present not the knowledge of the original sitter but *the spatial configuration of a moment*; it is not the human being that emerges from the photograph but rather the sum of everything that can be subtracted from that being.[42]

In Kracauer's reading, the ghostly character of photographs does not literally summon or present the being of the photographed subject, nor can it necessarily embody the spatial appearances thereof. Instead, it suggests that photographs can attest to the very space continuum in between the camera and the photographed subject; that is, the very "spatial configuration of a moment" when a photograph is taken. Therefore, what is immortalised in photographs is precisely this spatial aspect, the very existence of the photographed subject in front of the camera, and not so much the appearances of the photographed subject in the world.

Returning to Collins' photograph, although the contingent pixels cannot present the appearances of the moving subjects they hide, they can undoubtedly testify to their existence within the spatial continuum of the camera. That is, rather than presenting what they are, these pixels tenaciously refer to the spatial configuration of the moment when the photograph was captured by the camera. As Gunning notes, the photograph does not necessarily present its subject, but it "opens up a passageway to its subject … the photograph does make us imagine something else, something behind it, before it, somewhere in relation to it".[43] Here Gunning echoes Kracauer in saying that the significance of the photograph is not that it can preserve the appearances of the photographed subject, but that it situates the spectator somewhere in relation to the moment it was taken. Even if the contingent pixels in Collins' photograph do not present what they obscure, they can put us in relation to, or in the presence of, the spatial configuration of the moment of their making. These pixels indicate how the camera forever eternalises this spatial aspect, thereby conferring a temporal dimension to the spatial presence of the photographed subject in front of the lens. As such, the existence of the contingent pixels in Collins' photograph foregrounds two inherent features of the camera. On the one hand, these pixels make evident that the camera is a *preparatus* that unintentionally lies in wait and acti/passively records the exposed reality, resulting in unexpected details in the photograph that override the

photographer's intention. On the other hand, although the definite identity of the pixels cannot be known to the spectator, they can give evidence to the temporalisation of the space continuum, a spatial dimension that was once confronted and forever eternalised by the camera.

Having discussed these two aspects of the camera, in the following section, by retaining my focus on the contingent pixels, I will further expound on how the camera obscures a photographic relation through discussing the problematic of the referent in photography. Echoing Kracauer's claim, later theorist Roland Barthes put forward that the very essence of photography derives from the mere spatial existence of the photographed subject in front of the lens, that is, in the spatial continuum of the camera.

The Black Box of Contingency

> The photographic apparatus reminds us of this irreducible referential.
>
> —Jacques Derrida, *Deaths of Roland Barthes*

In *Camera Lucida,* Roland Barthes' last book that was first published in 1980, he made a contentious claim about the nature of photographs by calling them "the literal emanation of the referent", as if to say that every photograph carries within it a part of that which it represents.[44] While in language studies the term referent addresses the thing in the physical world that a word denotes or stands for, in photography this term refers to that which a photograph is of, e.g. in a portrait photograph the referent is the person who once posed for the camera in the world. However, as Barthes suggests, the term "referent" in photography is fundamentally distinct from the other systems of representation. As he writes, "I call 'photographic referent' not the *optionally* real thing to which an image or a sign refers but the *necessarily* real thing which has been placed before the lens".[45] For Barthes, when seeing a photograph the undeniable fact is that the photographed subject, "the real thing", has necessarily been confronted by the camera once in time. In light of this, he argues that while looking at a photograph it cannot be denied that "the thing has been there" in front of the camera.

He further proposes that the very essence of photography, calling it the "noeme" of photography, is therefore "that-has-been", referring to the once existence of the photographed subject in front of the camera.[46] In other words, that-has-been underlines the idea that the photographed subject once existed in the Kracauerian spatial continuum of the camera's perspective. A conspicuous fact that, as Barthes notes, "goes without saying" since otherwise there would not have been a photograph.[47]

As theorist John Lechte has argued, the Barthesian that-has-been, or the noeme of photography, stems from the Husserlian terminology of "noema". As he points out, "the purpose of the *noema* is to make it possible to avoid meaning becoming ensnared in the natural attitude of the contingent world". Consequently, Barthes' configuration of that-has-been, which he assigns as the noeme of photography, is essentially something non-perceivable and elusive, since it has to do with the process of signification. Therefore, simply put, "the meaning of 'it has been' would be time".[48] As Lechte suggests, that-has-been of a photograph is the method with which Barthes has maintained the contingency of time; it is a means whereby he attempts to address a temporal dimension that is imperceptible. That is why, for Barthes, the clear manifestation of that-has-been is grounded in the notion of the "punctum" of time (i.e. "its pure presentation"), which is not perceivable but nevertheless felt by the viewer.

While discussing Alexander Gardner's portrait of Lewis Payne as he is waiting to be executed in his cell, Barthes introduced the punctum of time as its indeterminate but immediate impact on the viewer: the very tension that arises when reading Payne's portrait as "this will be" and "this has been".[49] The photograph of Lewis Payne, which features him sitting and waiting hopelessly for his imminent execution, embodies the impossibility of choosing between the past and future tenses in reference to a photograph. While Payne's portrait suggests that "he is going to die", at the same time, being a photograph that was taken in the past, it testifies to the fact that he is already dead. By flickering back and forth from "that-has-been" to "that-will-be", historian of photography Geoffrey Batchen proposes that Barthes seeks to formulate the representation of time in photography as a temporal oscillation, which he seeks to encapsulate in the anterior future tense that he imputes to photographs.[50] Barthes addresses this oscillation between different times by referring to Lewis Payne's photograph as a "death in the future".[51] As philosopher Bernard Stiegler remarks, the punctum of time "is indescribable; it is only inscriptible, its description is indefinitely deferred".[52] That is to say, for Barthes, the punctum of time is not the perceivable or the describable aspect of time, but the very immediacy of the impact of time, arising from the incongruity between recognising a photograph as a past event and as what is going to happen. As Lechte succinctly puts it, "the punctum is not a feature in itself, but the impact of that feature", that is, the impact of time.[53]

Nonetheless, while the second half of *Camera Lucida* is devoted to the temporal aspect of the punctum (i.e. the immediate impact of that-has-been), the first half of the book is interspersed with another aspect of this notion: its accidental character. According to Barthes, in every photograph there co-exist two discontinuous and heterogeneous elements that do not "belong to the same world".[54] The first of these he calls the "studium", which is a matter of the cultural reading of photographs, resulting in an "average affect" that is experienced by the viewer. As he explains, "to recognize the *studium* is inevitably to encounter the photographer's intention, to enter

into harmony with them, to approve or disapprove them, but always to understand them".[55] For Barthes, the field of the studium signals the cultural, informative and thus the utilitarian capacity of photographs, which always aims to bring to light the photographer's intention. By endowing photographs with functions, the studium makes evident what the photographer intended to represent in the photograph, thereby producing what Barthes refers to as a "docile interest" for the viewer. However, the utilitarian property of the studium is unsettled by the existence of a second element that surpasses the photographer's intention, which he terms the punctum of detail.

The punctum of detail, Barthes writes, "is that accident which pricks me, but also bruises me, is poignant to me". The accidental character of the punctum not only supersedes the photographer's intention, but also imbues the punctum with a wound-like and pointed character, as if it could puncture the surface of the photograph "like an arrow".[56] The imperative facet of the punctum of detail is that, despite being located in the photograph, it always remains as a disparate element within the frame. For instance, observing the photograph of two handicapped children taken by Lewis H. Hine, Barthes identifies the boy's Danton collar and the girl's finger bandage as the "off-centre" part of the frame, and thus as the punctum of detail.[57] That is because, regardless of Hine's intention, the Danton collar and the finger bandage remain off-centre and incompatible with the rest of the photograph. Therefore, the punctum of detail refers to the unintentional visual elements that are captured in the photograph, marked by an incongruity that makes them heterogeneous parts of the frame. To be concise, while these accidental details constitute and inhabit the photograph, they remain *other* within the frame. [58]

In "Deaths of Roland Barthes", a posthumous tribute to Roland Barthes, Derrida points out that the punctum of detail is "a point of singularity that punctures the surface of reproduction" in order to address the spectator, all the while remaining "other" in the photograph.[59] The punctum of detail, writes Derrida,

> seems to concern only me. Its very definition is that it addresses itself to me. The *absolute singularity of the other* addresses itself to me, the Referent that, in its very image, I can no longer suspend, even though its "presence" forever escapes me, having already receded into the past.[60]

Cognizant of the fact that that-has-been always belongs to the past, Derrida suggests that the punctum of detail (i.e. the incompatible detail in the photograph) addresses itself to him without actually being present. That is, it manifests itself only as "the absolute singularity of the other", other in that it remains infinitely indissoluble within the studium. Remarking on the composition of the punctum and the studium in a photograph, Derrida states, "it [*punctum*] belongs to it [*studium*] without belonging to it and is *unlocatable within* it; it is never inscribed in the homogenous objectivity of the framed space but instead inhabits or, rather haunts it".[61] This means that, while

the punctum is a constitutive part of the photograph, it haunts the studium in order to manifest its non-belonging and discordancy in the frame. In other words, the punctum, despite its localisation in the photograph, remains invariably incompatible and therefore other within the frame.

Returning to Collins' photograph once more, on the one hand, the totality of the picture indicates the functional and informative side of the photograph, which allows the viewer to read it as a seascape, thereby reflecting the domain of the studium that makes us understand the photograph. As Barthes reminds us, to recognise the studium of photographs is "always to understand them".[62] On the other hand, the mere presence of the contingent pixels as the accidental details that override the photographer's intention makes them fall under the domain of the punctum: they are the "unlocatable within" that haunts the frame through non-belonging and otherness. While inhering in the photograph, these pixels remain as the off-centre details that inexorably withhold any determinate signification, thereby resisting falling into any cultural assimilation. Although the contingent pixels can attest to the existence of their referent in the spatial continuum, their real identities never come into presence due to their pastness. Strictly speaking, their identity remains perpetually speculative since they could be any number of possible conjectures. The identifiable pixels in Collins' photo, therefore, remain as incongruent points that bear witness only to the absolute singularity of the other. These pixels stand for the indissoluble and inscrutable other that is both *present* and *absent* in the photograph, contingent through and through.

Nevertheless, as Derrida points out, the otherness of the punctum in the field of studium, the very link between the two concepts, "is neither tautological nor oppositional, neither dialectical nor in any sense symmetrical; it is supplementary and musical".[63] For Derrida, the composition of the two concepts of the punctum and the studium is not something that can be exhausted through philosophical signification, i.e. by reducing them into meanings. Instead, the two concepts complement each other as if in a musical composition. The relationship between the two concepts is not that of an exclusion, as if the otherness of the punctum could eliminate it from the field of stadium, but the punctum gives rhythm to the stadium.[64] Derrida uses the term "contrapuntal" to address the way in which the two concepts combine with each other to form a whole, in the same way as musical melodies merge together while maintaining their independence.[65] Therefore, for Derrida, the two concepts do not have any theoretical privilege over one other, but they manifest the way in which photographic images are able simultaneously to yield and thwart meanings.

Drawing on a similar point, Rancière notes that while studium demonstrates that the photographic image is "a vehicle for a silent discourse", punctum informs us that the photographic "image speaks to us precisely when it is silent, when it no longer transmits any message to us".[66] For Rancière, the juxtaposition of punctum and studium, above all, manifests that photographic images have the capacity to show the relationship between the visible and the invisible within them; the fact that

photographs are silent but can speak precisely through their silence. He calls this capacity of photographic images their "double poetics", which is, "simultaneously or separately, two things: the *legible testimony of history* written on faces or objects and *pure blocs of visibility*, impervious to any narrativization, any intersection of meaning".[67] Here, he draws attention to the problematic that lies at the heart of the photographic image, that is, the conflation of the reference and the referent in photographs. While Rancière's former category refers to the capacity of photographs to function as the *reference* of that which they represent, which makes them the "legible testimony of history", the latter category addresses the ability of photographs perpetually to evade meaning by leaving their *referent* in the past. For the referent in a photograph is the actual photographed thing in the world which, after a photographic encounter, remains infinitely absent from the photograph. Commenting on the relationship between the reference and the referent in a photographic relation, Derrida notes:

> but should we say reference or referent? ... in the photograph, *the referent* is noticeably absent, suspendable, vanished into the unique past time of its event, but *the reference* to this referent...implies just as irreducibly the having-been of a unique and invariable referent.[68]

To exemplify, while in Collins' photograph the referent is the actual seaside, things and people whose identities are concealed forever in the past, the photographic reference implies the very existence, or the having-been, of these referents in front of the lens. Or, in Kracauer's reading, the reference marks the unique existence of the photographed things in the spatial continuum of the camera, and the referent is the actual photographed thing that is eternally held in the past. As Barthes famously claimed, photographs are "laminated objects" to which the referent stubbornly adheres; "it is as if the Photograph always carries its referent with itself".[69] Derrida, however, eschews choosing between the referent and the reference by addressing the photographic relationship by suggesting a new term. He proposes the term "the unicity of referential...not to have to choose between reference and referent: what adheres in the photograph is perhaps less the referent itself...than the implication in the reference of its having-been-unique".[70] For Derrida, what remains in the photograph is not so much the actual, physical or perceptible referent that was once confronted by the camera (i.e. the actual thing in the world), but rather the testimony to the unique existence of that physical referent: its "having-been-unique". Consequently, by proposing the term "the unicity of referential", he signals the capacity of photography to provide a new relation towards the photographed subject that is not hinged upon the reference/referent distinction. This term, without claiming that the physical referent adheres in photographs, underscores that the unique existence of the referent is perpetually suspended in them. What has often been overlooked in photographic discourse, Derrida contends, "is a matter of at once acknowledging the possibility of

suspending the Referent".[71] Precisely this aspect of photography (i.e. the suspension of the referent) problematises the photographic relation, in that, by suspending the referent, photography establishes a vexed relation towards that which will remain ceaselessly in the past. He outlines this point in *Right of Inspection* (1998), a photo-novel in which Derrida ruminates on the photographs of the Belgian photographer Marie-Françoise Plissart. As he puts it:

> If there is an art of photography (beyond that of determined genres, and thus in an almost transcendental space), it is found here. Not that it suspends reference, but that it indefinitely defers a certain type of reality, that of the perceptible referent. It gives the prerogative to the other, opens the infinite uncertainty of a relation to the completely other, a relation without relation.[72]

By suspending the "perceptible referent", which once existed in front of the camera, photography affirms the status of the referent as the other, thereby constituting an uncertain relation towards the referent in the photograph. That is, the photographic relation is to be understood as a "relation without relation", because, through infinitely deferring the perceptible reality, photography concurrently gives evidence to the existence of the referent *and* ensures that it belongs to an irrevocable past. In doing so it thwarts the possibility of constituting a determinate relation towards the perceptive referent in the world.

Returning to Collins' photograph, the existence of the contingent pixels evidently displays how Collins' camera suspends the perceptible referent, thus retaining it as the absolute singularity of the other in the photographic frame. In other words, due to the eternal suspension of their referent, the contingent pixels have constituted an indeterminate relation towards that which they represent, making it both present and absent in the frame. They manifest that their referents remain other and endlessly inaccessible, magnifying the way in which the photographic camera suspends the perceptible reality. Therefore, on the one hand, Collins' photograph reveals that the camera is an apparatus that active/passively records the spatial continuum exposed to its lens, resulting in unintended details that may override the intention of the photographer. By doing so, it eternalises the spatial arrangement of a photographic encounter, thereby granting a *temporal dimension* to this spatial configuration in the photograph. On the other hand, Collins' photograph shows that although the camera can bear witness to the that-has-been of the referent, seeding the photograph with the possibility of its immediate impact as punctum, it perpetually suspends the perceptible referent into an irreversible past. In doing so, the camera confers a *spatial dimension* to the unique existence of the referent in time by inexorably deferring it. As such, in a photographic act the camera not only functions as a non-living agent that cuts off or slices out a piece of space and time; but, as I have shown, it also functions as

a place wherein the Kracauerian spatial continuum is temporalised and the Barthesian that-has-been is spatialised: it is a *contingent place* that constitutes a relation without relation towards the perceptible reality exposed to its lens.

At this point, having discussed the ways in which the camera can be considered as a place in which time is spatialised and space is temporalised, I will zoom out from the camera's role to that of the other partaker of a photographic act: the photograph. However, as Batchen has remarked, a photograph has never had permanent physical features by which it could be identified as such, because "as a system of representation dependent on reproduction, the photograph is capable of having many distinct physical manifestations".[73] For instance, while a photograph can be produced in the material form of print with a multitude of forms and shapes, it can also be found in the immaterial form of information circulating in cyberspace. Irrespective of the forms in which the photograph is found, Batchen reminds us that the photograph is always infused with the potentiality of being reproduced, and that is what makes the photograph a pliable concept. In the following chapter, by focusing on the possibility of reproduction inherent to every photograph, I will next investigate how the examination of the photograph as a place can shed light on the spatial properties of this partaker of photography.

CHAPTER THREE

The Photograph:
A Place That Lacks Its Own Emplacement

> The photograph in some sense can elude history.
>
> —Roland Barthes, *Rhetoric of the Image*

According to Batchen, since the late nineteenth century photographs have been utilised and manipulated in a variety of different ways; therefore, from this time on "the photograph is treated as an entirely malleable concept, something to be made rather than simply taken".[1] The flexibility of the photograph as a concept stems not only from its manipulation in different mediums and discourses, but also from the fact that the photographic technology has been always altering and evolving since its conception. However, as Batchen notes, when looking at the history of photography it becomes evident that "a change in imaging technology will not, in and of itself, cause the disappearance of the photograph", because "photography has never been any *one* technology".[2] For Batchen, throughout approximately two centuries of technological developments replete with numerous cases of innovation and obsolescence, the photograph has remained, but as a pliable concept. Today, it has become commonplace for almost everyone to refer to a paper print, digital print or a picture on computer screens as a photograph. Yet, the question remains what characteristics define a photograph in the present time, while throughout the history of the medium it has been continually shaping and reshaping in a variety of forms.

As literary theorist Eduardo Cadava inquires, "how can we know what a photograph is when it has appeared in so many guises", such as "heliograph, photogenic drawing, calotype, talbotype, cyanotype, daguerreotype, photogram, pinhole image, analog or digital photograph?" As he further argues, due to the manifold guises photographs have appeared in throughout their history it has become obvious that "a photograph has never been a *single thing*, has never had a consistent form, has never remained identical to itself. Instead it has continually been altered, transformed, and circulated".[3] A photograph, as Batchen and Cadava hold, has never been a single entity, but a

malleable concept, constantly undergoing its own transmutation in different forms and within diverse mediums. It is because, since the advent of the medium, the photograph has been continually influenced by the imaging technology in which it has been produced and reproduced. However, precisely due to the potential of reproducibility embedded in each photograph, it has been able to travel from one place to another, thereby continuing its life in different times and spaces.

That is why Flusser looked at photographs as "silent surface(s) patiently waiting to be distributed", referring to the capacity of photographs to move from their context by means of reproduction.[4] Although since the nineteenth century photographs have been constantly transformed by the technological advancements of the medium, one of the main features they have persistently retained is their *movability* through different channels of distribution. The simple fact is that, either as materialised prints or as immaterial information, photographs can move into diverse channels of distribution by being reproduced. In this chapter, in order to examine how photographs move in different spaces, I will concentrate on how the photograph as a place travels through different distributary channels, the only quality that has inhered in them until the present day. While discussing different modes of distribution photographs can take, I will mainly focus on one specific channel that is undoubtedly the most prevalent in our time: the internet. It is because looking at photographs' method of distribution on the internet not only foregrounds how they have retained movability as their defining marker, but will also manifest how the photograph as a place inhabits the virtual space. To do this, firstly I will discuss how the photograph as a thing cannot ever be restricted to any specific location, but moves by means of reproduction. Then, by examining a case-study that makes evident photographs' movability, and by drawing on the works of philosophers Michel Foucault and Giles Deleuze, I will argue what kind of place the photograph can be when it is marked by movability, and *how* such place moves in space. In doing so, not only will this chapter show how the photograph can be seen as a place, but also how such a place localises in space. To this end I will begin my analysis by explaining the relationship between places and their inherent capacity of alteration; that is, their potential of constant change through which they reflect their becoming, as photographs do through their continual evolution within diverse mediums and practices.

Never in a Single Location

The photograph is always more than an image.

—Giorgio Agamben, *Profanations*

The putative misconception that places are static stems from the Platonic distinction between the two notions of "chora" and "topos" as the constituents of becoming and the origin of existence. While in Plato's terms chora refers to "the place or setting for becoming", topos is rather the thing that undergoes the process of becoming.[5] Although these two notions were used interchangeably in Plato's writings, Cresswell argues, chora denotes a place that is more specific: it is a place that is incessantly in the process of becoming a place. As he points out, while for Plato "chora most often referred to a place in the process of becoming, topos would refer to *an achieved place*".[6] In other words, the idea of place since Plato has been bifurcated towards two seemingly disparate directions: that of topos, which suggests places are static and finalised, and that of chora, which proposes that places are always in the process of becoming. Accordingly, the distinction between the two aspects of place as something processual, such as places that host activities, and as a finalised entity has been perpetuating until the present time.

However, as philosopher Jeff Malpas contends, the notion of place contains "both the idea of the social activities and institutions that are expressed in and through the structure of a particular place…and the idea of the physical objects and events in the world". For him, the concept of place is essentially a multifarious one and thus cannot ever be reduced to an achieved place, since it can reflect the entanglement of social interactions and physical places in which those interactions occur. The idea of place, Malpas notes, essentially involves both "physical objects" and "social interactions", since "it is within the structure of places that the very possibility of the social arises".[7] For Malpas, the idea of place is not to be deemed as a finalised and static entity, but as something that is invariably in the state of alteration through different social practices. Along the same line, geographer Allan Pred puts forward that places are essentially marked by inherent processes, "whether presented as elements of a spatial distribution, as unique assemblage of physical facts and human artefacts, or as a localized spatial form".[8] Through introducing the concept of "paths", Pred argues that both people and physical objects move through time and space, resulting in biographies that eventually lead to the formation of places. Thus, he defines the concept of place as "a process whereby the reproduction of social and cultural forms, the formation of biographies, and the transformation of nature ceaselessly become one another".[9] Pred suggests that places are not recognised by a set of predefined properties, but through processes, or "paths", with which they engage with sociocultural activities that constitute them.

Despite their different approaches towards places, what Malpas and Pred share in their understanding of the concept of place is that it is never found as an achieved place, that is, it is never a topos.

Regardless of being a geographical location or a physical object, a place should not be deemed as belonging to the inert, since it is always in the constant process of transformation. In the photographic discourse, a photograph can epitomise how a physical object can move through diverse sociocultural transformation, both affecting and being affected through this process. Photographs, Flusser proposes, even in their very physical form are "loose leaves which can be passed hand to hand", stressing that photographs are instilled with the capacity of movement by being constantly exchanged among people.[10] Acknowledging that photographs are essentially mobile artefacts, theorist and photographer Allan Sekula points out that the photograph is mainly used as "a token of exchange" in the photographic discourse, which can "be defined as an arena of information exchange". Precisely because photographs can be reproduced and relocated from one context to another, like "loose leaves", Sekula holds that photographic meaning is never naturally given within the photograph, but is always "context determined". Thus, he defines the photograph as necessarily an "incomplete utterance", since its meaning and form can be altered and adapted depending on its contexts of readability and modes of reproduction.[11] Because the meaning and shape of photographs are always hinged upon their context of delivery, Sekula notes, "the most significant feature of the photograph is its *reproducibility*".[12] That is, the fact that the photograph can be copied into infinite numbers, and each of the replications can enter into a new discourse of readability which, in turn, weakens the singular existence of the photograph in any particular time and space.

Undermining the concept of authenticity in "The Work of Art in the Age of Its Mechanical Reproduction", Benjamin propounded that the mass reproduction of artworks caused a significant shift in their singular existence in time, resulting in the loss of their "aura". In his terms, the aura of the work of art referred to "its presence in time and space, its unique existence at the place where it happens to be".[13] Before the advancement of technical reproduction, Benjamin argued that the work of art was appraised according to its ritual function, which would confer an aura of singularity upon the artwork. But, in the age of mechanical reproduction, the work of art is to a lesser degree valued by its ceremonial and ritual functions in human societies. Instead, according to Benjamin, the "cult value" of the work of art, which is the corollary of its ritual function, has been supplanted by its "exhibition value".[14] For Benjamin, photography is the quintessential indicator of the shift from the cultic to the exhibitional function of artworks, because it substituted the domain of "tradition" with "plurality" of copies through mass reproduction.[15] Nevertheless, he begins his article by stating that "in principle a work of art has always been reproducible", thus proposing that reproduction was not a new feature per se.[16] In relation to photography, Sekula notes, "the status of the photograph as an 'unique object' had an early demise

with Talbot's invention of positive-negative process".[17] That is, even the early chemical photographs had the possibility of being reproduced as their inherent feature and, therefore, reproduction was nothing new for the photographic medium. Cadava furthers this discussion by saying that even Greek coins, bronzes and woodcuts were duplicable: "if the technological reproducibility of a work of art suggests something new, this something new is not a 'first time' in history. Rather, it marks the *intense acceleration* of a movement that has always already been at work within the work".[18]

As Cadava suggests, the reproducibility of an artwork has always been its intrinsic feature, and after the technological advancement of the photographic medium this feature has only been extremely intensified. Precisely due to this intense acceleration in the reproduction phase, scholar Gabriela Nouzeilles contends, photographic pictures are always subjected to simultaneous forces of "domiciliation" and "dispersion", even in their seemingly most immobile state in an archive.[19] It is because, while being preserved and domiciled in an archive, photographs retain the possibility of being rapidly reproduced an infinite number of times, through which they can leave the archive and post-haste disseminate into different places and times. Nouzeilles refers to this aspect of photographs as "the archival paradox", which features the coexisting potentials of "inscription" and "itinerancy" embedded in each photograph. As she explains this point:

> The paradoxical condition of the archive—the hesitation between *inscription* and *itinerancy*—is intrinsic to photography itself. Photography is both Medusan and Protean. It does congeal what is sees, but it also sets itself, and with it its referent, into motion. It both mummifies and sets free.[20]

Endowed with the possibility of reproduction, Nouzeilles suggests, a photograph's location cannot be demarcated by its archival location, but marked by simultaneous capacities of inscription and itinerancy. In other words, a photograph laden with the possibility of being reproduced is as much domiciled in the place where it is situated as it is transferable to other locations. A photograph, Nouzeilles suggests, is "both the spectral shadow of a trace" (alluding to the ghostly existence of the referent in the photograph discussed in the previous chapter) and "its physical materialization".[21] That is to say, a photograph can concurrently be a physical object that can be touched and moved, *and* a place where the spectral image of the referent appears.

However, as Batchen notes, the awareness of the physicality of the photograph stems from the early daguerreotypes that had to be touched and handled with meticulous care.[22] Because of the careful handling of the early photographic images, their physical identity resulted in considering the photograph as "simultaneously [an] image and a thing".[23] As objects or things, in Flusser's terms, photographs are loose leaves that can be exchanged between people and move from one place to another,

facilitated through the intense acceleration of technological reproduction. However, also as an image, the photograph cannot be reduced to one place, since, as Casey points out, "the place of images" is not restricted to exact positioning, but signifies an "intense efflorescence". As he further explains, "what matters in the physical implacement of images is not how they are contained by a surface … but how they appear at a surface", because images are "indeed efflorescent phenomena".[24] While as a thing the photograph can be moved and exchanged from one hand to another, as an image it becomes an efflorescent phenomenon that can unfold towards different times and spaces. Consequently, whether considering the photograph as an image or as a thing, the indispensable fact to consider is that it cannot be delimited to where it is located, because having the inherent potential of reproducibility at its disposal, every photograph is capable of moving from its context and travelling towards a boundless number of contexts yet to come.

Refraining from calling photographs either objects or images, Flusser underscores their movability by stating that "photographs are *silent flyers* that are distributed by means of reproduction".[25] For him, the significance of the photograph lies not in its consideration as an object or an image, but in the fact that it can be reproduced, thereby perpetually moving through different channels of distribution like a flyer. Being a flyer that can travel through different circulatory channels, a photograph cannot be deemed a finalised place, that is, it cannot be a topos that is finished in and of itself. It is an understanding of the photograph that has been especially embraced by visual anthropologists.[26] As Pred and Malpas argue, the idea of place encompasses physical objects, social interactions and events in the world; however, a more defining fact concerning a place is that it never should be considered as an achieved place that does not undergo further alteration. Photographs as places manifest their constant modification and becoming through the possibility of being reproduced, whereby they can travel in a multiplicity of directions. That is why Cadava proposes that the only specifying feature of photographs, which has been preserved since their conception, is their inherent *itinerancy*. The fact that a photograph, through the inbuilt potential of being reproduced, can move across the globe and never remain in a single location: a movement through which "its significance is simultaneously altered and preserved".[27] In other words, irrespective of considering the photograph as an image or an object, Cadava and Flusser hold that the only defining index of photographs is their itinerancy, allowing them to travel across different locations like silent flyers.

At this point, having discussed the possibility of the photograph being a flyer that cannot be restricted to a single position, I will next look at a photograph to exemplify what specific kind of place photographs can be when their fate is to be everlastingly reproduced. In other words, by focusing on movability as a defining trait of photographs, in the following section I discuss how the photograph can feature a place that is never an achieved place; that is, how it manifests a place that is never permanently localised in time and space.

A Placeless Place Sailing Across Different Spaces

Photographic images are essentially mutable and fluid artifacts,
"at home" in any context while simultaneously in transient.

Gabriela Nouzeilles, *The Archival Paradox*

In 2005, the Spanish conceptual artist, Joan Fontcuberta, held an exhibition entitled *Googlegrams* at the Metropolitan Museum of Art in New York. In this gallery, he exhibited several photographic prints resulting from the accumulation of thousands of thumbnail images that were downloaded from the internet and combined by a photo-mosaic program. The photo-mosaic software, the artist explains, is a program that "selects each graphic sample from the bank of available images and places it according to chromatic value and density in the position that most closely coincides with a portion of the larger image being recreated, as if it were making a gigantic jigsaw puzzle".[28] Although the photo-mosaic software usually operates off-line, for the construction of *Googlegrams* it was connected to the internet in order to utilise the images that are made available via the Google search engine. Having been constructed by the photo-mosaic software, each of the *Googlegrams* reflected, in its totality, one of the photographic images that had become an iconic image of our time.[29] Figure 4 features one of these photographic images called *Googlegram: Niépce,* which was based on the first known photograph taken by Joseph Nicéphore Niépce, called *View from the Window at Le Gras,* 1826. As "a composite of ten thousand tiny electronic images that link the photography's chemical origins to its dematerialized pixelated present", *Googlegram: Niépce* was made to resemble the first photograph taken in the history of the medium.[30]

According to Cadava, *Googlegram: Niépce* represents the itinerary of photographic images, because it represents how Niépce's photograph has been travelling through different times and mediums up to the present.[31] It reflects how the first photograph taken in the history of photography has been transmuted and commuted to the present digital world. Tracing the places where Niépce's original photograph has been relocated to during the past two hundred years, Cadava suggests, the first photograph can reflect the "literal itinerary" of photography: the fact that a photograph can physically travel from one location to another.[32] However, *Googlegram: Niépce* not only shows how the first photograph has been transmuted and brought into the contemporary digital age, but can also foreground the characteristics of the photograph as a *place* that cannot be restricted to any particular location and time. In turn, Fontcuberta's photo can make evident *how* the photograph as a place can be disseminated through the internet, in a space whose movements do not necessarily correspond with the term

itinerary. To clarify, although Niépce's original photograph can truly reflect the "literal itinerancy" of photographs, having been immaterialised and circulated in the digital space, I will further argue that *Googlegram: Niépce* becomes a place that necessitates a different mode of itinerancy.

Figure 4: Joan Fontcuberta, (2005). *Googlegram: Nièpce*. © Joan Fontcuberta.

Fontcuberta's photo is, above all, an attempt to redefine what a photograph is in our age, an age when it can instantaneously travel from one place to another through accelerated modes of digital reproduction. In addition, it features how a photograph, being either a thing or an image, always carries the traces of distant places and times. As Cadava notes, regardless of what photographs are made of, "they must be understood as surfaces that bear the traces of an entire network of historical relations, of a complex history of production and reproduction, that gives them a depth that always takes them *elsewhere*, always links them to other times and places".[33] While proposing that photographs must be conceived as surfaces carrying the concatenated histories through which they were reproduced, Cadava signals another defining point about photographs: their capacity to be taken "elsewhere", to other periods of time and locations. It is true that photographs can either materially or immaterially go elsewhere, thanks to their engrained potential of reproduction, but they can also

contain "an elsewhere" within them while remaining in one place, as in the structure of an alibi. Like a photograph, an alibi essentially provides a piece of evidence showing that one was elsewhere when an act allegedly had taken place; in so doing, it includes another time and place within its operative structure.

As Barthes repeatedly pointed out, the essential function or principle inherent in all photographs is that they can be utilised as alibi.[34] That is, while remaining in one location photographs can testify to, and somewhat include the existence of, other places in them, thereby providing a spatial link to where they refer to in the world. That is why Barthes proposes that an alibi should essentially be understood as a "spatial term", since it features a place that always has "an 'elsewhere' at its disposal".[35] Strictly speaking, while as a probative instrument the alibi can be found in a particular place, it always attests to the existence of an elsewhere within its configuration. As Barthes points out, in the alibi "a place which is full and one which is empty" coexist, referring to the capacity of an alibi to include an elsewhere within it, whereas that elsewhere does not literally lie in it per se.[36] For Barthes, thus, an alibi can be understood as a place that resists being completely emplaced, as it always bears the traces of other times and spaces within its structure. In other words, while an alibi (such as a photograph that is used for evidential means in the court) can be localised, it always gives evidence to, and subsumes the existence of, other places and times, thereby reflecting what philosopher Michel Foucault once called a heterotopic place.

In his essay "Different Spaces" Foucault proposed the concept of "heterotopias" to refer to "places that are outside all places, although they are actually localizable". Unlike utopias, which are places that have no "real place", heterotopias are actual places that afford only temporary localisation, because they are marked by polyvalent functions that make them resistant to any permanent emplacement. Foucault demonstrates this point by the example of a moving train. As he explains, "a train is an extraordinary bundle of relations, since it's something through which one passes; it is also something by which one can pass from one point to another, and then it is something that passes by".[37] That is to say, the multifarious functionalities of the train do not allow permanent localisation, because it is a place that, particularly when it moves, shares the aspects of other spaces and times as its constructive components. According to Foucault, heterotopic places are defined by the following principles: the operational mode of heterotopic places can change according to the society in which they are located; they have "the ability to juxtapose in a single place several emplacements that are incompatible in themselves"; they are "connected with temporal discontinuities"; and, lastly, "they have a function in relation to the remaining space".[38] While Foucault's instances of heterotopic places mostly address immobile locations, such as prisons, hospitals, cemeteries, cinemas and brothels, this notion gains its full potential in an itinerant place, a ship that traverses an ocean. As Foucault writes:

> For example, the ship is a piece of floating space, *a placeless place*, that lives by its own devices, that is self-enclosed and, at the same time, delivered over to the boundless expanse of the ocean, and that goes from port to port, from watch to watch ... the sailing vessel is the heterotopia par excellence.[39]

A ship clearly embodies the qualities of heterotopic places because its mobility permits transfer from one harbour to another, while at the same time containing and being contained by other places along its route. In other words, the Foucauldian ship, like a photograph, functions as a flyer that sails through different places and times bearing the traces thereof, thus forming an itinerant life that does not yield enduring localisations. The Foucauldian ship displays a heterotopic character precisely because it is never permanently localised, but temporarily anchored in a harbour waiting to sail. Returning to *Googlegram,* this photo proclaims how Niépce's photograph has been sailing through different mediums and modes of reproduction, thereby revealing how the first photograph has become a heterotopic place that is never permanently localised. One the one hand, it features how in the age of intense acceleration of photographic reproduction every photograph is a placeless place that cannot be delimited to a single location, but appears in manifold disguises through different modes of reproduction. On the other hand, as a placeless place, *Googlegram* highlights that the photograph cannot be reduced to an achieved place that is finished per se. Instead, replete with the potential of reproducibility, the photograph becomes a flyer patiently waiting to sail across different channels of distribution. As Flusser submits, "as an object, as a thing, the photograph is practically without value": it is "a flyer and no more".[40]

Nevertheless, as a flyer fertilised by the possibility of reproduction, the photograph is not distributed as in the Foucauldian train that has determinate starting and ending points, but rather as a ship that sails through unspecified trajectories and in undetermined directions. As Flusser proposes, because photographs can be converted into electronic information, they do not abide by the conventional methods of distribution. Information, according to Flusser, is sent through four different methods: first, as in the theatre when the "receivers form a semi-circle around the sender"; second, as in the army when the sender relays information to conveyors; third, when the information is distributed into dialogues and enriched, as in scientific discourses. However, he argues that the distribution of photographs is fundamentally through a fourth method; that is, through "massification", when "the sender transmits the information into space, as on the radio".[41] Like the distribution of sounds into space, which cannot be limited to a one-to-one connection, Flusser suggests that photographs are essentially massified through undelimited spaces and towards countless destinations. Because photographs are distributed through massification, the space into which they traverse is thus rendered unspecified and

immeasurable. This means that, having been converted into reproducible information capable of proliferating massification, photographs are no longer distributed (as in the Foucauldian train) into a traceable and measurable space with an opening and ending (i.e. the spatial distance between the departure and arrival of the train). Instead, the photograph as a massifying flyer is more accurately distributed through what philosophers Gilles Deleuze and Félix Guattari termed as "smooth space", an uncountable space that can reverberate with the massifying character of photographs.

The Vagabond Locomotion of Photographs

Smooth space provides room for vagabondage

—Edward S. Casey, *The Fate of Place*

In their seminal book, A Thousand Plateaus: Capitalism and Schizophrenia, in which Deleuze and Guattari discuss a large array of philosophical investigations, a specific chapter is devoted to the distinction between two types of spaces: smooth and striated. According to the authors, whilst striated space features "homogenous" and "numeric" spatial movements whereby the movements in space can be specified, localised and thus counted, smooth space is intrinsically fluid and uncountable.[42] Striated space resonates with "the space of pillars" where all the movements are rendered into "parallel layers" and the flow is essentially "laminar" and linear. In turn, in striated space all the dimensions are expressed in fixed "units and points" and all motions are always "from one point to another". Within the structure of striated space, every location is fixed and countable and every direction is rendered homogenous and measurable, thus all locations and directions are determinate. This is mainly because in striated space all movements are essentially from one specific point to another. That is why the authors propound that striated space should be conceived as a "centred space" that provides countable units and absolute positions.[43] However, the counterpoint to striated space is smooth space, which is quintessentially uncountable.

According to Deleuze and Guattari, whereas striated "space is counted in order to be occupied", as it is hinged upon determinate motions, directions and locations, smooth "space is occupied without being counted". That means that, while in striated space the rhythms of movement can be identified and thus traced (e.g. as in the spatial movements of a train across the parallel rails on which it moves from one point to another), in smooth space movements are "without measure", as in the manner in which a fluid occupies space. For the authors, the smooth space manifests itself best in the movement of the air, the sea or systems of sound, since these spatial movements

are fundamentally fluctuating, non-centric and heterogeneous, in contrast to motions in striated space that are always from one countable location to another.[44] As they put it:

> Smooth space is a field without conduits or channels. A field, a heterogeneous smooth space, is wedded to a very particular type of multiplicity: nonmetric, acentered, rhizomatic multiplicities that occupy space without "counting" … an example of this is the system of sounds.[45]

According to Deleuze and Guattari, the distinctive principle between striated and smooth space is typified by two modalities of movement (i.e. two kind of motions that can be triggered through these spaces). As they argue, "in striated space, one closes off a surface and 'allocates' it according to determinate intervals, assigned breaks; in the smooth, one 'distributes' oneself in an open space, according to frequencies and in the course of one's crossings".[46] While in striated space movement is based on allocation from one fixed point to another, in smooth space movement is based on distribution through, and in, indefinite routes and directions. In other words, movements in striated space are based on fixed intervals that require determinate allocations (as in the case of a moving train that goes from one station to another), whereas movements in smooth space have distributary forms and are enacted through indeterminate trajectories (as in the movement of a ship that drifts in uncertain directions in an ocean). These two modes of movement, based on allocation and distribution, according to scholar Mark Nunes, remarkably manifest themselves when one searches for information in the internet space.

As Nunes has proposed, what Deleuze and Guattari refer to as allocation in striated space and distribution in smooth space can be epitomised by seemingly banal expressions of "surfing" and "cruising" information on the internet. Whereas the metaphor of "cruising the information" on the internet refers to going from one website to another in search of information (i.e. from point A to point B), "surfing the net" denotes a distribution into an infinite and untraceable plethora of information, which Nunes calls "the smooth cyberspace". That is to say, in surfing the internet one does not look for information from one single point to another, which is the function of cruising the net. Instead, as Nunes proposes after Deleuze and Guattari, in surfing the smooth cyberspace "the points are subordinated to the trajectory", because surfing the internet is primarily based on expansions and distributions whose directions are radically open.[47] Accordingly, surfing the net is not much concerned with specifying the trajectories from which the information is attained, but it is more concerned with a multiplicity of transitions between indefinite routes. As Nunes puts it:

To surf and to cruise. What separates these two metaphors is the space in which these activities can occur. "*Cruising*" involves a linear motion within a bounded space: one moves directionally. In "*surfing*", however, the ground itself appears unstable; the freedom involves "catching the wave" rather than mastering the routes.[48]

The primary difference between cruising and surfing lies in the fact that the former is contingent on fixed routes and is performed through linear movements, whereas the latter is somewhat a relay between unspecified trajectories. In other words, cruising is a form of movement that is migratory, but surfing is essentially a nomadic movement that is not dependent on any fixed itinerary or intervals. The migrant, Casey notes, "is someone who goes from point to point in a journey, the nomad proceeds by relays along a trajectory".[49] Therefore, as Nunes' reading of smooth space suggests, surfing for information on the internet is enacted through the space that is essentially multidirectional, uncountable and nomadic, unlike cruising which involves a linear motion within a bounded space. The critical difference here is that surfing the smooth cyberspace is not dependent on a fixed itinerary (i.e. it is not a movement from point A to point B, as in cruising). This means, surfing the smooth cyberspace is not restricted to any determinate itinerary that can be specified, nor hinged upon absolute intervals which one can arrive at or depart from. Instead, surfing in the smooth cyberspace is nomadic, with open-ended directions and uncertain itineraries; therefore, it has a form of vagabondage, which is the exemplary mode of movement in the Deleuzian smooth space. As Casey has put forward:

> Smooth space provides room for *vagabondage*, for wandering and drifting between regions instead of moving straight ahead between fixed points. Here one moves not only in accordance with cardinal directions or geometrically determined vectors but in a *polyvocality of directions*.[50]

As Casey proposes, the movements in smooth space are not to be understood as linear, straight or "laminar", since any motion in smooth space is quintessentially non-metric and indefinite in "polyvocality of directions". Consequently, in smooth space movements cannot be clearly demarcated and identified; instead, smooth space affords the possibility of vagabondage: a mode of movement that, much like surfing on the internet, is defined by indeterminate drifting that cannot be reduced to a point-to-point itinerary. By returning to *Googlegram* at this point, it becomes possible to argue that this photograph manifests the possibility of what I call the vagabond locomotion of photographs in the smooth cyberspace, which should be nuanced from photographs' itinerancy. In that, this photograph is the direct corollary of surfing the word "photo" and "foto" in the smooth space of the internet. This fact demonstrates the multiplicity of directions and locations from which each of *Googlegram*'s constitutive

photographs was received. The act of surfing on the Internet thus indicates that the provenances of *Googlegram*'s components remain multidirectional, uncountable and as such indeterminate, thereby undercutting the conventional mode of itinerancy with explicit starting and ending points.

To put it another way, Fontcuberta's photograph features how in the smooth cyberspace a photograph's movement cannot be delimited to a fixed itinerary, as in the case of the Foucauldian train that travels from one definite station to another. By surfing on Google, Fontcuberta discloses that, in the age of intense proliferation of immaterial images, the distributary directions and domiciliary positions of the photograph cannot be limited to an itinerary that can be specified and traced. Instead, being imbued with the possibility of post-haste reproduction and distribution in unspecified directions, every photograph has become a potential vagabond, inexorably voyaging through the internet like a flyer. *Googlegram* thus manifests that in the smooth cyberspace photographs are un-localisable places that ceaselessly sail into a plethora of digitised information and instantaneously massify through a polyvocality of directions, thereby manifesting *the vagabond locomotion of photographs*: the fact that in the smooth cyberspace the photograph's location cannot be delimited to "the place where it happens to be" (to use Benjamin's terms), nor can its distributary directions be demarcated by a fixed itinerary. Because, having the possibility of reproduction at its disposal, the photograph is never an achieved place that permanently anchors in a location, but a nomadic one that everlastingly travels from one location to another while transmuting in manifold disguises. In other words, Fontcuberta's photograph evinces how in the smooth cyberspace the photograph is a *placeless place* that drifts in and towards indeterminate directions and locations ad infinitum, signifying a place that perpetually lacks its own emplacement: a vagabond flyer par excellence.

Until this point I have argued that looking at the photograph's movement in smooth cyberspace can foreground how it becomes a placeless place, which continually journeys in and through a multitude of unspecified directions and locations. Considering the photograph as an image, however, can manifest other spatial facets that are preserved on its visual contour. That is to say, the spatial features of the photograph are not only limited to its transmissibility in the internet space, nor to the way it travels between people and different geographical locations, but also pertain to its surface. As Flusser reminds us, "the information the photo carries sits on its *surface* and not within its *body*, as in the case of shoes or fountain pens".[51] That means that the photograph not only consists of immaterial data or a materialised object that can move through different spaces, but is also a purveyor of visual information: it is an image as well. Therefore, in the next chapter I will shift my focus from the body of the photograph to its surface to look at the spatial features of photographic place: a visual place that is embedded in the photograph as an image.

CHAPTER FOUR

Photographic Place:
Looking at the Photographic Image
from Its Edge

There is no edgeless place.

—Edward S. Casey, *Keeping Art to Its Edge*

As Thrift notes, images are an indispensable element for understanding the inherent qualities of space, "because it is often through them that we register the spaces around us and imagine how they might turn up in the future".[1] Through framing a piece of space, photographic images not only enable us to register our surrounding space, but can also bestow meanings upon that space on the photograph's surface. As Cresswell argues, places are essentially regarded as "meaningful segments of space".[2] By selecting a piece of their surrounding space and preserving it as an image, people constitute what I refer to as photographic place: a meaningful image-place that provides the possibility of endless revisiting. In other words, having registered a portion of space on the photograph's surface, we utilise photographs as what Tuan considers to be place: "an object in which one can dwell".[3] In this chapter, in order to study the spatial aspects of the photographic image I will look at photographic place: a visual place that is preserved on the photograph's surface for dwelling.

However, the camera does not simply frame our surrounding space and preserve it as a photographic place, as if unaffected, but converts that space into a two-dimensional image. The result of this selection and ensuing conversion is image-places that differ from what we see in the world in two essential ways. Firstly, having been converted into a photographic place, the spatial scales in the world are not only preserved but also altered according to the perspectival rules executed by the camera. As art historian Ernst Gombrich once argued, although perspectival images seem to represent the world unaffectedly, we should be aware that "the idea of perspective is merely a convention and does not represent the world as it looks".[4] By underlying how perspectival conventions influence what we see in images, Gombrich undermined

the putative transparent quality of photography, the fact that photographs can embody the world as it appears to the naked eye.[5] As a result, the space we observe around us differs from its resultant two-dimensional image because the spatial scales in photographs can be altered according to the perspectival rules imposed by the photographic camera. Secondly, if the conversion of our surrounding space suggests that we do not see the world as it appears in photographs, the camera's selection of that space declares that we always and only see a part of it in photographic places. The fact that the camera can frame a piece of space from our vicinage and preserve it as a photographic place implies that the rest of the surrounding space has been eliminated from the image. Consequently, by capturing a segment of space and framing it as a photographic place, a so-called "blind field" comes into existence: a non-visible surrounding space that is left out of the photograph. For instance, looking at the photograph of a building in a street, the blind field refers to all the other buildings in the surrounding space that have been separated and thus rendered discontinuous from the frame. As Sontag notes, thanks to the photographic frame "anything can be separated, can be made discontinuous, from anything else, all that is necessary is to *frame* the subject differently".[6] Framing a part of space, therefore, not only converts a portion thereof into photographic place, but also implies that the photograph cannot expose what has been discontinued from the frame. In other words, the photographic frame functions as an *edge* that proclaims that a segment of space is *converted* to, and another is *detached* from, photographic place.

As Casey has suggested, in order to gain a better understanding of something one should conduct what he calls a "liminological study": a study that takes the comprehension of something to its very edge.[7] In this chapter, to investigate the spatial features of the photographic image I will carry out a liminological study of photographic place. That is, I will look at the spatial features that lie inside, outside and at the photograph's frame, or its very edge, in order to foreground the implications of framing for photographic images. Accordingly, this chapter seeks to show how a liminological study of photographic place (i.e. the study of its frame as an edge) can feature the spatial characteristics of photographic images. To this end I will first discuss the particularities of photographic framing in comparison to painting and film. Later, I will deploy two photographic places taken by ESA and NASA to discuss the significance of the excluded part of the frame for our spatial understandings of photographs. Lastly, I will show how considering the photographic frame as an edge, which both converts and discards a segment of space, can shed light on spatial features of photographic places. In the following section, I begin by explaining the specificities of the photographic frame through an examination of how different theorists have reflected upon this matter.

Specificities of the Photographic Frame

The "blind field", the extra-frame dimension.

—Clive Scott, *The Spoken Image*

The use of the lens in cameras was first described by Giovanni Battista Della Porta in the second edition of his book *Magica Naturalis,* published in 1589. For approximately 200 years lens cameras created circular images that would fade away around their circumference, mainly because of the round structure of optical lenses. It was not until the early nineteenth century that the portable *camera obscura* was equipped with the square and rectangular ground glass, a surface that would show only the central part of the image. As a result, the square and rectangular sheets of glasses of the nineteenth-century artists became the progenitors of the photographic frame as it is known today.[8] From its very conception, thus, the photographic frame was a means of selecting a part of the visual field and leaving the rest aside, thereby imposing its structure upon the world represented by photography. As theorist of photography Victor Burgin notes, not only does the photographic frame add a "unique point-of-view" to the system of representation, but its "agency" also structures that representational model.[9] The agency of the frame, for example, can be its capability of making visual connections between disparate elements from afar, when a house in the distance can be juxtaposed next to a house that is near, creating a coherence that did not exist before framing. Still, given that our way of perceiving the world is markedly dependent on the frame's predetermined structure, framing is not only an advantage but also a limitation. The restrictive aspect of the frame can be best exemplified by Camille Recht's evocative comparison between the painter as a violinist and the photographer as a pianist, quoted by Benjamin in 1931. While the violinist, Benjamin cites,

> must first produce the note, must seek it out, find it in an instant; the painter strikes the key and the note rings out … the photographer, like the pianist, has the advantage of a mechanical device that is subject to restrictive laws, while the violinist is under no restraint.[10]

Like the pianist, whose creative options are limited to the predetermined high and low pitches of the piano's keys, the photographer is restricted to the pre-structured way of seeing made available by the camera's frame. Metaphorically, the piano's keys are for pianos what frames are for cameras; they both provide the advantage of using a mechanical device by subjecting the user to its restrictive laws. Accordingly, the

photographic frame can give coherence to the world, yet at the same time it imposes its restrictive laws upon it. This is because the photographic frame is essentially a method of selecting a segment of the world and thus unselecting the rest, a selection process that relies on the predetermined structure of the frame.

Commenting on the specificities of the photographic frame in the early 1970s, Szarkowski suggests that while a painter *conceives* a representation of the world and then frames it at will, the photographer *selects* a piece of the world according to the viewing range of the camera's frame. Considering this selection process, the photographic subject is never strictly discrete, as if it is completely isolated from the world, but the frame creates the illusion of a self-contained subject in the photo.[11] In other words, seeing the photographed subject as isolated and independent from the world is to disregard the selection process of the frame. By selecting several visual elements in one photo, Szarkowski argues, the photographic frame constitutes a new relationship between the photographed subject and what has been eliminated from the frame. This tendency is usually absent from a painterly frame, since normally we do not think of what could have existed next to the painted subject in the world. Comparing frames in painting and photography, the theorists Joel Snyder and Neil Walsh Allen write, "when we look at a painting of a figure that dominates the canvas... we do not mentally construct the actual scene in the artist's studio and the peculiarities of the artist's cornea, retina, to depict the figure as he did". Instead, we confront the finalised painting only as the conclusion of the artistic process, ignoring what has been excluded from the frame.[12] Like Szarkowski, Snyder and Walsh argue that while the painterly frame compels us to look at what has been painted on the canvas (i.e. a conception of the world), the photographic frame motivates us mentally to construct the actual scene, as if we could see what lies vicinal to the frame in the world.

To deploy the terms introduced by Bazin in relation to film and applied to photography by the American photographer Eliot Porter, the painterly frame suggests a "centripetal" composition but the photographic frame tends to become a "centrifugal" one. In the centripetal composition the viewer is drawn to look at all the elements that are kept within the frame, but in the centrifugal composition "the eye is led to the corners and edges of the picture; the observer is thereby forced to consider what the photographer excluded in his selection".[13] The centripetal composition applies more fittingly to a painting than a photograph, since a painting is a *conception* of the world wherein the viewer's eyes are lodged inside the frame, but a photograph is a *selection* of the world whereby the viewer is inclined to imagine what is excluded from the frame. This means that, while it is true that when looking at a painting it is not sensible to ask what was located next to the painted subject in the studio, the photographic frame impels the viewer to ask what was lying next to the photographed subject in the world. This question, according to Cavell, essentially marks the distinction between the photographic and painterly frames. As he puts it:

> You can always ask, of an area photographed, what lies adjacent to
> that area, beyond the frame. This generally makes no sense asked of a
> painting. You can ask these questions of objects in photographs because
> they have answer in reality. The world of a painting is not continuous
> with the world of its frame; at its frame, world finds its limits. We might
> say: A painting *is* a world; a photograph is *of* the world.[14]

While the painterly frame is a limit at which the viewer is pulled back into the
painting, Cavell suggests that the photographic frame motivates the viewer to seek
what lies adjacent to the photograph subject in the physical world. Thus, for him
the photographic image becomes continuous with the world of its frame, whereas a
painting becomes a world in and of itself.[15] Echoing Cavell's argument more recently,
literary theorist Clive Scott suggests that photography generally distinguishes itself
from other visual arts by its *cadrage* (i.e. the frame). As he contends, in painting the
frame "affirms the autonomy of the picture surface", allowing the image to grow
inside the frame, whereas the photographic frame "invites reality to makes sense,
[and] constantly re-views reality and its varying potential compositions".[16] Agreeing
with Cavell, Scott proposes that the prominent quality of the photographic frame is
that it defies the autonomy of the picture surface, that it signals that the photograph is
of the world and not a world in itself. To clarify, for Cavell and Scott the photographic
frame does not constitute a world *within* itself, but declares that it has been positioned
on the world, selecting and preserving a part in the photograph.

As Scott has proposed, it is precisely because the photographic frame "is placed *on*
reality" that it naturally induces our awareness of a blind field.[17] In general, the blind
field refers to all that could have been included in the frame but has been rendered
discontinuous from it by the camera. Looking at the close-up photograph of a table
in a room, for instance, the blind field refers to all the surrounding spaces in the room
that are not visible in the photo. The blind field, Scott argues, is "the extension of
space and time beyond the photographic frame".[18] To exemplify the spatial dimension
of the blind field, he draws attention to the way newspapers tend to undermine the
omitted spatial part of their photographs. Instead of drawing the viewer's attention
to the blind field, newspapers usually refer to the photograph's comments, reports
and other accompanying texts. As Scott notes, this is "how a newspaper monopolizes
the news", by supplanting the photograph's blind field with texts, disregarding what
has been left out of the frame.[19] Nonetheless, not all kinds of photographs possess
a blind field, or can instantly activate awareness of one through their frames. For
instance, in staged photographs, when the entire scene is arranged and composed
by the artist before the photo is taken, the photograph does not persuade the viewer
to imagine beyond the frame. That is, the frame does not constitute a centrifugal
composition in which the viewer is inclined to conceive what has been excluded from
the photograph; instead, staged photography propels the viewer to look at the visual

elements that are kept within the frame. Because, like painting, in staged photography the photograph becomes a conception of the world and not a selection thereof, so the viewer's eyes tend to remain within the visual boundaries of the frame.[20] While staged photography is an instance of pre-photographic intervention, constructed and manipulated photographs can exemplify how the existence of the blind field can be influenced after the photograph is taken. For instance, in relation to photographic places, the photographs that are assembled in a post-photographic phase can obscure the existence of the blind field within their frames.

As scholars of photography Hilde Van Gelder and Helen Westgeest have suggested, photographic places generally fall into two categories: constructed places, which may or may not have a reference in reality, and existing places, which ostensibly have a reference in reality. While existing photographic places provide an expectation of the blind field, since they are taken from the world, constructed photographic places, however, owing to their fictitious appearance, tend to undermine this expectation in the viewer. According to Van Gelder and Westgeest, a clear example of an existing place in the early history of photography is William Henry Fox Talbot's *View of the Lincoln's Inn* (1843-1846), and the best-known early example of a constructed place is Oscar Gustave Rejlander's *The Two Ways of Life* (1857).[21] However, as they argue, in the early history of photography it was easier to distinguish between constructed and existing photographic places, whereas in contemporary photographic practices this distinction has become rather obscure. The obscurity between existing and constructed photographic places can be aptly exemplified by the landscape series taken by Joan Fontcuberta called *Landscape without Memories* (2005). By deploying a computer software, which transforms the cartographic data received from existing places in the world into photographs, the artist has built a series of photographic places that lie at the margin of construction and representation of the existing reality.[22] Although Fontcuberta's photographic places have been received from the world, due to their computer-simulated appearance, their frame does not instantly trigger the awareness of the blind field. Yet at the same time, given that these photographic places have been based on existing places in the world, their frame does not completely discard the expectation of the blind field in the viewer. In other words, Fontcuberta's constructed places neither immediately activate nor eliminate the blind field; instead, they indirectly motivate its expectation within the frame. Therefore, while some photographs can encourage the viewer immediately to imagine the blind field, to extend beyond the frame spatially, others may discard or obscure the excluded spatial dimension. To be clear, while staged and manipulated photographs do not imply the existence of the blind field, as they are conceptions of the world, existing photographic places activate and the constructed photographic places motivate its existence within the frame.

However, the existence of the blind field is not only peculiar to the photographic frame but also pertains to the filmic frame. The main difference is that a film not only implies the existence of the blind field, but also interpolates it into its sequence

of images to produce the illusion of continuity. As Scott states, "while the film continually moves into its 'blind field' and thus creates the illusion of ongoing reality, the photograph both implies a 'blind field' and reveals the illusoriness of its reality".[23] In other words, while in film the blind field might enter the frame after the passage of time, in photography the blind field remains forever off-frame but is nonetheless implied in the photograph. The "off-frame space" is a term Christian Metz utilises to refer to the spatial dimension of the blind field in photography and film. As Metz proposes, "in film there is a plurality of successive frames, of camera movements, and character movements, so that a person or an object which is off-frame in a given moment may appear inside the frame". That is, the filmic off-frame is always temporarily off-frame, so it may enter the frame through camera movements, character movements or the continuity of images. In addition, Metz reminds us that while photography is marked by "silence and immobility", film utilises other orders of perception, such as auditory, in order to obliterate the permanence of the blind field. For example, while looking at a film that shows a person walking in a street, by hearing the sound of tyres screeching on asphalt, the spectator can anticipate that the next frame will include a car. For Metz, in short, the filmic blind field may be temporarily off-frame, but it is never off-film. This means that the blind field may enter the frame and its arrival can be anticipated by the camera and the object movements, or the auditory markers that are embedded in the film. That is why he argues that, while the filmic off-frame space is "substantial", the photographic off-frame space is "subtle".[24] As he explains:

> If the filmic off-frame is substantial, it is because we generally know, or are able to guess more or less precisely, what is going on in it. The character who is off-frame in a photograph, however, will never come into the frame, will never be heard … The spectator has no empirical knowledge of the contents of the off-frame, but at the same time cannot help imagining some off-frame, hallucinating it, dreaming the shape of its emptiness. It is a *projective* off-frame (that of the cinema is more *introjective*).[25]

Although the photographic off-frame cannot enter the frame, Metz notes, the viewer cannot resist imagining, hallucinating or dreaming about what has been excluded from the frame, thereby projecting it onto the photograph's surface. Because, as Scott has noted, the existence of the photographic blind field is at the same time suggested and masked in the photograph.[26] In other words, even though the photographic blind field never explicitly enters the frame, its existence is unfailingly implied, in that, being a selected piece of space, the photograph allows the viewer mentally to construct the actual scene in the imagination, revealing that it is of the world and not a world in itself. Therefore, while a painterly frame does not possess a blind field and

a filmic frame may expose it at any given moment, the existence of the photographic blind field is often simultaneously *insinuated* and *concealed* within the frame. It is due to the existence of this imperceptible, excluded but nonetheless implied spatial dimension that it seems sensible to ask what was lying adjacent to the photographed subject in the world.

At this point, having discussed the specificities of the photographic frame, I will look at, first, an existing and, second, at a constructed photographic place, to foreground the spatial significance of the blind field in a variety of contemporary photographic practices. To make palpable how the implied but veiled existence of the blind field affects the photograph's surface I will look at an existing photographic place with an extremely maximised blind field. As Metz proposes, the photograph itself is the "in-frame, the abducted part-space".[27] In the following section, therefore, I will study an existing image-place that has been severed from extra-terrestrial space to see how the maximisation of the blind field affects the in-frame.

Photographic Place in a Maximised Blind Field

> Short distance is not in itself nearness.
>
> —Martin Heidegger, *The Thing*

As Flusser argues, photographs can generally be categorised into three types: amateur photos, e.g. snapshots taken in everyday life; professional photos, e.g. artistic and experimental photos; and photos made by fully automated cameras, e.g. photos taken by a satellite.[28] Figure 5, taken by an exceptionally automated camera, falls into the last category. In March 2004, the European Space Agency (ESA) launched a spacecraft called Rosetta to perform a detailed study of a comet in space. Rosetta was equipped with two extremely advanced cameras: one optical narrow-angle camera, NAC, intended for high-resolution mapping of the surface of the comet, and one wide-angle camera, WAC, optimised for capturing the vicinity of the comet.[29] During its journey Rosetta flew past Mars and manifold asteroids to reach the targeted comet. Eventually, after ten years of travelling through space, Rosetta reached its target in August 2014 to conduct a series of studies, such as photographing the comet's orbit and surface.[30] By optically zooming onto the comet, Rosetta's narrow-angle camera captured several black and white photographs of the comet's surface, with remarkably high visual and topographical precision. Figure 5 was taken in July 2016, shortly before the mission was successfully ended in September 2016. According to ESA, this photograph was taken by the NAC camera, which allows extreme optical zooming,

when the spacecraft was at a distance of 9,543 km from the comet, 503,791, 296 km from the Sun, and 544,445,312 km from the Earth.[31] This photograph, however, not only manifests an extraordinary topographical accuracy, but also epitomises how the camera can maximise the blind field by travelling through infinite space and optically zooming onto its subject matter.

Regarding ESA's photograph, the blind field refers to all the vast space through which the spacecraft has physically travelled and all that it optically zoomed into, in order to reach its subject matter; it is all the circumambient space that is excluded from this photograph. On the one hand, the camera's enormous distance from the earth indicates how it can traverse infinite space to select a piece thereof, bringing a photographic place into being. On the other hand, the substantial distance of the camera from the comet signifies how it can optically penetrate the space to reduce the field of vision, thus increasing the blind field of the photograph. By literally travelling through the space and optically peering into it, Rosetta's narrow-angle camera therefore *maximises* what could have been included in, but has instead been left out of, the photo. However, the maximisation of the blind field not only allows us to reach where we would not otherwise, but it also affects the way with which we visually comprehend photographic places. To grasp this point better, what is needed is a close observation of ESA's photograph.

Figure 5: *ESA/Rosetta/MPS for OSIRIS Team PS/UPD/LAM/IAA/SSO/INTA/UPM/DASP/IDA – CC BY-SA 4.0* (2016). © European Space Agency (ESA).

Looking at ESA's photograph, one realises that the monochrome terrain does not easily reveal itself to the viewer. The conspicuous lack of vegetation suggests that the represented location cannot be a place that bears traces of plant life, like a remote location in a forest. In addition, the presence of the unusual rocks scattered across the jagged ground implies that the embodied location is not a desert either, where vegetation life is usually rare to find. The absence of all traces of human life, too, adds an extra veneer of obscurity across the photograph. Deprived of all traces of plant and human life, the photograph seems like the abyssal zone of an ocean where the cycle of nature has given way to erosion, such as deep-water photos that are taken for the purposes of marine investigation. Still, due to the homogenous light that is projected across the perceptible elements from above, the viewer is assured that the photographic place is not captured at the bottom of an ocean. Hypothetically, the embodied location could have been a high mountain where vegetation ceases to exist and the natural cycle gradually corrodes all the existing rocks and stones. Yet, because of the absence of linear perspective and the horizon line, the viewer is incapable of identifying the location as a mountain at high altitude, where usually one sees the sky bordering with the summit. More noticeably, the strange area of darkness on the upper side of the photograph, where the shadows of rocks dissolve into the dark space, suggests that the embodied terrain cannot be a mountain's summit, because, unlike in this photograph, an illuminated summit usually has the sky in its background and not the abyssal black of infinite space. All the same, the area of darkness on the upper side of the photo can function as a threshold for a closer reading of the photograph because it is a visual linkage to the comet's *rim*, a type of edge that can attribute spatial functions to perceptible things or, if not fully represented as in this case, obscure their spatial purposes.

As Casey proposes, edges are found in a variety of forms, one of which is a rim. A rim, he argues, "is an edge that is at once determinate and detachable; it is perceived *as such*, not only as the end of an object or event but as separate from it". For instance, a rim can be the spatial ring that surrounds a hole in the earth, since a rim essentially "*surrounds* something, whether this is a thing or a non-thing".[32] In other words, the very purpose of a rim is to confer spatial functions to things by surrounding them, thus making them identifiable from other things. For example, if ESA's camera had not exceedingly zoomed onto the comet's surface and left some of the surrounding space around it, the photographic place could have had a rim (i.e. like the space photographs of the planet Earth in which we can identify the Earth by its surrounding spatial rim). The exclusion of the rim around the comet, above all, renders difficult the spatial reading of the photograph, in that it obscures the functionality of the represented location. As the scholar Filip Mattens argues, in both photography and architecture we perceive spatial connections between visible elements according to the way with which we understand their purposes and functions. For instance, looking at the interior of a building,

we do not see rooms; we see dining rooms, living rooms, staircases, and so on. We see these rooms in their functional connection with the adjacent rooms… This means that the way we *perceive* the concrete spatial nexus of the interior of a building is a function of how we spontaneously *apperceive* its practical organization.[33]

In photographs, too, we understand the spatial links between perceptible elements according to their function and use within their surrounding space. To clarify this point, only when the viewer can perceive the spatial link between the comet's surface and its surrounding rim does she/he apperceive the practical organisation of the photographic place. It is only after this spatial connection is made that the viewer can rest assured that ESA's photograph shows the surface of a comet, and not any other possible location. This means that by excluding the comet's spatial rim ESA's photograph has obscured the functions and purposes of the photographic place, obliterating the spatial links that could have been made between the in-frame and the off-frame. In other words, by maximising the blind field and reducing the field of view the purposiveness of the photographic place has been masked. It is the first reason that ESA's photograph cannot be easily identified by the viewer, since it does not explicitly represent its spatial nexuses with its surrounding space. As Mattens puts it, "When functionality and its significance vanish, so too does the purposive nexus that grounds our spontaneous spatial interpretations".[34]

However, the maximisation of the blind field not only eradicates possible spatial nodes between the photographic place and what is left outside the frame, but also affects our judgment of spatial scales within the frame. Commenting on how different spatial scales affect our visual judgment of photographs, philosopher Patrick Maynard distinguishes between interval, ordinal, nominal and absolute scales in photography. The maximisation of the blind field, more perceptibly, can influence the interval spatial scales in photographs. The interval scales refer to the proximity of visual elements in relation to each other, when "one thing's being closer to another than to a third" allows us to guess the *dimension* and *position* of things in photographs.[35] In terms of dimension, objects with familiar scales allow the human eye to compare the size of things relatively, allowing us to determine the interval scales in photographs. For instance, by looking at the photograph of a person standing next to a building, the human size allows the viewer to make an approximate anticipation of the size of the building. However, when a photographic camera optically zooms into space, bringing things visually closer to us, it also alters the perspectival depth and, in turn, distorts the interval scales in the photograph. The most obvious example of this spatial distortion can be found in travel photography, when a tourist standing in front of the Leaning Tower of Pisa pretends that he/she is holding up the tower, as if they are positioned adjacent to each other and have corresponding sizes. In this situation, thus, the proximity of the perceptible elements and their dimensions in the world

are not the same as what one sees in the photograph. That is how, through optical zooming, the camera can disfigure both the dimension and the position of things in photographs. As American philosopher Nelson Goodman rightly remarks, "there is nothing like a camera to make a molehill out of a mountain", and it is equally true that there is nothing like a camera to make a mountain out of a molehill (e.g. comparing a person's body with the Tower of Pisa).[36]

Looking at ESA's photograph, not only has the amplification of the blind field eliminated the spatial links between the photograph and its surroundings, but it has also affected the interval spatial scales within the photographic place. To recapitulate, this photograph was taken from 9,115 km away by means of extreme optical zooming. Looking at the lower side of the photograph, where several pieces of stone are lying on the ground, one cannot impartially estimate the real dimensions of the stones nor their distances from the rocky background. If the first blatant reason for this is the lack of any familiar scales for the viewer (such as a human body that could make scale comparison possible), another essential reason is that there is no accurate relation of proximity in the photograph. Owing to the exceptional zooming function of ESA's camera, one knows that the size and distance of the visual elements in the photo do not correspond to their real dimensions and position in the world. To be clear, on the one hand, the stones on the ground could be gigantic boulders much bigger than a human body and their distance to the rocky background could be a few kilometres. On the other hand, they could be infinitesimally small stones that are exceptionally augmented through the optical zooming capability of ESA's camera, placed within a few centimetres of each other. This impossibility of having an unbiased judgment about the dimension and position of the visual elements in the photograph, above all, indicates how the extension of the blind field can undercut the spatial scales within the photographic place. It is the second reason that ESA's photograph cannot be easily identified by the viewer, since the real dimension and position of the visual elements have been obscured in the photograph. To put it differently, lacking any accurate interval scales in the in-frame, the viewer of ESA's photograph cannot decide whether the camera has made a molehill out of a mountain, or the opposite.

Deprived of instructive spatial markers with which the photographic place could be impartially read, ESA's photograph seems to have come from no actual place in the world, because, having eradicated the photograph's spatial links to its surroundings and having distorted the spatial scales within it, the expanded blind field has divorced the existing photographic place from its former presence in the world. As the philosopher Jean Baudrillard notes, photography is mainly a method of dissociating the photographed subject from the world in order to capture its disappearance in the frame.[37] Observing the photographs of Sophie Calle, he writes, "photography is itself an art of disappearance, which captures the other vanished in front of the lens", leaving no traces thereof except for its "vanished presence".[38] By capturing solely the vanished presence of something in photographs, Baudrillard argues that photography

makes all the other traces of the photographed subject disappear, thus detaching it from its actual origin in the world. As he remarks in *The Perfect Crime*, photography is essentially a means of "dissociating the object from any previous existence and capturing its probability of disappearing in the moment that follows. In the end, we prefer the *ab nihilio,* prefer what drives its magic from the arbitrary, from the absence of cause and history".[39] Like a perfect crime that leads to nothing, Baudrillard holds that photography can strip off all traces that link the photographed subject to its prior existence in the world, as if it has been inscribed on the surface of the photograph out of nothing. That is, instead of arguing that the photograph is a trace that leads to the world, he suggests that every photograph states that the rest of the world has been detached from it, leaving no traces of its previous existence behind. To be clear, by dissociating its subject from the world, Baudrillard contends that every photograph is a trace that merely proclaims that the rest of the world is absent in it. As he puts it:

> Every photographed object is merely the trace left by the disappearance of everything else. From the summit of this object exceptionally absent from the rest of the world, you have an unbeatable view on the world. The absence of the world, which is present in every detail, reinforced by every detail.[40]

The maximisation of the blind field in ESA's photograph, above all, brings this point to the forefront: the fact that the rest of the world has been radically dissociated, detached and in turn absented in the frame. Despite the camera's effort to reach the unreachable part of the infinite space, the maximisation of the blind field has made the rest of the world inaccessible in the photograph, rendering an existing place unrecognisable in the frame. Firstly, by eliminating possible spatial relations between the inside and the outside frames the increased blind field does not allow the photographic place to signify its spatial links to its surroundings. Secondly, by impairing interval scales the amplified blind field has veiled the real dimension and position of the visual elements within the frame. Thus, the maximisation of the blind field has not only stripped off the *spatial nexuses* between the in-frame and the off-frame, but has also destabilised *spatial scales* within the frame, thereby dissociating an existing photographic place from its previous existence in the world. Regardless of the camera's attempt to make the unknown space known to us, through physically circumnavigating it and optically peering into it, the maximised blind field has achieved the contrary. It has produced an unidentifiable photographic place: an abducted part-space that merely proclaims that it is "exceptionally absent from the rest of the world". In other words, owing to the profound expansion of the blind field, ESA's photograph manifests a *defamiliarised photographic place* wherein "the absence of the world" is "present in every detail, reinforced by every detail", as if it has been inscribed on the surface of the photograph ex nihilo.

At this point, having discussed how the maximisation of the blind field can defamiliarise an existing photographic place, I will next look at a constructed photographic place whereby photography aspires to encompass the greatest amount of the blind field it is capable of. In other words, this time, through discussing a constructed photographic place taken by NASA, I will look at how the minimisation of the blind field affects the in-frame.

Photographic Place in a Minimised Blind Field

> Many places exist for us merely as images.
>
> —Hans Belting, *An Anthropology of Images*

How can a photographic place acquire a minimised blind field? The immediate answer to this question is: by increasing the photograph's field of view—to capture as much space as possible around the subject—and inscribing it onto the photograph's surface. This is precisely what the National Aeronautics and Space Administration (NASA) has managed to achieve through deploying Hubble's Advanced Camera for Surveys (ACS). This camera has a wide field of vision that sees from natural light to ultraviolet, making it capable of studying the distribution of stars and galaxies in the universe.[41] In January 2015, NASA published the largest photograph ever taken of infinite space, of our closest galactic neighbour called the Andromeda galaxy (figure 6). The view displays a 48,000-light-years-long stretch of the galaxy, a vast portion of infinite space that is captured in one single frame. Although the Andromeda galaxy is 2.5 million light-years away from Earth, it is still the biggest target in the sky out of myriad galaxies that Hubble routinely photographs, which are billions of light-years away.[42] In order to capture the widest possible angle, NASA took 7,398 exposures of its targeted galaxy and assembled them in one high-resolution photograph. NASA's photographic investigation resulted in the largest and the sharpest constructed photographic place made of infinite space. The resplendent resolution of the photograph, which shows over 100 million stars and thousands of star clusters embedded in the galaxy's pancake-shaped disc, allows the viewer to zoom through aeons of light years in one single photographic frame. According to NASA, the photographic cartography of the Andromeda galaxy is like "photographing a beach and resolving individual grains of sand".[43] That is how NASA, by capturing an enigmatic portion of space, has created a constructed photographic place with a profoundly reduced blind field, including as much space as possible in one frame. In other words, the extraordinarily wide viewing range of the photograph indicates NASA's ambition to reduce the adjoining space that

could have been left out of the frame. The immense portion of infinite space seized in this photograph, therefore, signifies how the photograph's blind field has been radically minimised.

Figure 6: *NASA, ESA, J. Dalcanton, B.F. Williams, and L.C. Johnson (University of Washington), the PHAT team, and R. Gendler (2015).* © The National Aeronautics and Space Administration (NASA).

NASA's photograph features an endless number of fulgurating stars, some of which are distinct from their surroundings and others that are unfurling into a stream of light in open-ended directions. Each modicum of the perceptual space in the photo may correspond to the entire size of the planet Earth, if not a significantly larger dimension. As NASA tells us, on the lower left-hand side the viewer can see the centre of the galaxy, where the amber light is unfolding towards the centre of the frame. The stream of refulgent stars coming from the bottom left-hand side towards the centre of the photo displays how the medium of photography has fleshed out the spatial arrangement of a galaxy from afar. By enhancing our sense of vision and expanding our field of view, thus, NASA has embodied the spatial construction that underlies the Andromeda galaxy, allowing us to scan across a sight that remains physically far-fetched in the universe. As Tuan points out, a "sight provides us with a spatially structured universe" since in it "all the objects are visible at the same time, and they are stable long enough to apprehend their relationship to each other".[44] Due to the profound reduction of the blind field, NASA has successfully provided the viewer with a sight of space, a stable view in which the spatial composition of a colossal galaxy is visualised for the human eye. As Tuan has suggested, a sight enables us to see spatial structures by rendering everything visible at the same time, so within it the objects can signify their relationships to one another. Being a sight of space in which the relationships between the perceptible elements are succinctly clarified, Andromeda's photograph can make visible another type of edge, a spatial edge that silently percolates through the photograph: a spatial gap.

As Casey puts forward, "a gap serves to separate rather than surround. It differs from a rim by being between two things rather than tightly enclosing one thing or group of things. It discontinues what it separates spatially".[45] Unlike spatial rims that surround things to confer spatial functions on them (e.g. ESA's photograph), Casey suggests that gaps come between objects in order to separate them and make them spatially discontinuous in their surroundings. Because of the exceptional image quality of NASA's photo, the viewer can zoom into every minute area of the photograph's surface to distinguish the stars from each other, and in turn, observe the dark areas that separate each star from its contiguous neighbour.[46] The area of darkness scattered across the photo's surface, giving it a veneer of black tone and making each star distinct in the frame, foregrounds the spatial gaps of the photograph. Through the expansion of the field of view, the space that encloses each star has been transformed into the gap that spatially discontinues it from the rest of the frame. In other words, the minimisation of the blind field has converted the spatial *rim* that surrounds each individual star into the spatial *gap* that infiltrates between them. Having converted the stars' rims into the gaps amid them, the photograph displays a spatially structured universe that enables the viewer to forge connections between all the perceptible elements in the frame. That means that, without the presence of the spatial gaps in the frame, neither the stars nor the Andromeda galaxy would have had any distinctive outline. Lingering in the background of the image, therefore, the spatial gaps have marked the contours of the stars and the galaxy, and in turn constituted the very coordinating spatial structure that permeates through all the visible elements in the frame. It is owing to the existence of the spatial gaps in the frame that the viewer can see a sight of space: a stable view in which the spatial fabric of infinite space has been laid bare for human apprehension.

However, by representing a grandiose sight of space, NASA assures the viewer that its photographic place surpasses the human way of seeing, declaring that the human eye cannot ever see the fabric of space as a camera does. As Snyder and Walsh Allen argue, the common fallacy about photography is rooted in the supposed resemblance of the human eye to the photographic camera, as if they could see the same thing. As they contend, the whole notion that a photograph shows us "what we would have seen had we been there ourselves" is utterly absurd.[47] As they explain this point:

> A photograph shows us "what we would have seen" at a certain moment in time, *from* a certain vantage point *if* we kept our head immobile *and* closed one eyed and *if* we saw with equivalent of a 150-mm or 24-mm lens *and if* we saw things in Agfacolor or in Tri-X developed in D-76 and printed on Kadabromide #3 paper.[48]

Snyder and Walsh Allen underscore the fact that the human eye essentially differs from the camera in its way of seeing, arguing that we would not have seen the same

scene had we been where a photograph is taken. For instance, NASA's photographic place could show us what we would have seen had we been there ourselves, *if* the human eye could register from natural light to ultraviolet, *if* we could see a panoramic view of aeons of light-years in detail, and *if* we could discern the imperceptible spatial gaps between the stars. In short, we would have seen the same if the human eye could do the impossible; that is, seeing a sight of space in which the spatial structure of a galaxy is expounded for human comprehension. Thus, assuring that we would not have seen the same had we been there ourselves, NASA's photographic place provides us with the only sight of the Andromeda galaxy. That is, incapable of seeing it with our eyes, Andromeda's photograph feeds our perception with the only image of how the spatial structure of a galaxy appears to be in the world. As Kracauer once argued:

> The photographic image cannot give a complete idea of anything whatsoever if the person viewing the image has not *already seen the thing*… a weak picture postcard that one brings back from a journey better fulfils the function of a photograph than does an elaborate showy photograph of *unvisited destinations*.[49]

For Kracauer, to have a comprehensive idea of photographed things, one had to have already seen them in the world; because, according to him, we perceive photographs by associating them with our previously acquired concepts from the world. However, Andromeda's photograph seems to defy Kracauer's contention, since it displays a photographic place that is *not* hinged upon what we have already seen in the world. For the subject of NASA's photograph remains perpetually inaccessible to the naked eye, i.e. it does not show what one could see if one had been physically where the photo was taken. Instead, NASA's photograph presents the viewer with the spatial sight of the Andromeda galaxy for the first time, thus it photographically presents a sight that remains perceptually unreachable to the human eye. Consequently, unable to see the actual sight with our own eyes, for the first time we confront a galactic sight of Andromeda in the photograph. This means that NASA's constructed photographic place has become the first and only source with which we can spatially think of the Andromeda galaxy as such, revealing how the photograph of unvisited destinations can feed our very perception of the world. In other words, by expanding our field of view and vision to the extent that they exceed our way of seeing, NASA's photograph foregrounds how a constructed photographic place *precedes* its memory in our perceptual world. According to the philosopher, Henry Bergson, when looking at the world our perceptual system conflates the immediate image that it registers from objects (afterimage) with their previously registered ideas (memory), merging them into a "memory image" that makes it impossible to distinguish between perception and memory. As he puts it:

If, after having gazed at any object, we turn our eyes abruptly away, we obtain an *'afterimage'* of it ... but, behind these images, which are identical with the object, there are others stored in *memory*, which merely resemble it, and others, finally, which are only more or less distantly akin to it. All these go out to meet the perception, and, feeding on its substance, acquire sufficient vigor and life to abide with it in space ... Any *memory-image* that is capable of interpreting our actual perception inserts itself so thoroughly into it that we are no longer able to discern what is perception and what is memory.[50]

For Bergson, the demarcating line between perception and memory is indiscernible, since by looking at an object and registering its afterimage we always unknowingly integrate that image with the memory of the object we possess from the past. As a result, we forge a memory image that amalgamates the instantly perceived afterimage with our previously registered memory of the object, rendering memory indistinguishable from perception. For instance, when we turn our eyes away from the photograph of a vista where several trees are lying in the background and the sun is shining from above, we do not merely interpret the scene through its afterimage; but we also deploy our memory of trees and the sun from the past to make a coherent memory image with which we understand the photographic vista. That is why, for Bergson, our perception resembles a "photographic view of things", since through it we synthesise the afterimage of something with its memory, forging a memory image with which we perceptually construe the world.[51]

Looking at NASA's photographic place, however, the only visual memory of the Andromeda galaxy is what we acquire as its afterimage, since there are no other means to register a memory of the sight of space that is fundamentally unreachable to the human perception. That means that there cannot be any previously registered memory of what the spatial fabric of the Andromeda looks like except NASA's photograph. Although the photograph's minimised blind field goes beyond our way of seeing, it allows the viewer to replace the afterimage of the photo with its memory, thereby perceiving an inaccessible spatial sight through the photograph. In this case, the afterimage of the Andromeda galaxy *becomes* its memory for the first time, revealing how a constructed photographic place can precede our perception of the existing world. Thus, by supplanting the afterimage of the Andromeda with its first memory, NASA's photograph manifests a photographic view of things that founds our very perception of an unvisited destination in the world. In other words, by radically minimising the blind field, NASA has constructed a *familiarised photographic place* in which our perceptual distance towards what remains physically far removed has been reduced: it is a photographically accessible sight of space wherein (to use Bergson's phrase) "we are longer able to discern what is perception and what is memory".

At this point, having discussed how the minimisation of the blind field can

familiarise a constructed photographic place, making it precede its memory in our perceptual world, I will further look at the implications of the blind field for the photographic frame itself. When a photograph is framed, Cavell proposes, "the rest of the world is cut *out*. The implied presence of the rest of the world, and its explicit rejection, are essential in the experience of a photograph as what it explicitly presents".[52] Hence, in the following section, I will look at photographic place from the very edge at which the rest of the world is cut out and its implied presence is consequently buried: its frame. To do so, I consider the photographic frame as *boundary* and not as *border*, in order to discuss how the mere existence of the blind field at the edge of the photograph affects the in-frame.

Liminality of the Photographic Place

That which is outside the frame
(putting-into-lethargy and absolute value of the frame).

—Jacques Derrida, *The Truth in Painting*

The liminal is not a state in which one
can remain—it is not "static" at all.

Jeff Malpas, *The Threshold of the World*

I have hitherto discussed the particularities of two types of edges, i.e. rims and gaps, in relation to ESA's and NASA's photographs respectively. However, Casey's most intriguing insight into the study of edges (i.e. liminological study) lies in his distinction between borders and boundaries. According to him, borders are essentially a means of closure, exclusion and therefore impermeability. For instance, the effect of having a border between two countries is "not just the restriction of traffic or trespass but their exclusion wherever possible. Every border is constructed such that it is closed or subject to closure". In other words, in Casey's view edges are seen as borders when they lose their inherent openness, that is, when they are established "not just to distinguish but to *keep apart*".[53] In contrast to borders, boundaries are a type of edge that are intrinsically made for transmission, porosity and thus permeability between the two grounds that they distinguish. The essential difference between borders and boundaries is that while in the former exclusion and closure are embedded in them as their very purpose, in the latter porosity and permeability "are built into them from the start".[54] For Casey, the distinction between borders and boundaries is not limited

only to geography but also applicable to all the arts that edges figure. In architecture, for example, borders are the impermeable walls and roofs, which are inherently meant to separate the inside from the outside, whereas boundaries are the passable doors and windows, which are meant to make connections between different spaces. In a different light, Casey puts it:

> *Borders* exist in oral poetry as pauses between stanzas of verse as they are read out or in written poetry as the margins of the page that surround a given poem. *Boundaries* arise … when the reverberations of pronounced words are still heard as the poet goes onto the next line.[55]

To be clear, while borders are established to articulate definite separations between two grounds, boundaries are made to dissolve precisely these separations, thereby allowing the distinguished spaces to communicate through them. Like poetry and architecture, what is inscribed on the surface of photographs, too, has an edge: the frame itself. However, I would like to suggest that the photographic frame operates not so much as a border, which utterly isolates and discontinues the image from the world, but rather as a boundary, which links the photographic image to the world it is severed from. This means that the photographic frame does not easily fall under the rubric of borders, because, as I have discussed before, the world of the photograph becomes continuous with the world of its frame through the possession of the blind field. In other words, having the blind field at its disposal, the photographic frame impels our imagination to ask what lies adjacent to the area photographed, outside the frame. In doing so, unlike borders in which closure and exclusion inhere within them, the photographic frame allows mental projection and thereby spatial extension beyond the frame, relating the inside to what lies outside in the world. Thanks to the existence of the blind field, therefore, the photographic frame functions as a boundary that innately links the in-frame to the outside, undermining its function as an impassable border around the photograph's surface.[56] In other words, considering the photographic frame as boundary is to recognise its imaginational permeability, viewing it as a porous edge that undercuts the establishment of any definite division between the inside and the outside. Remarking on the permeability of the photographic frame, the art historian John Tagg writes:

> The frame is an adjunct that is neither inherent nor indispensable. Marking a limit between the intrinsic and the extrinsic, it is neither inside nor outside, neither above or below… The frame thus stands out against the two grounds that it constitutes—*the work* and *the setting*—and yet, with respect to each of these, it always dissolves into the other. This oscillation marks its presence and effaces its effect.[57]

In Tagg's description, while the work refers to the image on the surface of a photograph, or that which is enclosed *inside* the frame, the setting refers to the context in which the photographic image is received, which remains *outside* in relation to the work. Concerning NASA's photograph, for instance, the work is the image of the galaxy that is sealed off within the frame, and the setting is the surrounding context in which one sees this image (i.e. a computer screen, a wall, a printed paper, a book, etc.). The frame, however, belongs neither to the realm of the work (inside) nor to the setting in which the work is received (outside). Instead, Tagg argues that the frame comes as an edge between the work and the setting, the two realms that it brings to existence by its mere presence, yet at the same time it effaces its effect by dissolving into them. In other words, for Tagg, too, the frame cannot become a border that circumscribes a definite distinction between the two grounds that it constitutes, but rather functions as a permeable boundary which, by establishing the work and the setting, fades its presence *in between* them.

As Casey has put forward, the *in* of the in between can be distinguished in three ways: first, as a "measurable distance" (e.g. a definite distance between two locations); second, as a "juxtaposition" (e.g. when one juxtaposes two imaginary locations on a map, which are not contiguous in geographical actuality); lastly, as when we say "that we are 'in-between jobs now', that is, situated between having one definite job and taking up another definite job: but exactly where is not at issue, since we are just somewhere in between these two distinct positions".[58] The position of the frame in relation to the work and the setting falls under the last category of in-betweenness. Similar to being in between jobs when a person is indeterminately situated between two definite positions, Tagg argues that the frame is only indeterminately emplaced between two distinct grounds. That is, the frame is just somewhere in between the inside and the outside, dissolving into both and withdrawing its presence in between them. In this situation (to use Casey's phrase) "where is not at issue", but the perviousness of the frame with reference to the work and the setting or, as Derrida calls them, the ergon and the milieu.

As Derrida proposes, no analytical framework can positively account for the concept of frame, since the frame is essentially a parergon, that is, "a hybrid of outside and inside", which, by its fragile existence between the two, divides the ergon (the work) from the milieu (the setting).[59] Submitting that the frame is a compound of inside and outside, or a parergon, he argues that it is inessential to ask where the frame takes place.[60] For the frame does not have any beginning or end by which it can be decisively determined; instead, Derrida states, the frame "creaks and cracks, breaks down and dislocates even as it cooperates in the production of the product".[61] That is, for Derrida the frame is not only a *permeable* edge with reference to what is enclosed within it (the ergon) and the context that encloses it (the milieu); but, more notably, it is a *malleable* construct as such, which constitutes the concepts of inside and outside by vanishing in between them. As he puts it:

> The *parergon* stands out (*se détache*) both from the ergon (the work)
> and from the milieu (the setting), it stands out first of all like a figure
> on a ground ... but the *parergon* is a form which has its traditional
> determination not that it stands out but that it disappears, buries itself,
> effaces itself, melts away at the moment it deploys its greatest energy.[62]

Even though the frame stands out from the work (the ergon) and the setting (the milieu), marking the limits of inside and outside in doing so, its significance lies in that it dispels its pronounced presence in between them, so much so that it melts away. That is why Derrida propounds that the essence or truth of the frame, if it had any, is essentially its "parergonality": the fact that the frame is a pliable construct and therefore fragile.[63] The term parergonality, on the one hand, underlines that the frame is intrinsically a malleable edge, which comes into being in order to demarcate between the two realms of inside and outside. On the other hand, this term also suggests that the frame, by burying and effacing itself between the work and the setting, makes pervious the edge at which the inside meets the outside. In other words, the parergonality of the frame features both its permeability *and* pliability, thereby presenting the liminal existence of the frame in between the ergon and the milieu. As Malpas defines:

> The liminal is that which stands in between, but in standing between
> it does not make some point of rest. Instead, the liminal always carries
> a movement with it—a crossing, a movement towards or away from, a
> movement into or out of. Etymologically, 'liminal' comes from the Latin
> *limen*, meaning threshold, but related also to the Latin *limes*, meaning
> boundary.[64]

The parergonality of the frame, to an undeniable extent, foregrounds its very liminality. Because, by standing out in between the inside and the outside, the frame does not make some point of rest, but instead sets into motion a movement into or out of the ergon and the milieu. That is, the Derridan concept of parergon features the frame as a liminal construct whereby the ergon intermixes with the milieu, yet at the same time remaining distinct from it. In the experience of liminality, Malpas writes, "the experienced elements, even though distinct, nevertheless evoke one another, never appearing entirely apart".[65] The liminality of the frame on the one hand suggests that, by coming as an edge in between the ergon and the milieu, the frame can distinguish and thus stabilise what is contained in it. On the other hand, it suggests that, by effacing its conspicuous presence in between the inside and the outside, the frame can make pervious and thus destabilise what is enclosed in it. To be precise, the liminality of the frame means that it can originate a crossing between the ergon and the milieu, thereby both stabilising and destabilising, familiarising and

defamiliarising their definite delineations through it. Bringing this liminality to the fore, Derrida succinctly asserts, "Framing always supports and contains that which, by itself, collapses forthwith".[66]

More fitting than many frames, the photographic frame can epitomise this liminal character by featuring how the ergon comingles with the milieu through the blind field. As I have already discussed, the existence of the blind field is simultaneously implied and masked within the photographic frame. Yet, it does not mean that the blind field exists inside or outside the frame, but that it rests precisely where the inside meets the outside, where the work merges with the setting, and where the ergon intermingles with the milieu. In other words, the photographic blind field resides neither on the surface of the photograph (the ergon) nor in the context in which it is viewed (the milieu), but rather it lies *at* the very edge wherein they confront one another. In this way, the blind field unfolds as a tertiary element where the edge of the inside confronts the edge of the outside, making a possible "edge effect" take place, a geographical term that fleshes out how the blind field emerges. As Casey proposes, an "edge effect" takes place where the edges of two regions intermix in heightened intensity and richness, resulting in an amplification that exceeds the number of parties involved. In this situation, he states, "instead of a mere summation of forces, there is an augmentation beyond the known and measurable forces of existing constituents: rather than 1+1=2, we have a circumstance of 1+1=2+n".[67] Analogous to an edge effect, which causes an augmentation that exceeds the sum of engaged parties, the photographic blind field arises as an *n* factor where *the edge of the ergon* coincides with *the edge of the milieu*, where the inside confronts the outside, at the margin of the frame. To illustrate this point we need to return to NASA's photograph.

Looking at NASA's photographic place in the way that I presented it here, the image of the galaxy that is enclosed inside the frame stands for the ergon, and the white surrounding area that engulfs the in-frame instantiates the milieu. Knowing that NASA's photograph is of the world and not a world in itself, the viewer can mentally construct the excluded surrounding space and thus spatially extend the in-frame into the white area. In turn, the viewer can envisage how the fluvial stars would unfurl beyond the frame. Through the imaginational permeability of the in-frame vis-à-vis the setting, therefore, the viewer projects the blind field onto the crossing of the inside and the outside. That is, thanks to the liminal existence of the blind field, the excluded spatial dimension inserts itself where the work intersects with the setting, unfolding towards the milieu. In this situation the blind field lies neither in the work nor the setting in which the work is received, but springs up as an *n* factor at the very edge of which the ergon confronts the milieu. Therefore, owing to the insinuated but concealed existence of the blind field at the edge of the photo, the photographic place itself becomes a liminal place, paving the way for an edge effect to come about.

This potentiality pertains not only to the surface of NASA's photograph but also to all the photographic places that possess a blind field, such as existing photographic places that activate and constructed photographic places that can motivate its existence within the frame. For the enshrouded existence of the blind field can transform the frame from a border into a boundary, allowing the work to uncoil towards the setting in the imagination. In other words, if the maximisation of the blind field can defamiliarise, and its minimisation can familiarise the in-frame, seeing the frame as a boundary that surreptitiously holds the blind field suggests that it is capable of *both*. On the one hand, given that a boundary is an edge that distinguishes between different grounds, it can make distinct a segment of space and bestow meanings upon it in the photograph, thereby underpinning what is enclosed in the frame. On the other hand, having the blind field at its disposal, the photographic frame can interpolate the excluded spatial dimension between the inside and the outside, thereby liquefying what is sealed off within the frame. Precisely this possibility of supporting and collapsing, underpinning and liquefying, familiarising and defamiliarising that is embedded in the frame marks the liminality of photographic place. That is, the liminality of photographic place suggests that the frame, where the implied presence of the rest of the world is buried, is a boundary that can manifest an extra frame dimension. In that, irrespective of its minimised or maximised manifestation, the mere existence of the blind field transmutes the frame from an impervious border into a porous boundary, allowing *mental projection* and *spatial protension* beyond the frame. As such, thanks to the crepuscular existence of the blind field at the edge of the photograph, the photographic place can become a *liminal place*, manifesting a photographic edge effect par excellence. In other words, calling the photographic place a liminal place, I propose, is to consider the frame as an indeterminate, permeable and pliable boundary between the inside and the outside, wherein the blind field reposes in a subterranean way.

As I have discussed, if the maximisation of the blind field can defamiliarise (ESA's photo) and its minimisation can familiarise the photographic place (NASA's photo), its mere existence suggests that the photographic frame can achieve both, making liminal what it holds within it. At this point, having discussed the possibility of the photographic place becoming a liminal place thanks to the existence of the blind field at the edge of the photograph, I will zoom out from the photograph to include the last participant of photography: the spectator. As theorist of photography Ariella Azoulay has proposed, a photograph is neither the immaterial or material thing that travels through different spaces nor that which is inscribed on its surface, i.e. the image; but it can be deemed a special encounter that takes place in relation to the camera or the spectator.[68] To grasp an ontological understanding of photography, she suggests that all the participants in a photographic act should be taken into account (i.e. the photographer, the camera, the photograph and the spectator). In doing so, it becomes possible to formulate the photograph as the result of an encounter.

Thus, in the following chapter I will next explore how the inclusion of the spectator in a photographic act can account for the spatiotemporal aspects of the notion of place.

CHAPTER FIVE

The Spectator:
A Place That Is Sempiternally Taking Place

Spectator is ourselves.

—Roland Barthes, *Camera Lucida*

As Barthes once noted, the study of photographs can be the object of three practices: to do, to undergo and to look, in relation to the photographer, the photographed subject and the spectator respectively. In this categorisation, the photographer functions as "the operator" who initiates the act of photography, the photographed subject is the referent whose spectral trace is forever embedded in the photograph, and the spectator is "all of us who glance through collections of photographs".[1] Throughout the last four chapters, I have paid extensive attention to the photographer or the "operator", to the referent in relation to the camera, and to the photograph as both a thing and an image, aiming to illustrate how each of them can feature spatiotemporal characteristics. To be clear: I have discussed how the photographer's body can be deemed a lived place replete with indeterminacies, how the camera is a contingent place that perpetually suspends the referent; and how the photograph as a thing becomes a placeless place that drifts towards unspecified directions and, as an image, a liminal place that possesses the blind field. Having discussed the aforementioned, in this chapter my examination of the notion of place apropos of photography comes full circle by the inclusion of the spectator in a photographic act.

As Azoulay has put forward, theorists of photography tend to neglect the fact that their reading of the medium stems from a particular field of discourse that regards the photograph strictly on its own terms. By doing so, they overlook the role of the spectator in a photographic act and reduce photographic productions to the "producer of the image" (i.e. the photographer).[2] According to her, an accurate reading of the medium of photography should not be limited to the photographic image, since "the photograph bears the seal of *the photographic event*, and reconstructing this event requires more than just identifying what is shown in the photograph".[3] Among other things, Azoulay's socio-political reading of photography puts forward that this

medium has the potential of making an event, which can take place in conjunction with either the camera and the photographer or the photograph and the spectator. Evidently, in her conception of photography the spectator's role is an indispensable one, since the photographic event can transpire either in relation to the photographer and the camera, or in relation to the one who looks at the photographic image: the spectator.

In this chapter, by embracing and expounding on Azoulay's formulation of the photographic event and further investigation of the concept of event as such, I will look at how the photographic event in relation to the spectator can shed light on spatiotemporal features of the concept of place. By reading the photographic act vis-à-vis the spectator, I want to demonstrate how photography can constitute an intangible place that makes only an elusive presence in time and space. To this end, by discussing several different perspectives upon immaterial facets of places, I will firstly foreground how a place can be regarded as something conceived through momentary confrontations. Subsequently, through examining the work of contemporary philosophers such as Alain Badiou and Slavoj Žižek, I look at the concept of "the event" in parallel with Azoulay's formulation of the photographic event. Eventually, having explained the immaterial existence of places and inherent properties of events, I will argue how the inclusion of the spectator in the photographic event can account for a transitory appearance of place in time and space.

Place as a State of Being

> Place is a unity containing within itself different aspects.
>
> —Andrew Merrifield, *Place and Space.*

In the first chapter of this book I discussed why the lived body of a photographer (i.e. a lived place) should not be regarded as a simple location in space, as if it had fixed coordinates and measurable distances from other locations. Mainly because a lived body is a porous organism that constantly enmeshes in its surrounding space and thus cannot be viewed as a single point or position within it; instead it is of the space. However, according to Cresswell, a place cannot be reduced to what geographers refer to as "locale" either. The term locale, he defines, "refers to the material setting" of a place that constitutes its appearances: it is "the way a place looks". In other words, while the term "location" addresses the exact point at which something is situated, the term "locale" describes the material assembly of a place that gives it a particular look. For instance, while the geographical location of the city of Baghdad can tell us

where the city is positioned in an abstract space, allowing us to locate it on a map or in a GPS system, it does not provide us with any other characteristics of Baghdad as a place. It is because Baghdad "is also a locale ... it has a material structure that, in part, makes it as a place", states Cresswell.[4] However, neither Baghdad's location nor its material constituents can account for its being a place, since, as Cresswell contends, practice lies at the heart of the notion of place.[5] For instance, as I have shown before in reference to photography, the camera is a place whose significance cannot be reduced either to the location or to the material setting thereof, due to its internal mechanisms that define its practical uses. That means that the camera's agency in a photographic act is not much hinged upon its locale (i.e. the way it looks) nor on its location in space as on its inner mechanisms, functions and the way through which it is put into practice.

Underlying the importance of practice in understanding the concept of place, geographer Charles W.J. Withers suggests that the notion of place should be perceived "both as location and as constitutive locale".[6] While location is habitually regarded as the fixed boundaries of a place in most historical and geographical work, Withers suggests that locale provides "more variations" for places; mainly because, being the material structure of a place that affords involvement, locale means that a place can be "a product of social interaction".[7] For Withers, the material setting of a place or its locale, above all, provides the possibility of experience, practice and social engagement. Consequently, he proposes that a place should be regarded simultaneously as a location and a constitutive locale. He exemplifies the significance of practice in relation to the material structure of a place by the instance of a laboratory, a place in and through which modern science is made.[8] According to Wither, looking at the laboratory as a place it becomes possible to argue that science "is *produced through places* as practice rather than simply *in places*".[9] That is to say, a laboratory signifies the concurrent functions of a location that is positioned in space *and* a locale that affects the practices carried out in it, thereby indicating the conflation of both in one place.

Nevertheless, geographer Edward Relph refuses to accept that the meaning of places comes from their "locations, nor from the trivial functions that places serve". Instead, he argues that "the essence of place lies in the largely unselfconscious intentionality that defines places as profound centers of human existence".[10] In other words, for Relph places are defined not by where they are located nor by the material structure that determines their functions, but rather by the unconscious recognition of places dependent on each individual. To be exact, he proposes that places are essentially marked by each person's perception of them and not much by their locales and locations. Relph's understanding of the concept of place features another aspect of places that is usually subsumed under the category of "sense of place", defined as "the feelings and emotions a place evokes" in individuals, which can be either personal or shared in a community amongst people. As Cresswell explains this point, when we talk and write about cities such as "Calcutta or Rio or Manchester for instance, even those

of us who have not been to these places have some sense of them". This individual meaning, conjured up from each person's emotional state about a place, is what is widely referred to as "sense of place". Nonetheless, Cresswell also contends that an apt understanding of the notion of place should combine the three aspects of location, locale and sense of place, since "in any given place we encounter a combination of materiality, meaning, and practice".[11] That is how he merges the three aspects of place (i.e. location, locale and sense of place), and defines places as "locations imbued with meaning that are sites of everyday practices".[12] To put it differently, for Cresswell the concept of place is not a palpable and effortlessly graspable one, but rather a matter of coalescence of its three facets into a unity whereby a place comes into being. Therefore, being simultaneously constituted of a sense of place, a geographical location and a constitutive locale that undergoes alteration, places become, as geographer Andrew Merrifield proposes, both "things" and "processes".[13]

According to Merrifield, although space is habitually deemed a patently abstract phenomenon, place is frequently associated with "an easily identifiable reality", such as a location or a locale.[14] He thus vehemently criticises this view by submitting that the notions of place and space are not polar opposites, but rather "different aspects of a unity".[15] That is to say, he argues that spaces become places, and vice versa, through time and depending on the situation in which they are enacted. He exemplifies the space-place relationship by drawing a comparison between the "circulatory capital" and "fixed capital" in the work of Karl Marx, *Grundrisse* (1973). As Merrifield discusses, while for Marx all capital is "circulatory capital", indicating the transformation of commodities to money to capital and back to commodities, at a certain moment capital becomes fixed at a place and, in turn, becomes "fixed capital".[16] The ability of capital to be both circulatory and fixed in the global capitalist system, above all, features the capacity of place to appear as an emergent and particular moment in this process. That is, while capital essentially has a fluid structure, through which it circulates from commodity to money to capital and so on, during its circulation it necessarily needs to be localised in a *place*, when it transiently becomes fixed capital. This movement is not only when circulatory capital becomes fixed capital, but is also when capital is both localised and processual, manifesting place as an emergent form in this circulation. As Merrifield explains:

> Capital is an inexorably circulatory process diffusive in space which also fixates itself as a thing in space and so begets a built environment … capital fixity must, of necessity, take place somewhere, and hence place can be taken as a specific *form* emergent from an apparent stopping of, or as one specific *moment* in the dynamics of capitalist social space.[17]

For Merrifield, like the fleeting fixation of capital in the capitalist system, a place emerges at certain movements as a form of being when it is simultaneously a thing and a process. However, Merrifield's understanding of place, as an emergent moment in the circulation of capital, differs from Tuan's who states, "if we think of space as that which allows movement, then place is a pause; each pause in movement makes it possible for location to be transformed into place".[18] In that, Tuan's conception of place implies a recess in the flow of space, but Merrifield understands place as a moment when it is both a process and a suspension, exemplified by the momentary emergence of fixed capital when it is still capital in circulation. Merrifield refers to this ephemeral appearance of fixed capital as the "moment of place", a temporal dimension in which "place *emerges* through the interpenetration of objective and subjective forces" as a "state of being".[19] In other words, for Merrifield the notion of place cannot be demarcated by its location, locale or sense of place; instead, it arises as "the moment of place" when a multitude of conflicting aspects fleetingly amalgamate into each other as place. As a short-lived and emergent moment, geographers Ash Amin and Nigel Thrift argue that a place cannot be represented or captured in a process, but is to be encountered.[20]

In their collaborative work, Amin and Thrift underlie the importance of encounter regarding places in contemporary urban life. Drawing on Whitehead's work, they argue that in our modern world, where places are linked together through a concatenation of fluid networks which provide unlimited and unexpected potentials and processes, places can be best identified through encounters. Similar to Merrifield's understanding of place as that which transpires as the moment of place in the circulation of capital, Amin and Thrift hold that places are never permanently fixed and presented in space and time, but appear as confrontational instants. As they put it:

> Places, for example, are best thought of not so much as enduring sites but as *moments of encounter*, not so much as "presents", fixed in space and time, but as *variable events*, twists and fluxes of interrelation. Even when the intent is to hold places stiff and motionless, caught in a cat's cradle of networks that are out to quell unpredictability, success is rare, and then only for a while.[21]

Amin and Thrift grant a relatively more indeterminate and fluid facet to places than do Cresswell, Relph and Withers, who argue that places can be understood in terms of location, locale and sense of place or the combination thereof. Instead, they argue that in the era when places are constantly intermingling with each other, affecting and being affected in doing so, they should be regarded as confrontational moments or mutable events. In other words, for Amin and Thrift and in part for Merrifield, places are not to be captured or presented as fixed in time and space, but encountered as inconstant events that yield evanescent appearances: they are *moments of encounter*.

According to Azoulay, the act of photography, too, should essentially be understood in terms of an event that, although it cannot be fixed or embodied in time and space, provides the possibility of an encounter. As she puts forward, in order to ask what a "photographic entity is, one should suspend the priority attributed to the photograph and the agent [the photographer]" and instead consider photography as "an encounter between several protagonists" (i.e. the photographer, the camera, the photograph and the spectator).[22] At this point, having discussed the possibility of places becoming moments of encounter that transiently manifest themselves through a process, I will first examine what Azoulay defines as "the event of photography", and further investigate the concept of the event as such, in order to indicate how photography can be place-productive.

"The event of photography"

Photography is an event that is not conditioned
by the eventual production of a photograph.

—Ariella Azoulay, *What is a Photograph?*

An event can always be localized.

—Alain Badiou, *Being and Event*

As Azoulay has put forward, in order to understand the question "what is photography" one must differentiate between "the photographed event", as that which the photographer seeks to capture in a photograph, and "the event of photography". While for her "the photographed event" is inextricably linked to the photographer and the time of taking a photograph, "the event of photography" signals the capacity of photography to engender an encounter in which none of the participants of photography gains precedence over the other, and out of which a photograph might be produced.[23] As she contends, "the event of photography (not the photographed event) might take place as the encounter with a camera, with a photograph, or with the mere knowledge that a photograph has been (or might have been) produced".[24] Azoulay formulates "the event of photography" with two different modalities of "eventness": first, as an encounter in relation to the camera; second, as an encounter in relation to the photograph, or in relation to its hypothetical existence.[25]

For Azoulay, despite "the photographed event" that always ensures the existence of the camera and the production of the photograph, in "the event of photography" the photograph is considered as "an unintentional effect of the encounter" between those who take part in it.[26] This means that "the event of photography" does not necessarily yield a materialised or immaterial photograph; instead, in this form of encounter the photograph can come into existence while one is in the vicinity of a camera. For example, while in disaster zones people are irredeemably exposed to the camera, they generally cannot see their own photographs, since for them "the camera is a tool that promises a picture that they will never see". In these situations, Azoulay proposes, the event of photography as the encounter between the camera and the photographed subject takes place, albeit that it does not produce a photograph. She demonstrates this point with a photograph of a Palestinian woman who is grieving in front of her destroyed house while being photographed by a cameraman who is standing beside her in the photograph. As Azoulay explains, "from her [the Palestinian woman's] perspective as a participant in the event of photography, the act of photography is not the equivalent of the photograph. Photography might rather consist for her in something like the presence of the camera in front of her".[27] For the grieving woman the fact that she is being photographed by the photographer ensures that the act of photography is taking place; consequently, a possible photograph of the scene becomes an extra element in this situation. For this reason, Azoulay regards the photograph as "an additional factor" in the unfolding of a photographic encounter, and not a necessary one.[28] Because, as in the case of the people who are photographed in war zones, those who may never witness their own photographs, the event of photography is set in motion without necessarily resulting in a photograph. That is, it comes about in relation to the hypothetical production of the photograph.

Nonetheless, Azoulay contends that the event of photography, as a form of encounter between the partakers of this event, can also take place in the absence of the camera. She exemplifies this point in a paragraph when she discusses the hypothetical existence of both the photograph and the camera in an interrogation process. As she puts it:

> When an interrogator in an interrogation cell tells a detainee that he has a photograph which shows the detainee in such or such a situation, the interrogator does not necessarily reveal the photograph to the detainee— if it exists at all. He conducts himself as someone who simply derives his authority from the prior event of photography which happened elsewhere which he merely continues. In fact, however, he generates this event in order to put pressure on the prisoner. In such a case, the event of photography can be said to take place in the absence of both camera and photograph.[29]

The example of the interrogator and the detainee points at a situation in which the event of photography occurs not as an actual encounter in relation to the physical camera or the photograph, but in relation to the possibility of their existence or, to express it better, in relation to their hypothetical existence. In other words, although for Azoulay the event of photography is defined by an encounter between the participants of photography, it is not necessarily conditioned by their presence. In our contemporary time when the omnipresence of the camera is conspicuously felt, Azoulay argues that the medium of photography is also capable of constituting a "potential event", even in the situations when the camera is not visible at all.[30] Due to the proliferation of cameras and, thus, their pervasive presence in our time, the event of photography can take place without the physical presence of the camera. Strictly speaking, it can happen merely by virtue of the doubt that the camera could exist and one could be viewed by it. Accordingly, as being a potential event or encounter, the precise time of the event of photography cannot be determined by its partakers, by those who are potentially exposed to a camera's vicinity. As a potential event, Azoulay contends that not all those who take part in the event of photography are aware that "this event is taking place, certainly not at *the time of its occurrence*".[31]

Azoulay's formulation of the event of photography, on the one hand, sets out an event that, although defined as an encounter between photography's participants, can exceed the founding elements that constitute it by becoming a mere potential. In doing so, the event of photography becomes a potential event that can transpire irrespective of the camera's or the photograph's actual existence (as in the instance of the interrogator and the detainee). On the other hand, her account of the event of photography features an encounter that one cannot prepare for, since, as a potential of an encounter, one cannot arrive at the precise time of its happening. These two characteristics, however, are not only peculiar to the event of photography but, as philosopher Slavoj Žižek has put forward, they reflect the way in which an event unfolds and gains its evental status.

According to Žižek, an event can concisely be understood as "the effect that seems to exceed its causes", which in turn does not provide a certain moment of recognition for its manifestation.[32] The event of photography can feature both of these characters, since not only can it become an effect that surpasses its primary causes (i.e. the encounter with the camera or the photograph) but also, as a potential of an encounter, it ensures that its time of occurrence cannot be anticipated by its partakers. As Žižek notes, the time of an event can be understood by the moment of falling in love, in that the time in which this event takes place cannot be foreseen by those who participate in it. In other words, people never fall in love in a present time but, according to Žižek, "we all of a sudden become aware that we (already) *are* in love. The Fall (into love) never happens at a certain moment, it has *always-already happened*".[33] That is, an event, such as the experience of falling in love, does not provide preparation for its time of occurrence (akin to the potential event of photography) but leaves

room for retroactive confrontation. As a result, Žižek holds that an event should be conceived as "something shocking, out of joint, that appears to happen all of a sudden and interrupts the usual flow of things; something that emerges seemingly out of nowhere".[34] For Žižek an event reflects an irruptive force that always unexpectedly transpires and is never in the present time, so it can be experienced only after it has already taken place, as in the moment of falling in love. Therefore, the time in which an event occurs cannot be accessed directly, but it is always experienced retroactively after it has always already taken place. In other terms, there is always a distance between the recognition of an event *and* its very time of occurrence, similar to the time of a photographic event. As Cadava holds, a photographic event should generally be understood as "the latency of experience; namely, the distance between an event and our experience or understanding of it. This distance tells us that we experience an event indirectly".[35]

For Cadava, the photographic event unfolds as an encounter that distorts the flow of time, which eludes direct comprehension and cannot be experienced instantaneously. As he proposes, "the photographic event interrupts the present; it occurs *between* the present and itself".[36] That is to say, within the structure of the photographic event time is no longer understood as "continuous and linear", but as something that unexpectedly erupts, and in so doing constitutes the present.[37] Under this light, Cadava proposes that the photographic event reflects the "latency of experience", the fact that our experience of this event is never immediate, but indirect, and after it has always already taken place. That is why Azoulay suggests that the participants in the event of photography are not aware of the time of its occurrence, since, being formulated as an event, it always occurs unexpectedly and surprisingly: it is an encounter that comes to pass without heralding its arrival time.

As philosopher Jean-Luc Nancy remarks, the time of an event is the time of "the unexpected arrival" of something that cannot be prepared for.[38] According to Nancy, an event never comes into being as something "given", but it "happens" unpredictably within a structure, thereby inducing a surprising shock in the body of the given structure.[39] As he puts it, "what is awaited is never the event; it is the advent, the result; it is what happens. At the end of nine months, one expects the birth, but that it takes place is what is structurally unexpected in this waiting".[40] What confers an evental status on the birth of an infant is that, although it has been structurally anticipated in the gestation period, it takes place as an interruption of that process, thereby revealing the potential that until then has been immanent within the structure. In other words, before its unexpected appearance, an event is rather a non-present element embedded within the structure and it can become present only after its unanticipated arrival (as in the unforeseen birth of an infant within the structure of pregnancy). This view of events as the non-present elements within a structure that come into being unexpectedly has been given scrupulous attention in the work of philosopher Alain Badiou.

Before its manifestation, Badiou holds that an event is regarded as "the existence of an inexistent" within a structure, which can only manifest itself unexpectedly.[41] That is why an event can be recognised as such only by its consequences after it has taken place. An event, Badiou writes, "is almost nothing: it appears at the same time as it disappears".[42] For Badiou, the event comes into being through the very transitory moment when a non-existent element (or, in Badiou's terms, an "inexistent" element) suddenly pops in and out of existence within a structure, and in doing so manifests that which has been previously dormant in the given structure as a new possibility.[43] As Badiou states, "for me, an event is something that brings to light a possibility that was invisible or even unthinkable ... it is the creation of possibility".[44] Like the event of falling in love or the unanticipated birth of an infant, Badiou's event happens as the unexpected arrival of something that has been, until the time of its emergence, hidden within the fabric of the world. Therefore, the Badiouian event, too, cannot be recognised at the time of its happening, but acknowledged as an event after it has always already happened, akin to the event of photography that eludes direct recognition by its participants in the moment at which it takes place.

As philosopher Fabien Tarby notes, for Badiou "the event is the occurrence or the flash, the dazzling revelation or an instant, of the void subjacent to the situation, buried in the structures".[45] However, he also underlines that Badiou's event should be primarily understood as something that "exceeds the structure" by which it is constituted.[46] That is to say, whilst the Badiouian event lies as a void beneath the situation from which it comes into being as a fulgurating instant, it appears as an extra component to the structure that gives birth to it. To put it differently, although the event belongs to the structure that generates it, it appears as the *additional element* of the given structure, thereby exceeding its establishing ground. Philosopher Quentin Meillassoux exemplifies the additional character of the Badiouian event by the instance of the political uprising in France which took place in May 1968. This political uprising has been frequently addressed by Badiou as the quintessential instance of the event as an additional element with regard to its founding structure. As Meillassoux lucidly explains:

> What exactly do we mean, when we say that "May 68" was an event? In this expression, we are not merely designating the set of facts that have punctuated this collective sequence (student demonstrations, the occupation of the Sorbonne, massive strikes, etc.). Such facts, even when joined together in an exhaustive way, do not allow us to say that something like an event took place, rather than a mere conjunction of facts without any particular significance. If "May 68" was an event, it is precisely because it earned its name: that is to say that May 68, produced not only a number of facts, but also produced May 68. In May 68, a site,

in addition to its own elements (demonstrations, strikes, etc.), presented itself.[47]

May 68 became evental because it emerged as an additional phenomenon that exceeded the number of facts that had constituted it (i.e. strikes, riots, people struggles, etc.) Consequently, all the collective phenomena that took place in May 1968 presented the emergence of an event that had been until the time of its appearance hidden within the structure. That means that all the occurrences gave birth to an additional element that is now known as May 68, surpassing all the facts and figures that had established it. With reference to photography, what Azoulay addresses as the potential event of photography, to a certain extent sheds light on the way in which an event can become an additional phenomenon regarding its founding structure as well. As a potential embedded within the structure of photography, the event of photography is no longer defined by its constitutive elements, but it becomes something that exceeds the structure from which it arises. That is, as a potential encounter the event of photography is an additional possibility buried within the structure of photography, awaiting the time of its maximal appearance, thereby providing a retroactive sign of recognition to its emergence. As Meillassoux points out, events can be understood as possibilities that exist "only minimally" within structures "until their maximum appearance".[48] Before its maximal appearance, an event, such as the one of photography, is merely a potential that lies dormant within its establishing ground.

However, after its maximal appearance, the Badiouean event constitutes a site, which he refers to as "evental site", a multiple entity that "none of its elements are presented in the situation".[49] Explaining the primary features of these sites, Badiou remarks that it is "essential to retain that the definition of evental sites is *local*".[50] For Badiou, the event after its maximal appearance is always confined to the area from which it has transpired, to the very location in which it has produced an evental site. As he states, "the event is attached, by its definition, to the place, to the point, in which the historicity of the situation is concentrated. Every event has a site which can be singularized in a historical situation".[51] That is to say, the Badiouian event gains its evental status inasmuch as it occurs in its evental site, at the very point and particular location where multiple phenomena are singularised into the event as an additional element of the structure that gave birth to it. Despite the fact that "the event is a singular multiple" that is fundamentally "unpresentable", Badiou contends that it can "*always be localized*".[52] While for Badiou the event manifests the emergence of a non-presentable element from beneath the situation, after its manifestation the event becomes indispensably anchored to the location from which it came into existence; it localises in its evental site, thereby becoming attached to it. It is precisely this feature of the event (i.e. localisation) that marks the essential difference between Badiou's event and Azoulay's formulation of this concept.

As I have discussed, the event of photography shares with other modes of events its two main features, namely the unexpected time of its occurrence, which allows only retroactive recognition thereof, *and* the possibility of becoming an effect that exceeds its establishing causes. Nonetheless, unlike the Badiouean event, the event of photography fundamentally resists localisation because, as Azoulay points out, the event of photography "is made up of an infinite series of encounters" which, due to the existence of the spectator, never stops happening.[53] This means that Azoulay's understanding of the event of photography does not abide by the putative conceptualisation of history as the linear progression of events in time, and instead reflects what Siegfried Kracauer once called the "historicism" of photography. Unlike "history" that fixates "the temporal sequence of events", Kracauer argued that the "historicism [of photography] makes a register of the temporal sequence of events, whose connections are not contained in the transparency of history".[54] In other words, if "history" means that the sequence of events can be registered in time and space (as in the case of the Badiouean event), "historicism" means that photography is capable of crystalising events whose existence evades any permanent localisation (as in the case of Azoulay's never-ending event of photography).

Therefore, being an ongoing series of encounters that never comes to a halt, the event of photography does not give rise to a site, since it never becomes attached to where it takes place. As Casey points out, by adequately stating our relation to a place we transform it into a site, which is always localisable.[55] A site, he defines, "is place as seen through the reducing glass of simple location", whereas a place "is never simply located".[56] According to Casey, a place becomes a site when it is localised, when its boundaries are demarcated and determined in space and time. As an infinite series of encounters, however, the event of photography cannot be localised, since this event can always be regenerated and ceaselessly reiterated by the participation of the spectator. In other words, Azoulay's formulation of the event of photography does not yield a site but, as I will further discuss, can expose a place that is never simply located in time and space.

At this point, having discussed the characteristics of the event of photography vis-à-vis other modalities of the event and outlined its resemblances and main differences, I will lastly examine how this particular event, through the assistance of the spectator, can account for place as something eventual, processual, indeterminate and non-localisable.

The Evental Place of Photography

> The event of photography is never over
>
> —Ariella Azoulay, *Civil Imagination*

> Place *is not;* place *is to be.*
>
> —Edward S. Casey, *The Fate of Place*

In Azoulay's formulation of the event of photography, the photographer's role is to set the event in motion or, in Barthes's terms, he or she is "the operator" of the act of photography who initiates the act. For this reason, Azoulay holds that the event of photography is neither oriented towards nor determined by the photographer, since in this event the photographer is merely viewed as "a proxy, a service provider who can bring to the eyes of the spectator what his eyes see".[57] Instead, she argues that the "final addressee" of the event of photography is the spectator and not the photographer, whose task is merely to initiate the event and, thus, direct it towards the spectator. Azoulay's formulation of the event of photography, however, does not address any specific spectator, as if the spectator could be chosen by the photographer, but presupposes the existence of a spectator who is "situated outside of the time and the place of the photograph".[58] The existence of this spectator who is not confined to the photograph's time and place, Azoulay contends, is always promised at the very moment the photograph is taken. She exemplifies this point by discussing a daguerreotype photograph, taken in 1845, called *The Branded Hand of Captain Jonathan Walker,* which displays a photograph of a hand into which are burned the letters SS.

As Azoulay explains, after attempting to smuggle slaves out of the state northward, the captain, Jonathan Walker, was sentenced to imprisonment, ordered to pay a fine, and had his hand branded with the letters "SS", indicating that he was a "slave stealer". Upon his release from the prison, Walker (the person whose hand is captured in the photo) immediately photographed his palm as a sign of protest against the court's injustice in order to eternalise his objection in time by means of photography.[59] Although Walker did not have any particular spectator in 1845, he still decided to photograph his burned hand, assuming the existence of a hypothetical spectator who would witness this photograph in the future, somebody who would take on the responsibility to rectify the injustice that had been imposed upon him. This hypothetical spectator, whose existence is presupposed when the event of photography takes place in relation to the camera, is what Azoulay refers to as "the

universal spectator". According to her, the universal spectator functions as "an implied absentee presence in the act of photography", who allows the future participation of various protagonists in this event.[60] This means that the universal spectator is not an addressee that can be chosen, eliminated or conceived of by the photographer when the photograph is taken. Instead, as Azoulay puts it:

> This universal spectator, hovering above the encounter between the photographer and the photographed person at the time the photograph is taken, is *an effect of the act of photography* ... without assuming the existence of such a universal spectator—whether alive or dead—there is no explanation for the willingness of individuals to conquer the world as photographs and submit the violence this involves. The place of the universal spectator is kept after his death as a *vacant space*, allowing individuals to continue to be looted in the act of photography and moreover to participate in this willingly and consentingly.[61]

The universal spectator does not refer to any specific individual whose identity can be revealed at the time the photograph is taken, but instead it exists as a potential that presents itself as the corollary of the act of photography. This means that, although the possibility of the universal spectator comes into being when the photograph is taken, its identity remains unknown and belongs solely to the future. To elucidate Azoulay's conception of the universal spectator one needs to look at one of the most iconic war photographs of our time, the photo that manifests how a presumed spectator came into being at the time it was taken.

On 8 June 1972, press photographer Nick Ut captured *Terror of War* in the southeast region of Vietnam, called Trang Bang, aiming to publicise the carnage of the Vietnam War through photography (fig. 7). Ut's photograph features in the centre of the frame Phan Thị Kim Phúc, also known as "the napalm girl", a screaming 9-year-old girl who is running up the highway in pain towards the photographer. Just before the photograph was taken the naked girl had been severely burned on her back by the napalm bomb dropped by the South Vietnamese air force.[62] It is precisely at this time, when Ut captured the inhumane condition to which the Vietnamese civilians were subjected, that the universal spectator was conceived for this photograph. If *The Branded Hand of Captain Jonathan Walker* shows how the photographed person initiated the existence of the universal spectator, *The Terror of War* epitomises how the photographer effected this supposed spectator at the moment of capturing the photo. Put another way, without referring to any particular person, an "implied absentee" sprang up at the very moment at which this photograph was taken, hovering above the encounter between the napalm girl and Nick Ut as "an effect of the act of photography". Thanks to this implied spectator, the final recipient of the event of photography was not the photographer, but all the individuals who

were yet to come (i.e. all of us who look at this photograph in the present time). Thus, while its assumed existence germinates when the photo is taken, the universal spectator is actualised only after that time. In other words, after the photograph is taken everybody who bears witness to the photographed event (i.e. that which is presented in the photograph) occupies the place of the universal spectator, since his or her place is always vacant, waiting to be occupied by posterity.

Figure 7: Nick Ut (1972). *Terror of War.* © ANP/AP/Nick Ut.

Azoulay's understanding of the spectator becomes universal, allowing future individuals to partake in the event of photography, essentially because the universal spectator *bears witness* to the photographed event through the photograph, an act that cannot be restricted to any time and place. That is, as an act of bearing witness to the photograph, the event of photography can transpire in any time and location, unlike the moment of witnessing what is captured in the photograph, which happens only once in relation to the photographer. As theorist Gerhard Richter puts forward, the act of photography can be understood as an interplay between "the moment of witnessing", which is always singular and linked to the photographer, and the universal "act of bearing witnesses", which permits the unanticipated participation of the spectator in the act. Thus, as Richter puts it:

> To appreciate this interplay between *singularity* and *universality* in the space of photography, we may think of the photographic image as a technically mediated *moment of witnessing*, in which the inscription with light cannot be separated from an *act of bearing witness*, which, by definition, always must be addressed to the logic and unpredictable movements of a reception that is irreducible to the act itself.[63]

The potential of bearing witness to the photograph, which belongs to spectators of the photographic image, is embedded in the photograph at the very moment it is taken, even though it is irreducible to that moment. Thus, for Richter, when a photograph is taken the singular "moment of witnessing" and the universal "act of bearing witness" become inseparable in the photograph. Although the act of bearing witness cannot be reduced to the moment a photograph is taken, its possibility comes into existence at that very moment. That is why Azoulay propounds that the universal spectator is "an effect of the act of photography", which initiates its existence immediately after the photograph is taken. In that, the potential of bearing witness to the photograph after it is taken, and not witnessing the moment it is taken, becomes available as the corollary of the act of photography. In other words, the existence of the universal spectator is the reason for Jonathan Walker to photograph his burnt hand in 1845 and for Nick Ut to capture the atrocity of the Vietnam War in 1972, thereby providing the universal act of bearing witness to the photographed event through the photograph. Therefore, if the moment of witnessing is singular and connected to the time a photograph is taken, the act of bearing witness is universal and permits an infinite number of spectators to partake in the event of photography, thereby ceaselessly reiterating this event.

As Azoulay contends, the universal spectator "permits the event of photography to be preserved as one bearing the potential for permanent renewal that undermines any attempt to terminate or to proclaim that it has reached its end".[64] Unlike the other events previously discussed (i.e. the event of falling in love, the birth of an infant, and May 68) Azoulay's formulation of the event of photography is never subjected to termination, owing to the existence of the universal spectator who can always resume this event in the future. Consequently, as an event that bears the possibility of everlasting renewal, the event of photography does not produce a *site* that can be localised, but reflects the characteristics of *place* as a moment of encounter that is always susceptible of imminent recommencement by the universal spectator.

As I have previously discussed, places are not simply delimited to their locale, location or sense of place but, as Merrifield and Thrift have put forward, they can also be deemed as fleeting "moments of encounter" that manifest themselves in "the moment of place" in a process.[65] Concurring with Thrift, who suggests that places are grasped as momentary confrontations in a process, Casey further argues that the processual dimension of a place never comes to a halt, since for him the concept of

place is essentially "a matter of *taking place*".[66] Thus, he argues that a place is never "simply presented" in an instance that can be demarcated and singularised by any specific time or location, but is to be "recognized as an undelimited, detotalized expansiveness" that is continually in process.[67] While Casey's account of place in part accords with Thrift's, suggesting that places are never permanently fixed and presented in space and time, it differs from Merrifield's who conceives of place as an instance or "the moment of place", which momentarily appears through a process. Because, if for Merrifield places are deemed to be short-lived moments that appear in a process which can be singled out as in the instance of fixed capital, for Casey those fleeting moments are considered to be place as far as they always continue to happen. For this reason he argues that "place is not determinate in character", since it cannot ever become distinct in a process, but is to be understood as that which is continually happening without cessation.[68] This means that for Casey a place does not include a pause or the moment of place when it fugitively becomes a thing, but is to be recognised as an endless process that affords only confrontation. As he puts it:

> Place is not entitative, as a foundation has to be—but eventemental, something in process, something unconfinable, to a thing. Or to a simple location. Place is all over the place, not just here or there, but everywhere. Its primacy consists in its omnilocality, its continual inclusion in ever more expansive envelopments.[69]

While for Merrifield a place reflects that which is simultaneously a thing and a process, as in the instance of fixed capital that is also circulatory capital, for Casey a place is never a thing, but an inexorable process that is never confinable to any time or location. Strictly speaking, for Casey a place is recognised as such insofar as it is always taking place, untrammelled by any fixative temporal and spatial confinements.

Returning to the event of photography at this point, I would like to propose that this event manifests the characteristics of *place as infinite moments of encounter between the photograph and the universal spectator*, which in turn never cease happening in time and space. The event of photography reveals the place as the moment of encounter that is, in Casey's terms, simultaneously "in process", "eventemental" and "unconfinable". Firstly, this place is inherently processual due to the existence of the universal spectator who, through providing the possibility of bearing witness to the photograph, ensures the unending renewal of the event of photography. That means that the event of photography does not only occur once, but can endlessly extend towards the future by virtue of the spectator. Hence, as an everlasting moment of encounter, this place is always in process, since the possibility of bearing witness to the photograph is infinite, thanks to the universal spectator as the effect of the act of photography. Secondly, through reflecting the two defining features of events discussed in this chapter, the event of photography also foregrounds the qualities of the place as a moment of

encounter that is inherently evental. In that, not only is the time of its occurrence always experienced retroactively, but also as a potential quiescent within the structure of photography, so this event becomes an effect that exceeds its establishing causes, thereby gaining its evental status. Thirdly, the event of photography in relation to the spectator cannot be delimited to any specific location since, as I have previously discussed, photographs themselves are never simply located, but massified through a polyvocality of directions. That is, in the age of digitisation, when photographs can become flyers that constantly sail through indeterminate directions, the event of photography is unconfinable to any specific time and location. As such, in relation to the universal spectator and the photograph, the event of photography manifests the dispositions of place as infinite moments of encounter; always processual in time, unconfinable to any location and evental regarding its emergence. In other words, the event of photography gives birth to a place that never localises in time and space but exists omnilocally through them: an *evental place* that fugaciously but perpetually comes into being between the spectator and the photograph. As Nancy contends, an event "is the taking place of place" and, as I have discussed, so is the event of photography; however, only after the inclusion of the universal spectator who imbues this event with the possibility of eternal resumption, thereby evincing an evental place that is sempiternally taking place.[70]

Hitherto in this book I have brought the spatiotemporal characteristics of each partaker of photography to the forefront, through arguing how the photographer is a lived place, the camera is a contingent place, the photograph is a placeless and liminal place and, eventually, how the spectator can feature as an eventual place. In my last approach towards reading the concept of place apropos photography, however, I will deal with place as the subject matter of photography. Although usually in photography the subject matter seems to be determined by the photographer, it is always affected and influenced by a wide range of representational practices that give shape to the medium.[71] That means that if on the side of the photographer the subject matter seems to be that which the camera points at (e.g. a physical place in the world), at the moment it becomes a photograph it is a matter of specific representational systems that define its significance and possible meanings. In order to look at how a representational scheme deals with place, in the next chapter I will single out a photographic genre that has an inextricable affinity with both physical places in the world and embodied ones in photographs. In my final approach towards reading photography vis-à-vis the concept of place, thus, I will argue how a specific photographic genre utilises its representational methods to communicate its subject matter through places.

CHAPTER SIX

The Genre: The Aftermath of Place

> There always exists a lacuna between the representation and
> what is represented, no matter how that representation is conceived.
>
> —Dan Stone, *Chaos and Continuity*

As John Szarkowski noted in the 1960s, while paintings are made from conventional schema deployed by the painter, photographs are taken; they are primarily a matter of organising elements of the world, a process that imparts a factual character to photographs. He further remarks that the factuality of the photographic picture essentially differs from the reality of the world it represents, and that these things ought not to be confused.[1] As Szarkowski reminds us, although after a photographic shooting the subject matter and the picture thereof seem to be alike, as if a photograph of a place and a physical place in the world could be the same, they are not the same thing. This is because, after being photographed, the physical place transforms into a photographed place through a set of historical and representational practices peculiar to the medium of photography. Fully to grasp a photographed place, therefore, one should become acquainted with the means with which photography embodies actual places in the world; that is, the representational schemes and genres whereby it transforms them into photographs of places. Only afterwards does it become possible to examine how photography translates an actual place into a photographed place in order to communicate specific contents to the spectator. But, since the advent of photography, a wide range of photographic practices have conveyed meanings through places, such as cityscape, landscape, street and topographic photography, each through distinct representational techniques and different understandings of what characterises a place in the world. There is, however, one photographic genre that includes and employs all the aforementioned photographic practices in order to relay its content, and it does so by simply regarding them as particular places in the physical world: aftermath photography.

In this photographic genre the photographer visits a vacant physical place in the world, where something went wrong in the past and, irrespective of its physical

characteristics, considers it a place instilled with meaning. In doing so, the aftermath photographer aims to direct the spectator to the concomitant histories of physical places in the world by putting an undeniable emphasis on their specificities in the world of photography. In this genre, a narrow street is as much of a place as an infinitely immense landscape, since for aftermath photography what defines a place is not its physical features, but the historicity that is anchored to it. As a result, aftermath photography not only creates an incontrovertible rapport between physical places and their photographic embodiments, but also essentially puts place at stake. As art historian Donna West Brett puts it, aftermath photographs are "both constructing notions *of* place, and in turn, as being constructed *by* place".[2] However, after the photographer captures a terraqueous piece of the world with the camera, viewing it as a place replete with historical significance, the inherent representational systems of photography make the photographed place intelligible to the viewer. So, if on the photographer's side every physical location on the earth with entailed histories is seen as a place, then each photographic practice requires a different way of seeing, thus, different way of dealing with space and time. For instance, while looking at a street photograph the viewer is inclined to perceive time as the instant at which the photo was taken; while looking at landscape photographs the viewer is impelled to extend the act of looking and, in turn, experiences a "pause in time".[3] In other words, although the photographer views a narrow street and an enormous landscape equally as places, having turned them into photographic representations, they require different methods of looking in order to correspond to the representational system in which they are delivered. In this chapter, to examine how a specific representational model affects our way of accessing the subject matter, I will narrow my focus to the way in which aftermath photography deploys landscape pictures to communicate its content. In that, as Casey contends, landscapes "are congeries of places in the fullest experiential and represented sense. *No landscape without place;* this much we may take to be certainly true".[4]

Yet, aftermath photography does not only communicate its content through photographed places, since for this genre what makes an area distinct from others is not its visual attributes, but the event that took place therein prior to the photographer capturing the photo. Thus, to convey the histories that are attached to a physical place in the world, this genre requires an accompanying text to narrate the story behind the photographed place. That means that in aftermath photographs the content of the photographed place is given not only through the image but also through text. As Clive Scott notes, by underlining the role of text regarding the photograph, it becomes possible to argue that the photographic narration is "not *in* photos, but *with* photos".[5] Accordingly, in order to comprehend how the genre of aftermath photography communicates a content to the viewer, this chapter considers both the image and the text as the containers of meaning, that is, as means of signification.

Therefore, to investigate how a particular representational model deals with place, both in the material world and the world of photography, in this chapter I look at how aftermath photography translates a *physical place* into a *photographed place* in order to communicate a specific content to the spectator. To do this, I will first focus on the relationship between landscape and place, in order to foreground how the physical landscape in the world can be seen as a place, and how such a place propels the photographer into its vicinity. Having discussed how the physical landscape as a place affects the photographer, I will then examine how the embodiment of that place (i.e. the landscape photograph) influences our way of seeing. To this end, I will concentrate on the temporal aspect of looking at landscape photographs within aftermath photography, indicating how this genre utilises landscape images to elongate the act of looking. Afterwards, while retaining my focus on aftermath photography, I will further explore the function of the text in relation to photographed places, showing how an accompanying text directs the spectator's attention to the subject matter of the photo. Finally, by delving into several concepts given by philosopher Giorgio Agamben, I will argue how the genre of aftermath photography, by turning physical places into photographed places, deploys places as markers of meaning and vehicles of signification. To this end, in the following section I will begin my analysis by looking at the very material and physical place in the world (i.e. the landscape), before it enters into the representational space of aftermath photography.

Landscape and the Agency of Place

It is in and through *landscape*, in its many forms, that our relationship with *place* is articulated and represented.

—Jeff Malpas, *Place and the Problem of Landscape*

Agency is a matter of intra-activity.

—Karren Barrad, *Posthumanist Performativity*

According to art historian Lucy Lippard, the contemporary usage of the term "landscape" is rooted in the German fifteenth-century term, *landschaft,* as a "shaped land, a cluster of temporary dwellings … the antithesis of the wilderness surrounding it" and "in the Dutch seventeenth-century word *landschap* or *landskip*—a painting of such a place, perceived as a scope, or expanse".[6] Since the very conception of the

term landscape in cultural and geographical lexicons, Lippard suggests, it has been associated with human dwellings in places and the way in which humans visually perceived those experiences. Yet, not everyone has the same way of experiencing and perceiving places, since each place evokes a different set of meanings to individuals according to their interests and the way in which they interpret their experiences. For instance, while a landscape can be a topographical view of a place for one individual, it can be a matter of geopolitical evolution of the same place for another. In other words, what a landscape is depends on the beholder's understanding of the place. As geographer D.W. Meining states in his famous article "The Beholding Eye", the same landscape can evoke ten different versions of meaning depending on each individual's way of perceiving it. Looking at the landscape, he explains:

> We may certainly agree that we will see many of the same elements— houses, roads, trees, hills—in terms of such denotations as number, form, dimension, and color, but such facts take on meaning only through association; they must be fitted together according to some coherent body of ideas. Thus we confront the central problem: any landscape is composed not only of what lies before our eyes but what lies within our heads.[7]

Therefore, the same landscape can be viewed as nature, habitat, artefact, system, problem, wealth, ideology, history, aesthetic and, finally, as place, depending on what attributes and qualities individuals elicit from and assign to it. Considering the landscape as a place, Meining proposes, it becomes "a locality, an individual piece in the infinitely varied mosaic of the earth".[8] It is because to view landscapes as places is to regard them as "particular localities" wherein "our individual lives are necessarily affected in myriad ways".[9] In this view, the landscape evokes its affinity with places; it manifests the "individuality of places", the fact that each particular place has its own inherent features, specificities and concomitant histories that constitute its context. Landscape, as Relph has suggested, is "both the context for places and attribute of places".[10] The view of landscapes as places is what Casey embraces as well, that is, as particular localities that are inherently interlaced with, and comprised of, places, since for him landscapes are to be essentially understood as "placescapes" and never as spaces.[11]

According to Casey, despite being a "cusp concept", the term "landscape" makes it possible to distinguish between place and space, yet it always remains within the former category. While it is common practice to consider the landscape as a mere middle term between place and space, he firmly contends that the landscape intrinsically falls into the category of place. Even if landscapes are made up of a colossal terrain of places which may seem to fade into an expanded space, Casey argues that they do not

become "open wide spaces" but can create regions as "a very large set of places".[12] As he puts forward:

> There is no landscape of space, though there is landscape both of place and region … A landscape may indeed be vast; it can contain an entire region and thus a very large set of places. Yet it will never *become* space, which is something of another order altogether. No matter how capacious a landscape may be, it remains a composition of places, their intertangled skein.[13]

Irrespective of the expansiveness and grandiosity of a landscape, Casey holds that the landscape is always the "intertangled skein" of places, and thus never belongs to the category of space, featuring the attributes of regions as the interconnections of numerous places. As he argues elsewhere, both landscapes and seascapes belong to the same category; that is, they come into being "when places are concatenated into regions".[14] For Casey, therefore, a landscape or a seascape reflects the characteristics of place as *place-cum-region*, i.e. as a numerous concatenation of places that are coalesced into a region, which are nevertheless always place-bound and place dependent.

As Malpas elucidates, Casey foregrounds the inherent affinity between landscape and place to clarify that the landscape should be understood as "an articulation of place" and "the relationship to place".[15] However, "the problem of landscape" results not only from "our relationship with place", but also "from the problematic nature of that relationship", states Malpas.[16] It is through the concept of landscape that, firstly, we become aware of the intrinsic rapport between places and ourselves, and then we realise the different methods of engagement that we utilise to understand places. According to Malpas, a landscape essentially arises "out of our original involvement with the place" in which a specific locality "affects and influences us".[17] In other words, he claims that the landscape makes comprehensible the ways in which we *involve* with a place, wherein our perception and understanding are hinged upon the particularity and singularity of the place. Malpas even goes on to argue that this involvement with particular places is not only limited to our lived experiences, when, for instance, a photographer confronts the landscape as a view in nature, but it is also true when we confront a representation of the landscape as an artwork, as a "view of a view". As he writes, we must acknowledge that landscape art

> should not be constructed as merely the presentation of a view but as rather the "view of a view"… But the very possibility of such view in the first place already depends on having a place and so an experience … It always already depends on an involvement and orientation with respect to some *particular place* or locale.[18]

Confronting a landscape either as a vast concatenation of places that constitute a region *or* as a representation of that lived experience that is located somewhere is always dependent on a particular place where humans are involved with some localities. On the one hand, Casey argues that our engagement with places can give rise to the landscape as a multitude of places that are concatenated into regions, an involvement that is always place-bound and place-caused. On the other hand, Malpas suggests that this involvement is always based on a specific place or locale, whether it is with a view in nature or with a view of a view as a representation. Despite their different approaches, what Casey and Malpas share regarding the defining attributes of the landscape is that they both concur that the landscape is about our mode of involvement with some specific localities, an involvement that is necessarily place-dependent. Nevertheless, the pertinent question about the relationship of landscape and place is how people get involved with some particular localities that are marked by expansiveness and grandiosity.

As Meining reminds us, the idea of landscape as a place embraces not only that which we see, but "all that we live amidst", because it regards the landscape as an environment that includes sounds, smell, visual relationship and the "ineffable feel of place as well".[19] Due to the complexity of our engagement with the landscape as a place, for instance, Crouch has recently coined the term "flirting" to address "a nuanced, contingent, uncertain and fluid" method whereby people engage with a landscape in an indeterminate way.[20] Concerning people's involvement with a landscape, the term flirting suggests that not all the constitutive elements of the landscape are necessarily visible in it nor belong to it, since being also an environment it is made up of a multitude of distinct but interrelated elements that, taken together, make a coherent unity as landscape. Long before Crouch, however, sociologist George Simmel referred to the constitutive elements that permeate through the landscape without belonging to it as "the mood of landscape".[21] He explains this point in a rather long passage where he compares a person's and a landscape's mood as follows:

> When we refer to the mood of a person, we mean that coherent ensemble that either permanently or temporarily colors the entirety of his or her psychic constituents. It is not itself something discrete, and often not an attribute of any one individual trait. All the same, it is that commonality where all these individual traits interconnect. In the same way, *the mood of landscape* permeates all its separate components, frequently without it being attributable to any one of them. In a way that is difficult to specify, each component partakes in it, but a mood prevails which is neither external to these constituents, nor is it composed of them.[22]

The mood of landscape conjures up an intermingling of all its constitutive elements (e.g. sounds, smells, lights, sights) between the beholder and the specific locality from where he or she perceives the landscape. Yet, as Simmel notes, the mood of landscape does not belong to any of the components that give rise to it. To deploy a term used by geographer Nicholas Entrikin, the mood of landscape refers to a mode of "betweenness" that permeates between a particular location and a beholder while remaining independent of both. As Entrikin submits, places are "best viewed from points in between", so, too, are landscapes, viewed as particular localities marked by the involvement of humans with places, given that this involvement not only includes people and places but also the non-human elements that pervade in between them.[23] Drawing on Schiffer, Ingold clarifies that the category of "non-humans" not only includes the immediately visible, but also comprises "a blank category that covers everything else that is given independently of people", including "sunlight and clouds, wild plants and animals, rocks and minerals and landforms".[24] In other words, non-humans are all the in-between ingredients of the landscape that in their totality evoke the mood of landscape, the feeling that "permeates all its separate components, frequently without it being attributable to any one of them".[25]

As Simmel further points out, while the mood of landscape allows us to call a landscape "cheerful", "heroic", "melancholic" or ghostly, it always pertains "to *just this* particular landscape". "Even if mood was nothing more than the feeling evoked by a landscape in the observer", Simmel states, "then this feeling, too, in its actual determinateness, would exclusively be tied to *just this*, and precisely this, landscape and could not be transferred to any other".[26] Here Simmel draws attention to the fact that the mood of landscape, being its evoked feelings resulting from the intermingling of all its intermediary elements in the observer, is necessarily tied to a particular place. To be precise, the mood of landscape anchors to the vast locale where the involvement of humans and non-humans is acted out. It is through the mood of landscape (the invisible in-between elements that are sensed but not necessarily perceived) that each landscape acquires its distinctive character for the observer. Consequently, the mood of landscape underlines how, by acknowledging the non-human elements that pervade in between people and particular localities, places can become meaningful and distinctive, allowing people to be possessed by, and attached to, them, and eventually to have feelings for them.

Discussing how each specific place can become meaningful for people by acknowledging their in-between elements, sociologist Michael Mayerfeld Bell has proposed that places make us believe that they have ghosts, endowing them with distinctive significance for those who visit them.[27] By the term ghost Bell refers not to a spiritual, metaphysical or supernatural element, but to a sentiment that "gives a sense of social aliveness to a place", generating "the specificity of the meaning" each particular place acquires through people's engagement with it.[28] The ghost of place is the corollary of people's involvement with places when it results in a sense

of familiarity and attachment to specific locations, a feeling that lingers in between people and places. To a certain extent, thus, the ghost of place reflects its mood. If for Simmel the mood of landscape instigates feelings for its entirety, without belonging to any of its constitutive elements, Bell's understanding of the ghosts of place, too, suggests that places can induce feelings through people's involvement with them, engendering a ghostlike presence that permeates in between them without belonging to any of them. Also similar to the mood of landscape, which is always rooted in a specific location, the ghosts of place are, according to Bell, the "stubborn and quirky singularities" that always pertain to a particular place and not the others.[29] Whether they call it a ghost or a mood, Bell and Simmel underline the fact that, firstly, places have the potential actively to interact with people through the non-human elements that permeate between them. Secondly, they underscore that this involvement between places and people is always peculiar to the particular localities wherein their interactions transpire. In other words, they argue that places have the *agency* to interact with people through their in-between non-human elements that are localised in them.

As geographer Phil Hubbard notes, agency is not only an attribute of humans who have the potency to make things happen, but it can also be deemed "a *relational effect* generated in networks by humans and non-humans alike".[30] Hubbard suggests that, although agency is usually considered to be an attribute of humans who can actively intervene in the world, by taking into account the role of non-humans in our interventions with the physical world it becomes possible to view agency as a relational effect in which non-humans are active as well. For instance, both the mood and the ghosts of place can highlight the fact that places can actively affect people through the intervention of their non-human elements, thereby constituting the agency as a relational effect in between them. Ingold exemplifies the active involvement of non-humans by arguing that we not only "see" landscapes, which implies the passivity of the landscape in the act, but also "hear" the physical landscape, which implies that the landscape is active in this interaction. As he writes:

> To be seen, an object need do nothing itself, for the optic array that specifies its form to a viewer consists of light reflected off its outer surfaces. To be heard, on the other hand, an object must actively emit sounds or, through its movement, cause sounds to be emitted by other objects with which it comes into contact... In short, what I hear is *activity*.[31]

For example, when a photographer confronts a landscape, it is not only a matter of ocular involvement with the place, which would imply that the landscape is passive, but also includes other senses, such as aural, revealing the activity of the landscape in this interaction. In this instance, agency is deemed a relational effect between places and people through the engagement of the in-between ingredients of the landscape,

those components that are localised where the photographer confronts the landscape as a concatenation of places. In this case, in short, agency is an enactment that comes into being in between people and places.

As theorist Karren Barad contends, agency is not an attribute that either humans or non-humans can possess, but an "enactment" that congeals in between them; it is an "intra-action".[32] Opposing the idea of "interaction" that presupposes the passive engagement of one of the involved parties, Barad proposes the term "intra-action" to underscore that agency results from the sedimentation of active parties, which are all equally affected and affecting in the act.[33] At this point I would like to suggest that *the agency of place* (analogous to the mood and the ghosts of place) comes into being only through the intra-active involvement of people with places, manifesting the non-human elements that perfuse in between them, whereby each particular place acquires its distinctive significance in the observer. Put differently, the agency of place is its very potentiality to engender a relational effect between humans and specific localities through their intermediary components. Therefore, before a photographer converts a physical place into the photographed place, before an actual place in the world is turned into its representation in the photograph, the physical place in the world has the potential of actively affecting the photographer through the intra-active involvement of its intermediary non-human components. The agency of place, thus, reflects this intra-action, which coagulates and sediments wherein a photographer involves with the place, driving the photographer to a particular locality with quirky singularities that make it distinct from other places. To be precise, the agency of place signals the ghosts or moods with which places actively affect the beholder in a sheer inbetweenness: *it is the very gravitating relational effect that propels the photographer to a particular place and not to others.*

Having argued that the landscape can be seen as a concatenation of places into regions where people are involved with particular localities *and* the possibility of the given localities to acquire agency through intra-acting with humans, I will next shift my focus from physical places to when they become photographed places. In other words, I will indicate that, if it is a geographical matter before the photograph is taken, then when the physical place is turned into the photographed place it becomes a matter of representation. As literary theorist Ernst Van Alphen notes, "we do not see the world in photographs, but concepts of the world. In order to understand photographs adequately we have to consider them as conceptual, which means we have to be aware of the translations that have taken place from the world in the photographic technology".[34] That is, photographers do not literally cut physical places from the world and capture them in the photograph as if unaffected, but translate them through the photographic apparatus in order to make a representation thereof. To grasp a better understanding of the photographed place as the subject matter of photography, therefore, it is essential to learn how our way of seeing delivers the meaning of the photograph. In the following section, by retaining my focus on the

particularity of places that exist in the world I will next indicate that photographic shooting somehow produces some "representational carcasses" of physical places and, in doing so, it leaves their agency behind it.[35] To this end I will focus on aftermath photography that, by regarding landscapes as particular localities instilled with meanings, pays significant attention to their distinctiveness and singularities, aiming to show how we *see* photographed places in this specific genre.

The Spectrality of the Image

> The encounter with the photograph is the encounter between two presents, one of which, already past, [one of which] can be animated in the *act of looking*.
>
> —Marianne Hirsch, *Surviving Images*

> We do not believe in ghosts, we are haunted by them.
>
> —Tom Gunning, *To Scan a Ghost*

In 1972, art critic John Berger coined the term "way of seeing" to underscore that we learn how to see artworks by means of different representational schemes and practices, and in so doing we impart meanings onto them through this learned ability.[36] The way we look at photographed places is, too, learned through different representational systems and genres that aim to elicit the meanings of photographs. However, merely knowing the "way of seeing" photographs does not always ensure an unconditional degree of understanding them, albeit that it can lead us to gain a more precise level of interpretation for unearthing the content of photographic images. This is the case in the genre of aftermath photography which, by putting an ineffaceable emphasis on an exact locality captured in the photograph where there is nothing to see except the place, inquires into the veracity of our way of seeing and understanding the photographic content.

Instead of recording events as they happen, in aftermath photography the photographer visits vacant places where something has occurred before, to first capture and later convey the traces of the event through photography. As West Brett suggests, by showing vacant places where something has occurred before, aftermath photographs "promise a possible connection to the event, to the memory and history of the site, but in their failure to deliver, allow space for interpretation".[37] By confronting the spectator with photographed places, where usually something has gone wrong in

the past, aftermath photographs provide the possibility of reflection upon the past through embodying vacant places. According to West Brett, by attempting to record some essence of the past events in particular places, aftermath photos "offer a view into the past from the edge of the present".[38] To this genre, therefore, what is of essential importance is how representing particular localities can become a vehicle for accessing the past when they are observed in the present. In what follows I will narrow my focus on how aftermath photography specifically deploys the representational methods of landscape genre in order to communicate a trace of the past from the present time of photographed places.

Figure 8 is an instance of aftermath photography, a photographed place taken by Dutch artist Gert Jan Kocken, presented as a part of the gallery entitled *Disaster Areas* (1999). In his exhibition Kocken displayed a series of landscape photographs from different European countries, such as Italy, Austria, the Netherlands and Belgium, where some calamitous events had happened due to the negligence of the people living or working there. By returning to the exact location where the incidents had taken place and capturing their vicinities in photographs, Kocken asked whether photography could constitute a connection with the past through representing places, and by underlining their particularities. That is, through involving with places with the aid of photographic apparatus the artist stressed the role of particular localities in the act of the remembrance of the past. Kocken's photograph displays a seaside view in Zeebrugge, Belgium, twelve years after the disastrous event had taken place in this specific location. The incident occurred on 6 March 1987, when a roll-on-roll-off car-ferry called the *Herald of Free Enterprise* capsised in the displayed location shortly after leaving Zeebrugge harbour, killing 192 people.[39] Just four minutes after its departure, the ferry sank near the harbour as a result of the staff's negligence in leaving the ferry's bow door open.[40] Despite the poignant story that lingers behind the picture's surface, looking at the photograph the viewer is confronted with a place imbued with delicate serenity mirrored by the blue seascape. The entire photograph evokes a strong sense of tranquillity, a sentiment reflected by the caerulean sky overlaid by the translucent clouds ending in the middle of the photograph where the sky edges with the sapphire sea, arousing a tangible placidity in the observer. The scene could have been a Sunday-afternoon photo of a family who visits the seaside to savour the unspoiled landscape, energising and refreshing for the following week, just by looking at the scenery. What we look at, thus, is not a place that in any sense could reflect the tragic story behind it, but a particular location recorded by the representational elements of the genre of landscape.

Figure 8: Gert Jan Kocken (1999). *Zeebrugge (Belgium): On March 6th 1987 the Herald of Free Enterprise capsizes just outside the harbor of Zeebrugge killing 192 people.* © Gert Jan Kocken.

According to scholar of photography Liz Wells, there are mainly two key lines in landscape photography: the first one focuses on "pictorial images", which are constructed according to the "preconceived idea" of what a landscape can look like, and the second one is "straight" or "topographical", which mirrors "the composition of the classic landscape painting".[41] Landscape photos in aftermath photography, including Kocken's photograph, evidently fall into the category of straight landscapes, since in this genre the photographer's primary intent is to make an exact geographical record of the physical place in the world.[42] That is, landscape photographs used in aftermath photography aim to make a topographical document of a specific location while reflecting the compositional elements of landscape painting. As scholar Isis Brook summarises, the classic appreciation of landscape pertains to three categories, which do not always remain distinct but interrelate in many cases: first, the pastoral, which reflects a landscape that is meant to please the viewer through "regularity, smoothness, tranquility and unity", wherein nothing is abrupt; second, the sublime that "relies on an emotional response to the grandeur of features", such as vastness and irregularity, which creates "a sense of awe in the person experiencing them"; and, third, the picturesque that reconciles the two by blending "the craggy irregularity of the sublime into the smaller more intimate compass of the pastoral".[43] Although, to

a large extent, Kocken's photograph may correspond with the characteristics of the pastoral by conveying a sense of tranquility and calmness, it borders the sublime if one considers the immensity and limitlessness of the stygian sea that is vanishing into the horizon. As a result, looking at Kocken's photograph leaves the viewer uncertain about which aesthetic category can aid the interpretation of the represented scene. In other words, the traditional aesthetic categories of landscape seem to fall short of an adequate explanation for Kochen's photograph, primarily because they are all premised upon the interpretation of the landscape as a visual scene. As Brook contends, all the aforementioned categories have regularly been criticised, as they offer a "scenic conception of landscape" as something merely visual.[44] Landscape photography, however, not only is about the scenic interpretation of places, but also has a strong affinity with the temporal dimension of seeing, when a specific location is affixed to the immutable photographic frame, inviting the viewer to cease the sequence of time.

When we look at landscape art, Agamben puts forward, "we perceive a *stop in time*, as though we are suddenly thrown into a more original time. There is a stop, an interruption in the incessant flow of instants that, coming from the future, sink into the past".[45] When looking at landscape art, Agamben suggests, the temporal sequence of time seems to come to a halt, as if the beholder departs from actual time and enters into a temporal suspension. Remarking on the temporal suspension caused in the act of looking, theorist of modern art Thierry de Duve argues that it is mainly in "time exposure" photographs that the viewer experiences a halt in time.[46] In time exposure photographs (e.g. landscape, portrait and still life photos) de Duve contends that the viewer experiences a "now" that is "without any spatial attachment", since "it is not a present but a virtual availability of time in general".[47] According to de Duve, while snapshot photographs can create a tension between arriving too early to witness the event in the photograph and always being too late to experience the event in real life, time exposure photographs provide the possibility of a temporal cessation generated from the "act of looking". In other words, he puts forward that the now of time exposure is not embodied as that which one can see happening within the photograph's narrative, but remains as a potential that viewers can experience through a prolonged looking. As de Duve explains:

> The word *now*, used to describe the kind of temporality involved in time exposure, does not refer to actual time … It is to be understood as a *pause in time*, charged with a potential actualization, which will eventually be carried in the time-consuming *act of looking*.[48]

In confronting a landscape photograph, thus, one not only registers a visual scene but also experiences a pause or stop in time: a *temporal arrest* that constitutes the now of the landscape, which awaits actualisation within the elongated act of looking at the photograph.

Nevertheless, as Victor Burgin reminds us, in a long confrontation with a photographic image it "no longer receives our look, reassuring us of our founding centrality, it rather, as it were, avoids our gaze".[49] Here Burgin foregrounds two essential elements embedded in prolonged looking at photographs. First, he stresses the fact that by remaining for a long time with photographic images, such as landscape photographs, one does not merely see the image, which implies a passive registration of the scene, but rather looks at the photograph, which entails an intentional observation. Second, he suggests that due to the elongated confrontations with photographs, to a certain extent, they seem to elude our gaze; that is, they do not permit our persistent seeing to be non-judgmental about what is looked at, which is implied in the act of gazing, but, instead, they can invite us to stare at them, which implies a seeing that entails a sense of judgment. As geographer Denis Cosgrove explicates, most European languages differentiate between the passive and active usage of the sense of sight in relation to "seeing" and "looking". As he elucidates:

> The former suggests the passive and physical act of registering the external world by eye; the latter implies an intentional directing of the eyes towards an object of interest. In English, *viewing* implies a more sustained and disinterested use of the sense of sight; while *witnessing* suggests that the experience of seeing is being recorded with the intention of its verification or subsequent communication. *Gazing* entails a sustained act of seeing in which emotions is stirred in some way, while *staring* holds a similar meaning but conveys a sense of query or judgment on the part of the starer.[50]

On the one hand, looking at landscape photographs encourages the viewer to sustain his or her look at the landscape, bringing the now of the photograph to a standstill and causing the experience of a temporal suspension as the direct result of long looking. On the other hand, long looking at photographs impels the viewer to relinquish the viewing position to become a witness whose act of looking requires further verification. In doing so, elongated looking at landscape photographs invites the witness to stop uninvolved gazing and, instead, make a judgment about what is looked at; to stare at it. At this point, the close rapport between aftermath photography and the landscape genre becomes more tangible. If photographers like Kocken opt to choose a serene landscape to convey a heart-rending story, it is because looking at landscape photographs can cause an interruption in the incessant flow of instants, providing the possibility of a temporal arrest within which we are invited to witness the remnants of the past, in order to make a judgment about them. That is, if Kocken has employed the genre of landscape to convey a tragic story, it is to invite us to *look* intentionally at something long gone, to *witness* the veracity of the past laid bare by photography, and, finally, to *stare* at the photographed place with our judging eyes. By

photographing a placid seaside, therefore, Kocken does not intend to convey a scenic conception of landscape that awaits a passive registration, but instead he invites us to look, to witness and to stare at the photograph in order to inquire about the past in the temporal abeyance caused by the sustained act of looking.

All the same, in aftermath photography we are called to look tenaciously at something that inevitably evades the photographic frame, since we are invited to look at that which remains absent within the photographed place. As philosopher Jean Luc Nancy reminds us, there are essentially two types of absence in the history of representation: the first is "the absence of the thing" and the second one is "the *absence within* the thing".[51] It is the latter type of absence that pertains aptly to aftermath photography, a genre that aims to evoke the memory of the past as a dormant absence within the photograph, rendering inefficacious the viewer's attempt to assimilate and locate the absence in the frame. As West Brett notes, aftermath photographs that show a location where traumatic events took place in the past "present a tension between making visible what is absent", yet, failing to do so, they situate "the viewer at the edge of an absence".[52] That is, this genre aims to communicate a sense of absence that remains latent within the photograph, where the viewer is encouraged to look indefatigably and yet unavoidably in vain. For, irrespective of our attempt to look at, witness and stare at Kocken's photograph to understand the event that once occurred in this location, we are confronted with the event as an absence within the photographic frame. In this situation we are drawn into the tension between seeing and not seeing the event in the photographed place, where our eyes are promised something that they cannot see. For West Brett, this situation resembles an astigmatic condition: a "defect of the eye or of a lens whereby rays of light from an external point converge unequally in different meridians, thus causing imperfect vision or images".[53]

West Brett deploys an optometric term to indicate that looking at photographed places within the genre of aftermath photography does not necessarily point to any specific focal point in the photograph, as if the internal absence within the frame could be addressed directly. Instead, as she puts forward, "an astigmatic view allows for multiple view points; the focal point is not fixed and, therefore, enables different ways of seeing places of trauma that account for the viewer being excluded from the image".[54] As in the astigmatic condition, when our eyes cannot constitute a lucid vision of what they are looking at due to the unequal point of convergence of light rays, West Brett suggests that traumatic landscapes leave us with manifold focal points in the photograph, causing the beholder to remain on the periphery of the image and its reception.[55] Due to the failure in delivering the latent absence to the fore, aftermath photography makes the viewer feel excluded from the image; yet, at the same time it persistently demands that the viewer look at that which remains indiscernible within the photograph. Consequently, whereas aftermath photography utilises the landscape genre to *invite* the viewer for an active engagement in the act of looking, the elusive absence within the photograph combined with the past time of photography *excludes*

the viewer from the frame. The result of this situation, as literary theorist Ulrich Baer proposes in his book, *Spectral Evidence*, is a feeling of "nonbelonging" in the viewer.

Commenting on the vacant landscapes of German photographer Dirk Reinartz, taken in a former concentration camp (photos that also fall into the category of aftermath photography, but, indeed, with an undeniably different degree of tragedy and intensity), Baer suggests that his photographs create a simultaneous sense of exclusion and invitation in the viewer. Our knowledge that these photographs belong to the irretrievable past, he states, "excludes us from the site as powerfully as the conventions of landscape art pull us in", leading to a "sense of nonbelonging" in the viewer.[56] According to Baer, while the classic compositions of landscape painting inherited by photography create a sense of fondness for Reinartz's photographs, his landscapes also remind us "that we are excluded, that we have arrived *après coup*, too late and perhaps in vain".[57] It is because, looking at landscape photos marked by the inherent pastness of photography, the viewer knows that the photographed place and its accompanying context belong to the irrevocable past, a time to which we are always too late to respond. It is precisely the same concurrent senses of exclusion and invitation that permeate through Kocken's photographs as well. Whilst the familiar composition of the landscape genre invites us pleasingly to traverse the photograph in the act of looking, the historical context of this specific location unsettles our viewing position by reminding us that we have arrived too late to avoid the disaster. The result of this disquieting situation, Baer notes, is that "these images create in us the feeling of being addressed and responsive to the depicted site and, crucially, of seeing the site not for its own sake but as *a pointer back to our own position*".[58] In other words, he proposes that the vacant landscapes that bear the traces of traumatic events in the past *reverse* the act of looking at the photograph and create a sense of being addressed by the absence within the landscape. In this situation, therefore, it is not only the viewer who unilaterally stares at the landscape, but it is as though the landscape can point back and address the viewing position whence it is looked at.

To recapitulate, West Brett proposes that in looking at traumatic landscapes one has to adopt an astigmatic lens, a method that suggests there is no single focal point in the landscape with which the internal absence can be addressed, but multiple focal points that enable a blurred and opaque kind of vision. Baer, however, furthers this point by proposing that not only is there not a single focal point that can be addressed by the viewer, but also "the picture points back to one viewing position", as if the landscape can observe and address the viewer.[59] To be precise, Baer points out that the internal absence in traumatic landscapes essentially occludes our vision, and in so doing it enables the absence within the photograph to point back to us while we cannot point at it, evoking a feeling of being observed by a ghostly presence in the landscape. It is a situation in which one has the feeling of being addressed by that which comes from the photograph without being able to identify the source of sight in the

photograph. Derrida has called this one-sided source of sight, which comes from the photograph towards the viewer, as the "visor effect" of the medium of photography. According to Derrida, the visor effect refers to a situation when a spectral presence in the photograph, "the invisible visible" within it, addresses the viewer without any possibility of exchange. As he explains, "a visor symbolizes the situation in which I can't see who is looking at me, I can't meet the gaze of the other, whereas I am in his sight".[60] Similar to when the internal absence in traumatic landscapes points back to us without us being able to point at it, Derrida's understanding of the visor effect manifests a pure unilateral gaze that comes from the photograph towards the viewer.

As Derrida puts forward, the visor effect makes it possible to consider "the spectre" in photographs as "someone who watches or concerns me without any possible reciprocity".[61] By the spectral presence of photography Derrida refers to the irreversible temporal aspect that is embedded in each photograph: the fact that the photographed subject can address us, as in the absence within traumatic landscapes that points back to one viewing position, but we cannot reverse time and address the photographed subject or, in the case of Kocken's photograph, avoid the disaster. In photographs, Derrida puts it:

> The spectre is not simply someone we see coming back, it is someone by whom we feel ourselves watched, observed, surveyed ... it concerns me, it regards me, it addresses itself only to me at the same time that it exceeds me infinitely and universally, without me being able to exchange a glance.[62]

Although the viewer of photographs can feel a spectral presence emanating from the photo, as if it stealthily observes and watches the viewer, this ghostly existence remains infinitely out of reach, as it belongs to the irreversible past time of the photograph. Derrida's notion of the spectre in relation to photographs, therefore, refers to the temporal irreversibility caused by the pastness of photography, which constitutes a non-reciprocal gaze to which we cannot respond but, nonetheless, feel necessitated to do so. In accord with Derrida, Stiegler emphasises this point by suggesting that the "ghostly effect" of photography is essentially "the sentiment of an absolute irreversibility"; it is a situation in which the photograph "touches me, I'm touched, but I'm not able to touch". [63] For Stiegler, too, when the past time affixed in each photograph collides with the present time of its observation, it results in a feeling as if the viewer is touched by the photographed subject without being able to touch back. As Derrida and Stiegler have pointed out, the spectral presence in photographs is caused by the moment when irreconcilable temporalities clash with each other, one that refers to the present time when a photograph is looked at, and the other to the absolute irreversible past lodged in the photograph. The result of this situation is a ghostly effect that seems to address itself to the viewer of the photograph, yet at the

same time infinitely exceeds the viewer, as each photograph is inevitably marked by the irrevocable pastness of its subject.

Pertaining to Kocken's photograph, the ghostly effect refers to the temporal incongruity between being addressed by the absence within the landscape, a sense that is reinforced by the genre that invites our elongated act of looking, and the past time of photography that declares that we have arrived *après coup* and too late to avoid the unfolding of the disastrous event. Through simultaneously referring the viewer to the internal absence buried in the photograph *and*, yet, assuring the viewer that there cannot be any response to the call of this absence, hence, Kocken's photograph can constitute a non-reciprocal call that comes from the photograph towards the viewer. In other words, the spectral presence of Kocken's photograph comes into being precisely when the viewer is simultaneously pulled in by the now of the landscape and excluded from it by the temporal irreversibility of photography. As such, even though our attempt to look, to witness and to stare at the absence within Kocken's photograph may leave us in vain, they make possible, and reinforce, the spectral presence that lies on the edge of different temporalities, pointing to our viewing position without any possible reciprocity. In Nancy's words, it is when the landscape becomes "a perspective that comes to us", and not a perspective that we project onto it, manifesting the unilaterality of the visor effect of photography.[64]

At this point, having discussed the ability of aftermath photography to constitute a temporal arrest in which the spectral presence of the photograph resides, I will look further at the *direction* from which this ghostly effect originates. Although it seems that the ghostly effect of photography (as the incongruity of different temporalities) originates directly from the photograph itself, as I will further show in the case of aftermath photography, this temporal clash does not simply take place in the photograph. It is not to say that the ghostly presence does not reside in the photograph, as it is the photograph that attests to the absolute irreversibility of the past, but in this specific genre the historical context of the photographed place only *in part* originates from the photograph. While in aftermath photography the temporal discordance that creates the spectral presence is only partially in the photograph, in the case of "spirit photography" it utterly resides in the photograph. Spirit photography was an approach to photography that aimed to capture ghosts or other spiritual entities in photographs, especially common in the late nineteenth century, led by figures such as American spirit photographer William Mumler. The spirit photographers, by juxtaposing two or more photographs, attempted to induce spooky feelings within the viewer, aiming to convey the existence of ghosts and spectres in real life.[65] As theorist of photography Louis Kaplan suggests, like the invention of the telegraph that aimed to defeat temporal and spatial distances, spirit photographers aimed to tap "into the so-called fantasy of discorporation by claiming that the human soul can exist independently as a shadowy trace of its material and corporeal frame".[66] Regardless of their true or false nature, "whether they were a spiritual revelation or trickster's hoax", Kaplan notes that

spirit photographs created their "spooky effect" by blurring the ontological boundaries between empiricism and spiritualism, the living and the dead, between presence and absence.[67] As Gunning reports, by "super-imposing two or more images photographed at separated times", the spirit photographers of the nineteenth century could create eerie portraits resulting from the "encounter of two ontologically separate worlds".[68] By "ontologically separate worlds", Gunning refers to the unique time of each portrait that was combined with another photograph's temporality to yield an "incongruous juxtaposition" that evoked their ghostly effect. In this case, therefore, the ghostly effect as the incompatible clash of different temporalities took place only in the photograph, since the collision of the disparate times of each portrait would be visible in the image. In the case of aftermath photography, however, the viewer becomes aware of different temporalities only when the knowledge of the irreversible past (i.e. the historical context of the photographed place) is communicated by the photograph's caption; when, for example, Kocken's caption informs the viewer that 192 people were drowned in this specific location and can no longer be saved. As Baer notes, without an accompanying text a traumatic landscape is only "a view without context".[69]

Thus, by retaining my focus on the genre of aftermath photography and Kocken's photograph, in the following section I will further investigate the origin of the photograph's spectral presence in relation to its caption, aiming to indicate that in this particular genre the incongruous juxtaposition of different temporalities occurs not *in* but *with* the photograph.

The Temporality of the Text

In Rome, people with fine sympathetic natures stand up and weep in front of the celebrated "Beatrice Cenci the Day Before Her Execution". It shows what a label can do. If they did not know the picture, they would inspect it unmoved, and say, "Young Girl with Hay Fever; Young Girl with her Head in a Bag".[70]

—Mark Twain, *Life on the Mississippi*

The image is mute, and the text crackles with white noise.[71]

—Jean-Luc Nancy, *Distinct Oscillation*

Aiming to delineate some of the inherent characteristics of photography in the 1950s, Siegfried Kracauer pointed out that photographs aid perception by "isolating

what they present" from the rest of the world, calling this trait the "selectivity" of photographs.[72] Then he argued that the "selectivity" of photographs creates an emphatic but alienated state in the spectator, because by isolating a part of the world photographs at the same time draw attention to that which is represented in the frame, and refer to what has been excluded from it. For this reason, Kracauer argued that photographs always suggest a sense of infinity, since they always embody the fragments of the world from which they were selected, isolated and cut out, signifying that the photograph necessarily "precludes the notion of completeness".[73] That is to say, Kracauer suggested that it is precisely due to the selectivity of photographs that they can invite the viewer to imagine infinite possible relationships between the outside and what is captured in the frame and, in so doing, they encourage the spectator to perform an unrestricted interpretation of their content. In brief, he proposed that the photograph is an incomplete representation of the world that stimulates unbounded interpretation. For instance, while one person can construe a photographed place as a geological examination of the recorded location, another can interpret it as a means of estimating the real estate value of the represented property. One of the ubiquitous ways to avoid the unlimited ways of reading photographs is to label them with captions, in order to orient the spectator's attention towards a narrower way of interpreting the photograph's content.

Remarking on Atget's photographs of vacant places in Paris, taken around 1900, Benjamin said that "free-floating contemplation" was not an apt way of describing the content of these photographs, since having no caption they would refer the viewer to an infinite number of possible interpretations. According to him, Atget's photographs of deserted places in Paris indicated that "for the first time, captions have become obligatory" in the history of photography.[74] However, not only could the lack of caption in Atget's photographs promote unobstructed reflection, which may or may not have corresponded to the content of the image, but, as art theorist Rosalind Krauss has pointed out, the absence of caption in his work puts the "artistic intention" at stake, leaving it "as mute and mysterious as ever".[75] Atget's caption-less photographs, therefore, could foreground two essential features of titles in relation to photographs: first, a photograph's caption can orient the viewer's attention towards a specific channel of interpretation, inhibiting the act of looking to that of mere "free-floating contemplation"; second, a photo's caption can help the viewer comprehend the photographers' intention in taking the photos. In other words, Atget's instance indicated the dependence of photographs on captions and, thus, language for communicating the historical context they wanted to deliver to the viewer. That is why in the history of photography Atget's case stands as an early example of how language could have aided the interpretation of photographs by narrowing reflection, and how it could have led the viewer's perception towards a more accurate understanding of the artistic intention.

Nevertheless, as Burgin contends, it is not necessarily every photograph that must have a caption to indicate a bond with language or to carry a linguistic component; "even a photograph which has no actual writing on or around it is traversed by language when it is 'read' by a viewer".[76] For Burgin, there is no photograph that can be purely visual in our act of looking; therefore, what we do is utilise our previously taken-for-granted ideas of how to read the photograph as a text, so the photograph becomes "the site of a complex intertextuality". He exemplifies this point by saying that "an image which is predominantly dark in tones carries all the weight of signification that darkness has been given in social use; many of its interpretants will therefore be linguistic".[77] For instance, by simply looking at Kocken's photograph we are not only utilising our visual sensory system to understand the photo, but, in Burgin's terms, we are also "invaded by language". In that, by employing our previously acquired knowledge that a translucent sky and a calm sea conjure up adjectives such as serene, placid and tranquil, the viewer is already immersed in the realm of language through the photograph. That is why Burgin argues that even an uncaptioned photograph carries a linguistic component within it, because "in the moment it is looked at: in memory, in association, snatches of words and images continually intermingle and exchange one for the other".[78]

Although Burgin is right in proposing that each photograph is traversed by language immediately after it is looked at, in the case of aftermath photography the underlying linguistic codes in the photograph lead the viewer astray, instead of aiding the viewer to elicit the content of the image. For instance, by merely looking at Kocken's photograph without a caption we are embroiled in what Barthes called the "polysemy" of images, the fact that in each photograph coexist infinite possible meanings and signs depending on the viewer's reading of the photo. Therefore, instead of understanding the tragic story that impelled Kocken to this particular location, the viewer, who is unaware of the photograph's historical context, is inclined to read the visual quietude and aesthetic beauty of the image, thus imputing tranquillity and serenity to a woeful seascape. To be clear, without a caption, in the genre of aftermath photography, the viewer is misled rather than guided by the act of looking and, in turn, ensnared in the polysemy of images.

According to Barthes, "all images are polysemous", implying a "floating chain" of possible meanings and messages from which "the reader is able to choose some and ignore others". Each society, he notes, has developed numerous techniques "to counter the terror of uncertain signs" and the "floating chain" of meanings that each image can evoke: "the linguistic message is one of these techniques".[79] As he explains, in our modern society, which functions through mass communication, the "linguistic message" can appear "as title, caption, accompanying press title, film dialogue, comic strip balloon" and other supplemented texts.[80] Exemplifying the way in which a linguistic message can narrow the overwhelming possibility of meanings a photograph can evoke, Barthes further states that a photograph's caption "helps

me to choose *the correct level of perception*, permits me to focus not simply my gaze but also my understanding".[81] For Barthes, the linguistic message is essentially a way of channelling our understanding towards what an image is meant to communicate according to its maker; that is, it is a tool the viewer uses to eschew from solely gazing at the image, thus allowing the image to entrap the act of looking in a polysemous state. In other words, a photograph's caption prevents the viewer from being traversed and invaded by the latent linguistic codes that reside *in* the photograph, and instead it gives direction and a correct level of perception to the act of looking through the linguistic messages that are supplemented *with* the image.

Discussing the role of caption in photographs, Clive Scott states, "photography tends to strengthen our assumption that something is worth looking at only if we already know what it is". That is, only when we have a contextual knowledge of what we are looking at, given by an accompanying linguistic message. It is because, he writes, photographs "refer too pointedly and yet do not know how to name what they refer to". By acknowledging the infinity of meanings an uncaptioned photograph can suggest (or what Barthes refers to as the polysemy of photographic images) Scott further asserts that photographs are not "self-sufficient" as, "without a title, they are incoherent".[82] According to him, a photograph's caption is essentially to be understood as "an intervention, a response [of the producer] forestalling the response of the viewer".[83] Scott suggests that a photographer captions the photograph in order to take an advanced action, to curtail impertinent interpretations on the part of the viewer, inhibiting the polysemy of the image to govern the act of looking. To illustrate his point, he distinguishes between two types of caption in relation to photographs: first, "the rebus" caption, which always predetermines and affixes the meaning of the photograph according to the photographer or the person who exhibits the photograph; second, "the quotational" caption, which allows the viewer to interfere in the meaning of the photograph or to react to it, leaving space for participation and interpretation in the act of looking.[84]

With regard to aftermath photography, the caption seems to fall into the category of the rebus, because it is the photographer that firmly predetermines the significance of the represented locality, making the meaning of the photographed place impervious to any alternative interpretation. As Scott notes, a rebus caption always precedes the photograph making it "dependent on its purveyor", and consequently leaves no room for the viewer's interference in the meaning of the image.[85] This appears to be the case with Kocken's caption, in that his caption inflexibly asserts that the embodied seascape merely shows a particular place or locality wherein a disastrous event befell 192 people, precluding the viewer from reading the vista differently from the way the photographer demands. In contrast, for example, the seascapes of the Japanese photographer Hiroshi Sugimoto (fig. 9), which bear a striking resemblance to Kocken's photograph in terms of composition and angle, can foreground the use of the quotational caption.

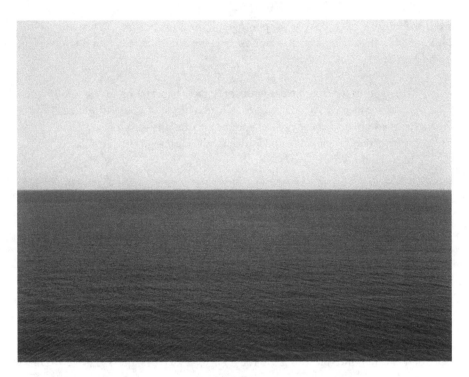

Figure 9: Hiroshi Sugimoto (1980). Caribbean Sea, Jamaica (gelatin silver print).
© Hiroshi Sugimoto / Courtesy of Gallery Koyanagi.

By captioning his photographs with only the year and the name of the displayed location (i.e. *Caribbean Sea, Jamaica, 1980*), Sugimoto permits viewers to interfere in the meaning of the photographed place, allowing them to construe the seascape according to what they ascribe to and elicit from the embodied location. In Sugimoto's case, therefore, the topographical caption simply functions as a description that invites the viewer to the further examination of the photographed place, leaving open the question of why this specific location has been photographed and not any others. In other words, while Kocken's caption precedes the photograph in order to restrict the range of possible interpretations that may transpire in the act of looking, Sugimoto's topographical caption succeeds the photograph, inviting the viewer to partake in and react to the photographed place through further elucidations. Therefore, the difference between the quotational and the rebus captions is not only about how they deliver the image's content but also *when* they instigate their work; that is, the time in which these different types of caption trigger the process of meaning-making.

As Scott suggests, a caption never refers to the time of the photograph, since it is either predetermined by the photographer, which implies that it initiates its

work before the viewer looks at the photograph, or it functions as "a reaction to" the photograph, which suggests that a caption activates after the photograph is looked at. As he puts it:

> The caption never coincides with the image, never exists in the same time: it either *precedes* the image, as it may do in a rebus—the image is called upon to encode or enigmatize the caption—or *succeeds* it, acts as a reaction [a quotational]. Consequently, meaning is itself displaced, removed from the image.[86]

Apart from their different methods of delivering the content of the photo, Scott proposes, these two types of caption make it clear that the caption is never synchronised with the photograph. That is, the caption is either anterior, as in the rebus, or posterior, as in the quotational vis-à-vis the temporality of the photograph. At this point, given the different temporal functions each of the aforementioned captions can play, a closer look at Kocken's caption can be instructive. Even though Kocken's caption abides by the category of the rebus, thereby preceding the photograph and making it dependent on its purveyor, the way the caption utilises language making it succeed the photograph and comes after it. To be exact, whereas Kocken's caption delivers the meanings that were formerly cleaved to the image by the photographer, occluding further interpretations of the image, it deploys the language of news photography and, thus, asks for the viewer's further response to the image. As film theorist Peter Wollen suggests, looking at the verb forms used in photo captions can shed light on how they supply their contents. According to him, "art photographs" are usually captioned with noun phrases that lack all verb forms to stress a state, "documentary photographs" use the progressive present to highlight actions, and "news photographs" tend to use the narrative present to highlight events.[87] Common in news titles and headlines, "the narrative present" is the employment of the simple present tense when narrating recent past events, "especially with an effect of vividness or immediacy".[88] By foregrounding the role of verb forms in photograph captions, Wollen consequently proposes that while art and documentary captions signify states and processes respectively, the caption in news photography signifies events that are allegedly contemporary with the photograph's time.[89]

Returning to Kocken's caption, by using the narrative present in a caption that resembles that of news photography (i.e. *The Herald of Free Enterprise* Capsizes *Just...*), the photographer invites the viewer to look back at the sapphire seascape as if looking at a news photograph, thus making the caption come after the image in order to solicit the viewer's reaction to the photo. That is, having read the photograph's caption reminiscent of news photography, the viewer is inclined to look at the seascape as if it displays the event that has just happened in the recent past, which thus requires immediate attention and reaction. Therefore, on the one hand, by imputing a

predetermined and seemingly rebus caption to the seascape Kocken curtails other possible interpretations and dissuades the viewer from looking further into the vista, thereby making the caption *anterior* to the image. On the other hand, by deploying the language of news photography he persuades the viewer to make further inspections of the seascape, as if they can observe the event of capsizing, thereby making the caption *posterior* to the image. This temporal tension presented by the bilateral function of the caption (i.e. being both a rebus that is predetermined and anterior to the content of the photograph *and* a quotational that is posterior and activated in the act of looking), therefore, reinforces the simultaneous invitation to, and exclusion from, the photograph. A contradictory sense that, as I have discussed before, already reigns in the realm of the image, reflecting how aftermath photography combines the temporal suspension of the landscape genre with the pastness of photography concurrently to pull in and draw out the viewer from the photographed place. As such, owing to the temporal tension caused by the bilateral function of the caption, Kocken's photograph yields to an uncanny sense of non-belonging in the viewer, a sense to which not only the image, but the text, is held as an accomplice as well. In this situation it becomes perceptible that in aftermath photography the incongruous juxtaposition of different temporalities, or the originary source of the photograph's spectral presence, does not necessarily occur *in* but *with* the photograph.

Accordingly, not only can Kocken's photograph indicate how the landscape and news photography border with each other through the aftermath genre, aiming to put the viewer in relation to the internal absence of the photograph; but also, it can manifest that, in this situation, the meaning is itself displaced and removed from the image. In other words, in the case of Kocken's photograph, the meaning resides neither inside the image nor in the text but, as Scott notes, "in their point of convergence". As he proposes, captions generally usher in the act of looking through three ways: first, *"as a destination"*, as a description of what is represented in the picture; second, *"as point of departure"*, as something non-interfering that directs the viewer "and then leaves the image to do its work"; and lastly, *"as a parallel but displaced commentary,"* set at a distance from the picture, so that the meaning is neither in the picture nor in the title, but in their point of convergence".[90] In the case of Kocken's seascape, evidently, the caption does not explain what is in the picture, nor does it function as a non-interfering element that allows the image to continue its work; for, once the caption is read and the context of the image is revealed, the text and the image split from each other, voicing different narratives. To be clear, if the image articulates a state of ataraxy conveyed by the stilly seaside, calling the viewer to gaze gratifyingly across the picture's surface, the text projects a despondent and sombre ambiance onto the photograph, precluding the act of looking to induce any pleasure in the viewer. In doing so, the text and the image countervail each other, leaving the meaning of the photographed place to be displaced and removed, wavering in between them without being located in either of them. As a result, the caption merely functions as a parallel

but displaced commentary about the photograph which, by distancing itself from the image and unsettling the photograph, signifies that the meaning is neither in the image nor in the text, but in their very spatial conjuncture. In this situation, the text and the image gain sheer equality in their collaboration, pointing to their point of convergence or, as theorist of visual culture W.J.T. Mitchell notes, to their "site of struggle", where the meaning of the photograph resides.[91]

Observing the relationship between the text and the image in photography, Mitchell argues that the "overlapping between photography and language is best understood, not as a structural matter", but as a mode of "resistance". To gain a better understanding of the nature of this resistance, he suggests that we need to know what values have motivated it.[92] That is to say, for Mitchell in photography the relationship between the text (i.e. the Barthesian linguistic message that supplements the photograph and not the linguistic codes that reside in it) and the photograph is to be understood as a kind of resistance and struggle. In order to realise the essence of this resistance, he suggests that we need to search for the underlying intentions that create the tension between the photograph and its accompanying text or, in the case of Kocken's photograph, we need to know *why* the photographer has decided to juxtapose the caption and the photograph in this particular way. To instantiate a case in photography, Mitchell discusses James Agee's and Walker Evans' photo essay called *Let Us Now Praise Famous Men*, aiming to unearth the underlying motivations and intentions that make the text and the image become a "site of struggle".[93]

In their collaborative photo essay, which was published in 1941 in the USA, the American writer, Agee, and photographer, Evans, documented the lives of impoverished sharecroppers during the Great Depression.[94] This photo essay is separated into two sections, one of which includes the uncaptioned photographs taken by Evans and the other half includes Agee's text, which gives generic descriptions about the photographs to foreground the devastating context in which they were taken. In the words of Agee, who wrote the descriptive text: "The photographs are not illustrative. They and the text are *coequal*, mutually independent, and fully collaborative".[95] As Mitchell argues, the main reason for the separation of the image and the text is that the authors intended that, as beholders, "we find ourselves drawn, as it were, into a vortex of *collaboration and resistance*" with the photographs.[96] That is, the authors have separated the text and the photographs to ask the viewer to collaborate in the image through the act of looking and, at the same time, given the disconcerting contextual background offered by the text, to remain distant and foreign from the images. Reminiscent of aftermath photography that deploys the image and the text as coequal, simultaneously to invite and exclude the viewer from the photograph, Agee and Evans utilised the text and the image as mutually dependent, in order to create a vortex of collaboration and resistance. In both cases, while the beholder is invited to participate and engage in the image through the act of looking, the disturbing contextual knowledge given by the text resists and nullifies the possibility of any collaboration, leaving the beholder in an

ethical deadlock that hinders effortless access to the photograph. As Mitchell notes, for Evans and Agee the separation of the text and the image in communicating the devastating content of the photographs "is not, then, simply a formal characteristic but an *ethical strategy,* a way of preventing easy access to the world they represent".[97]

Even though Kocken's photograph and Evans' photographs have different subjects and narratives behind them, the ways in which they utilise the text and the image to convey the photograph's content bear a resemblance to each other. That is, they both use the image as a means of invitation, collaboration and participation, and the text as a means of resistance, exclusion and nullification, constituting a vortex within which the viewer is caught in between the coequal puissances of the text and the image. With reference to Kocken's photograph, while the image encourages the viewer to look, to react and to respond to it, the text discourages the act of looking by foregrounding the poignant narrative that lingers behind the picture's surface, thereby nullifying the invitation of the seascape and excluding the viewer from the image. In doing so, the coequal but counteracting forces of the image and the text impede easy access to the unsettling content of the photograph, confronting the beholder with an ethical predicament in which the meaning ceases to be either in the image or in the text. Instead, in Nancy's words: it "oscillates distinctly between the two in a paper-thin space: recto the text, verso the image".[98]

At this point it can be said that Kocken's photograph conflates the temporal arrest of the landscape genre with the rhetoric of news photography as an ethical strategy in order to thwart easy admission to the content of the photograph, thus safeguarding the internal absence within the photographed place. What is to be conveyed in this condition, therefore, resides precisely in the cadaverous space between the photograph and its caption, which can be activated only through the elongated act of looking at the image *and* reading the text, manifesting that the ghostly effect of aftermath photography takes place not in, but in between, the text and the image. In other words, the content of Kocken's photograph is not in the image but *with* it, wavering in a "paper-thin space" in which "what Text exposes, Image posits and deposits. What Image configures, Text disfigures. What the latter envisages, the former faces down".[99] In this situation, the content of the photographed place is not simply located in the image or in the text, but exists in their site of struggle or point of convergence, oscillating unremittingly between the two in an empty space in which the beholder is held at an ethical impasse between resistance and collaboration, invitation and exclusion.

At this point, having discussed how in aftermath photography the incongruous juxtaposition of different temporalities takes place at the spatial convergence of the text and the image, I will further discuss what the implications of this spatial juncture are for the viewer, and how it can convey the content of the photograph. To recall, the content of Kocken's photograph refers not only to the locality that is visible in the image, but also to the event that had taken place in that location

which, being projected by the caption onto the frame, remains as the internal absence within the photograph. In the following section I will indicate how the spatial vortex generated by the temporal suspension of the landscape genre with the rhetoric of news photography can communicate the content of the photographed place. To this end, by retaining my focus on the aftermath genre, I will deploy several Agambenian concepts to foreground how the internal absence within the photographed place can be communicated, and what this communication, in turn, demands from the viewer. However, communication not as something that can necessarily make visible the photograph's content through the lacunary space, where the viewer faces the ethical dilemma of collaboration and resistance, but, in Agamben's words, communication as a way of making a "gesture".

The Exigency of the Photographed Place

A good photographer knows how to grasp
the eschatological nature of the gesture.

—Giorgio Agamben, *Judgment Day*

Spectrality is a form of life.

—Giorgio Agamben, *Uses & Disadvantages*

Exigency ... does not precede reality; rather, it follows it.

—Giorgio Agamben, *The Second Day*

In Agambenian philosophy, the term "gesture" refers to how a communicative act can convey something without articulating it, that is, without making the content of the communication visible. Instead of making evident the content of an expressive act, Agamben writes, a gesture "makes expression possible, precisely by establishing a central emptiness within" the communication. For Agamben, in every expressive act (e.g. presenting a photograph that aims to convey a specific content to the viewer) there is a part that is communicated as "the central emptiness within" it, which essentially remains unarticulated and impalpable in the communication. As he puts it, the term "gesture" refers to "what remains *unexpressed* in each expressive act".[100] That is to say, although the gesture resides in an expressive act that aims to

convey something, it remains as the unexpressed part of the expression, and therefore does not aim to produce or make visible the content of the communication. Instead, "what characterizes gesture is that in it nothing is being produced or acted, but rather something is being *endured* and *supported*", states Agamben.[101] That which can be endured and supported in a communication refers to the unexpressed aspect that can exist only as the central emptiness within it, as something that intrinsically resists articulation. To be clear, Agamben proposes that, although the gesture can become the vehicle of transmission for the unexpressed within an expression, it cannot produce or make visible the content of this transmission; instead, it merely functions as the carrier of the unexpressed part of the communication. That is why he argues that the term "gesture" in relation to a communicative act essentially differs from production and praxis, because,

> if producing is a means in view of an end and praxis is an end without means, the gesture then breaks with the false alternative between ends and means that paralyzes morality and presents instead means that, *as such*, evade the orbit of mediality without becoming, for this reason, ends.[102]

The gesture does not approach an end in order to produce something, as then it could manifest and make visible the content of the communication, nor does it refer to an end that does not ensue from any methods; instead, it becomes a means or a way of reaching something that never approaches an end. For Agamben, therefore, the gesture refers to pure means, whereby the unexpressed aspect of a communication can be conveyed, albeit that nothing can be produced or acted out. That is, the gesture is the possibility of presenting a means, a method, with which the unarticulated part of an expression is endured and supported, but not expressed. As Agamben succinctly puts it, the gesture is the "communication of a communicability".[103] In other words, the gesture is the very possibility of a communication in which the content can be transferred without being produced or acted out. The gesture, in short, is *"the process of making a means visible as such"*, states Agamben.[104]

Returning to Kocken's photograph, if the artist situates the viewer in an ethical impasse between the image and the text, it is not to embody or to produce the content of the photograph, but it is to draw the viewer's attention to what remains unexpressed in this communication (i.e. the very internal absence within the photographic frame). This means that, by entangling the viewer in between the act of looking at the image and reading the caption, Kocken constitutes a spatial vortex within which the central emptiness of this communication becomes palpable, but not necessarily visible, to the viewer. Having trapped the viewer in between the caption and the photo, therefore, the artist "makes a means visible as such", a method through which the content of the photograph is communicated precisely as the unexpressed within

this communication. It is when the photograph's gesture makes its first debut, as *a means of remembering* the internal absence within the photograph, as a method of conveying the unexpressed part of the communication. In this state, the viewer is not only compelled to remember the absent event (the fact that 192 were drowned in the represented location) through the caption but, through the act of looking at the photograph, the viewer also remembers that there is no way to reverse time and to save the deceased.

As Christian Metz reminds us, photography has the capacity of creating "a remembering of the dead, but a remembering as well *that they are dead*, and that life goes on for others".[105] While Kocken's caption asks the viewer to remember the people who were drowned in this particular location, due to the staff's negligence, the photograph announces that they are long dead and there cannot be any access to their world except by this very act of remembrance that implies the redemption of the dead. As art critic John Berger has pointed out, "memory implies a certain act of redemption. What is remembered has been saved from nothingness. What is forgotten has been abandoned".[106] As he further explains:

> Photographs are relics of the past, traces of what has happened. If the living take the past upon themselves, if the past becomes an integral part of the process of people making their own history, then all photographs would acquire a *living context*, they would continue to exist in time, instead of being arrested moments.[107]

As Berger suggests, photographs can obtain a "living context" only if the living do not discard the past as forgotten from their memory, and instead take responsibility for past events by remembering them through photographs. If the living consider the past not as irrevocable, but as retrievable, animated by the act of remembrance, all photographs can carry on their existences in time, signifying how photography can constitute a certain act of redemption. If Kocken decides to embroil the viewer in between the counteracting forces of the image and the text, it is not only an ethical approach that thwarts easy admission to the photograph, but also it is to preclude the past events from being easily forgotten: it is to make them indelible in the viewer's memory. That means that if Kocken's caption alone, written on a newspaper, were easily forgotten and ergo abounded into nothingness (as usually happens to the content of newspapers), the juxtaposition of the caption with the seascape has generated a living context for the photograph in which the viewer is impelled to remember, and not to easily forget the past events. To use Berger's phrase, it is this unusual juxtaposition, of the caption borrowed from news photography with a landscape genre that invites a sustained act of looking, that causes photographs to "continue to exist in time, instead of being arrested moments". Within this situation, what Derrida and Stiegler refer to as the spectral presence or the ghostly effect of the photograph, evoked by the absolute

irreversibility of time that addresses the viewer without any possible reciprocity, too, gains a living context.

As Agamben puts forward, "spectrality is a form of life", although not a life that can be lived in flesh, but "a posthumous or complementary life that begins only when everything is finished". As he proposes, there can be two types of specter, one of which is always completed in time and finished per se, and the second type that does not admit that it has reached an end, and accordingly refuses to accept its condition and completion in time. Agamben refers to the latter type as the "larval spectres". As he puts it:

> There is also another type of spectrality that we may call larval, which is born from not accepting its own condition, [but] from forgetting it so as to pretend at all costs that it still has bodily weight and flesh … While the first type of spectrality is perfect, since it no longer has anything to add to what is has said or done, the larval specters must pretend to have a future in order to clear a space for some torment from their own past, for their own incapacity to comprehend that they have, indeed, reached completion.[108]

If aftermath photography can generate a spectral presence through the incongruous juxtaposition of different times, a temporal clash that takes place at the spatial convergence of the text and the image, it falls under the category of larval spectre, as this ghostly effect can be endlessly reanimated when the photograph's content is remembered. In that, being caught in the spatial juncture between the text and the image compels the viewer to remember the unexpressed part of the photograph; in doing so it imparts a living context to what has not been articulated and made visible in this communication. This means that the photograph's content can continue to exist in time without reaching any completion, when the text is read, and the image is seen and, thus, the poignant content is remembered, when the living remember the past and redeem what has been forgotten and abandoned. Consequently, in this situation the spectral presence of the photograph is never perfect, as if it has nothing "to add to what it has said or done"; instead, it can manifest a larval spectrality that is "born from not accepting its own condition". It is as though the absentees of the photograph, all the people who were drowned in the represented locality due to the staff's negligence demand to be urgently remembered and refuse to be easily forgotten. In other words, Kocken's photograph reveals how the larval spectres of different times, lingering in the spatial vortex where the unexpressed part of the photo is communicated as a gesture, announce an *exigent* demand of remembrance of the dormant absence within the photograph.

As Agamben puts forward, "exigency consists in a relation between what is or has been, and its possibility". For it says that, although a life "has been completely

forgotten", it "remains unforgettable". Concerning Kocken's photograph, if "what is" addresses the photograph and what "has been" refers to the content the photograph aspires to express, the exigency of the photograph refers to the possibility of remembering what remains unforgettable within this representation. As Agamben further explains, "exigency does not properly concern that which has not been remembered; it concerns that which remains unforgettable. It refers to all individual or collective life that is forgotten".[109] Bearing this in mind, if Kocken juxtaposes a caption that pretends to bring news *with* a landscape that reinforces the sustained act of looking in a temporal arrest, it is to manifest the exigency of the photograph: the fact that the unarticulated central emptiness within the photograph resists being forgotten and thus cast aside. It is owing to this exigency that the larval spectres of different temporalities refuse to accept their completion, to bestow a living context on that which is not represented in the photograph. That means that, if the caption alone were to allow the viewer easily to forget the unsettling incident, and if the seascape alone were to lead the viewer to misconstrue what this particular locality is meant to convey, their uncanny admixture renders unforgettable the quiescent absence that is buried within the photograph. Therefore, by constituting a spatial juncture in which the beholder is held in between the simultaneous invitation and exclusion of the image *and* the coequal resistance and collaboration of the text, Kocken has educed the exigency of the photographed place: *the urgent demand of remembrance of, and judgment about, what remains unexpressed yet unforgettable within the photograph.*

At this point it becomes possible to argue that, if before the photographer turns a physical place into a photograph it is a matter of *agency*, when an actual place is turned into a photographed place through the aftermath genre it becomes a matter of *exigency*. As I have already discussed, before its transmutation into a photograph, a physical place can sediment the intra-active involvement of the photographer with a specific locality through the non-human elements that perfuse in between them, wherein this relational effect inspissates the agency of the place. The agency of a place is the gravitational force that propels the photographer to one specific location and not to others, indicating how actual places in the world can actively affect the beholder in a sheer inbetweenness. However, after being converted through the aftermath genre, when the actual place is embodied as an image, and its context is delivered by the text, the photographed place departs from the agency of place, and instead manifests its exigency in the photograph. The exigency of the photographed place is its urgent demand of remembrance of, and judgment about, what remains latent but nonetheless unforgettable within a particular locality. The decisive point here is that when agency marks the way in which the photographer experiences the physical world, exigency foregrounds how the spectator participates in the photographed place as an artwork.

As Agamben suggests, after Aristotle, when experiencing the world means "to have a judgment" about what one involves with, artistic representation refers to

our capacity "to judge" what has been experienced.[110] In reference to the aftermath genre, if before a physical place is turned into a photographed place it demands of the photographer *to have judgment* about a particular location, having been converted into an artistic representation it demands of the spectator *to judge* the embodied place through the photograph and its caption. In other words, if the physical place in the world encourages the beholder to see, to view and to gaze at a specific location, when it becomes its representation it demands the spectator to look at, to witness and eventually to stare at the embodied locality, so as to judge the ensuing events that took place therein via the spatial conjunction of the text and the image.

Therefore, the conversion of a physical place into a photographed place within the aftermath genre manifests how *the agency of place* in the world is translated into *the exigency of place* in the photograph, through the lacunary space where the viewer is called to remember and judge the past by means of represented particular localities. However, as I have discussed throughout this chapter, this translation does not entail the explicit communication of the photograph's content, since in that case there would not have been any unexpressed part left within the photograph. As Benjamin reminds us, "translation must in large measure refrain from wanting to communicate something, from rendering the sense", as does Kocken's translation by deploying an ethical strategy that safeguards the internal absence within this communication.[111] Instead, in relation to aftermath photography, the photographic translation of a physical place into a photographed place is rather the "communication of a communicability" through which the central emptiness of a particular locality is passed on to the viewer as a gesture. This is how the medium of photography makes a means visible as such, allowing the larval spectres of different temporalities, coming out from caption and the photograph while reaching the spectator in between them, to announce that they have not, yet, reached completion.

The judgment day, Agamben notes, is our "normal historical condition", and only our "fear of facing it creates the illusion that it is still to come".[112] To conclude this chapter, if Gert Jan Kocken has chosen to juxtapose the temporal abeyance of the landscape genre (the image) with the rhetoric of news photography (the text) to deliver the content of the photographed place, it is to inaugurate a photographic judgment day. This judgment day is *every day*, when the living take the past upon themselves, when the image is seen and the text is read, and thus the internal absence is summoned from within them, pointing back to our position beseeching for the sovenance of the unforgettable past.

Epilogue:
The Geophilosophy of Photography

Throughout this book, I have attempted to show how a geophilosophical reading of photography can shed light on the spatiotemporal account of place. A philosophical thinking about photography that propounds that places are not delimited to what they are made of, where they are located, when they come into existence or how they appear in time and space. I started my analysis from the ground level, before the act of photography begins. By reflecting on the photographer's body as a place, I demonstrated how a lived body cannot be reduced to a location or point in space, as if it had fixed geometrical boundaries. Then, looking at how the camera deals with the perceptible referent, I showed that a camera's significance cannot be limited to where it is located or what it is constituted of, but lies in its sheer mechanical automaticity that surpasses both its locale and location. Further, by concentrating on the transmissibility of photographs, I discussed that the photograph's identity is marked not only by its evolving guises and material settings, but also by its dispersive directions and indeterminate origins in the internet space. At this time, turning from the photograph's body to its surface, I discussed how the photographic image can interact with the non-visible spatial dimension that is implanted in its frame (the blind field), thus projecting an expanding spatial dimension onto its very edge. Later, I elevated my view from the ground level to subsume the spectator in the photographic act, arguing that the very transient but eternal encounter between the viewer and the photograph, promised by the vacant space of the universal spectator, can be deemed a place. Finally, through foregrounding the function of text and image in aftermath photography, I showed how this genre communicates its content to the spectator through the empty space that is located in between the photograph and its caption. In other words, through paying distinct attention to each partaker of photography in this book, I have argued how this medium accounts for the concept of place as that which resists being delimited to *where it is* (the photographer), to *what it is* (the camera), to *where it goes* (the photograph), to *what it encloses* (photographic place), to *when it transpires* (the spectator), and to *what it represents* (aftermath photography).

Thus, I have attempted to conduct a geophilosophical analysis of photography through reading each of its participants via the methodological lens of place. That is, instead of regarding indeterminacy, contingency, omnilocality, liminality and eventementality as the prerogatives of spaces, I have endowed places with such qualities, to show how photography can corroborate Casey's dictum that "place is

not the content of definite representation". Rather than viewing space as an abstract entity that continually evades representation, I have demonstrated the imperceptible, intangible and intractable aspects of each partaker of photography in order to elicit their placial dispositions. In other words, instead of analysing place through space, I have given precedence to the former in order to show how place *creates* space (the photographer), how it *fixes* space (the camera), how it *passes through* space (the photograph), how it *interpolates* space (photographic place), how it *promises* space (the spectator) and how it *operationalises* space in between the text and the image (aftermath photography). In doing so, throughout this book I have been creating a geophilosophical lexicon with which to read the photographic act, which does not simply view the act as a photographer taking a photograph with a camera. Instead, my geophilosophy of photography aspires to recognise the photographic act as: when a *lived place*, by spatiotemporally eternising the photographed subject through a *contingent place*, conduces a *placeless* and *liminal place* that provides the possibility of an *evental place* to come to pass ad infinitum, thereby turning *the agency of place* into *the exigency of place* photographically.

Acknowledgments

The germination, unfolding and completion of this book were made possible thanks to the help of several entities to whom I would like to express my gratitude. Firstly, I would like to thank Leiden University Press (LUP) and the series editors of *Media, Art, Politics,* Pepita Hasselberth and Yasco Horsman, for warmly embracing and kindly emplacing this book in their book series. Next, I am grateful to Leiden University Centre for the Arts in Society (LUCAS) for its financial support in finalising the book. I am eternally indebted to László Munteán, not only for giving me the confidence to pursue my quiescent thoughts, but also for reassuring me about the yet-to-be-knowns; for the said and the unsaid. In the same vein, I want to thank Mette Gieskes for being an assiduous teacher from whom I learned a great deal, and for being a human who intrinsically emanates hope, sincerely and incessantly. I am also grateful to Ernst van Alphen and Helen Westgeest, my dear colleagues at Leiden University: without their perceptive comments this book would not have found its place. The revisions Jamie Bruce McGrath has made to the draft of this book have been quite indispensable; he has not only proof-read this manuscript, but proved that friendship has a place outside time and space. Just before finalizing the book, Kate Elliott has also patiently and diligently annotated it with beneficial linguistic and stylistic remarks, for which I am truly thankful. With sheer appreciation, I would also like to thank Gert Jan Kocken, Hiroshi Sugimoto, Susan Collins, Joan Fontcuberta and Alan Metnick on behalf of Gary Metz, the acclaimed artists who have generously allowed me to reproduce their photographs in the book.

Last but not least, I want say a million thanks to my parents, not only for giving me abundant love and support, but also for embracing my anachronistic and idiosyncratic lifestyle: for accepting me as a vagabond soul who cannot permanently inhabit somewhere, and, precisely by doing this, for making me feel in situ in the world.

Notes

Introduction

[1] Edward S. Casey, *The Fate of Place: A Philosophical History* (Berkeley, CA: University of California Press, 1998), 286 (emphasis in original).

[2] Ibid., x.

[3] Stephen Paul Hardy, "Placiality: The Renewal of the Significance of Place in Modern Cultural Theory", *Brno Studies in English*, vol. 26, no. 1 (2013), 85-86.

[4] Casey, *The Fate of Place*, 286.

[5] Ibid.

[6] Doreen Massey, "Power-Geometry and a Progressive Sense of Place", in *Mapping the Futures: Local Cultures, Global Change*, ed. John Bird et al. (London: Routledge, 1993), 59-69; Yi-Fu Tuan, *Space and Place: The Perspective of Experience* (Minneapolis, MN: University of Minnesota Press, 1977), 6.

[7] Tim Cresswell, *Place: An Introduction,* 2nd edition (Chichester: Blackwell Publishing Ltd, 2015), 1.

[8] Casey, *The Fate of Place*, 337.

[9] Ibid., 231.

[10] For instance, Helen Westgeest et al., *Take Place: Photography and Place from Multiple Perspectives* (Amsterdam: Valiz, 2009); Donna West Brett, *Photography & Place: Seeing and Not Seeing Germany After 1945* (New York: Routledge, 2016).

[11] Edward S. Casey, *Getting Back Into Place: Towards a Renewed Understanding of the Place World* (Bloomington, IN: Indiana University Press, 2009); Jeff Malpas, *Places and Experiences: A Philosophical Topography* (Cambridge: Cambridge University Press, 1999); Dylan Trigg, *The Memory of Place: A Phenomenology of the Uncanny*, (Athens, OH: Ohio University Press, 2012).

[12] To see an overview of recent ontological attempts to read photography see Diarmuid Costello, *On Photography: A Philosophical Inquiry* (New York: Routledge, 2018).

The Photographer: A Corporeal Place in the Phenomenal World

[1] Vilém Flusser, *Towards a Philosophy of Photography,* trans. Anthony Mathews (London: Reaktion Books, 2000), 84 (originally published in German as *Für eine Philosophie der Fotografie* (1983)).

[2] Ibid., 27.

[3] John Wylie, "Landscape and Phenomenology", in *The Routledge Companion to Landscape Studies,* ed. Peter Howard et al. (New York: Routledge, 2013), 56.

[4] Hubert Damisch, "Five Notes for Phenomenology of the Photographic Image", in *The Photography Reader*, ed. Liz Wells (New York: Routledge, 2003), 87 (emphasis in original).

5 Hans Belting, *An Anthropology of Images*, trans. Thomas Dunlap (Princeton, NJ: Princeton University, 2011), 15.
6 Ibid., 28 (emphasis added).
7 Tim Cresswell. "Place", in *International Encyclopedia of Human Geography*, ed. Nigel Thrift and Rob Kitchen (Oxford: Elsevier, 2009), 173.
8 For Belting, the distinction between images and pictures is a crucial one. Images, he proposes, "may live in the work of art, but does not necessarily coincide with the work of art", and pictures are where images "may reside": Belting, *An Anthropology of Images*, 2.
9 Ibid., 37.
10 Here the word "synthesis" implies that the human body is not a passive container where images are shaped, but an active partaker in the act of perception: ibid., 38.
11 Casey, *The Fate of Place*, 213.
12 Alfred North Whitehead, *Science and the Modern World* (New York: Free Press, 1953), 91.
13 Ibid., 92.
14 Ibid., 205 (emphasis in original).
15 Tuan, *Space and Place*, 35.
16 Ibid., 37.
17 Ibid., 36.
18 Casey, *The Fate of Place*, 226.
19 Ibid., 219.
20 Edmund Husserl, *The Crisis of European Sciences and Transcendental Phenomenology*, trans. David Carr (Evanston, IL: Northwestern University Press, 1970), 217.
21 Ibid., 217 (emphasis added).
22 Casey, *The Fate of Place*, 223
23 Cresswell. "Place", 1.
24 Casey, *The Fate of Place*, 233.
25 Ibid. (emphasis added).
26 Edmund Husserl, "The World of the Living Present and the Constitution of the Surrounding World External to the Organism", in *Husserl: Shorter Works*, trans. F. A. Elliston and L Langsdorf (Notre Dame, IN: University of Notre Dame Press, 1981), 248.
27 Ibid., 250.
28 Maurice Merleau-Ponty, *Phenomenology of Perception*, trans. C. Smith (New York: Routledge, 2002), 250.
29 Ibid., 139-140 (emphasis in original).
30 Tim Ingold, *The Perception of the Environment: Essays on Livelihood, Dwelling and Skills* (London: Routledge, 2000), 173.
31 Casey, *The Fate of Place*, 293.
32 John Szarkowski, *Looking at Photographs: 100 Pictures from the Collection of the Museum of Modern Art* (New York: Graphic Society, 1976), 144.
33 Since this photograph does not have a title, I will refer to it as Metz's photograph throughout the paper. *Quaking Aspen: A Lyric Complaint*, ed. Alan Metnick and Salvatore Mancini (New York: Shadow Imaging, 2012), np.
34 Ansel Adams is believed to be associated with the so-called West Coast School, along with Wynn Bullock, Minor White, and Paul Caponigro. But Gary Metz's works, although not being officially acknowledged, fall under the aesthetics of New Topographics photographers, including Robert Adams, Frank Gohlke Nicholas Nixon, etc. The main difference between these two schools in landscape photography is the transition from "the sublime" to "the

banal" landscape. Toby Jurvoics, "Same as it Ever Was: Re-reading New Topographics", in *Reframing the New* Topographics, ed. Greg Foster-Rice (Chicago, IL: University of Chicago, 2013), 1.

[35] Gary Metz, "The Landscape as a Photograph", in *Quaking Aspen*, 114.

[36] Rob Shields, "A Guide to Urban Representation and What to Do About It: Alternative Traditions of Urban Theory", in *Re-Presenting the City: Ethnicity, Capital and Culture in the Twenty- First Century Metropolis*, ed. Anthony D. King (New York: New York University Press, 1996), 230.

[37] John Wylie, *Landscape: Key Ideas in Geography* (London: Routledge, 2007), 149.

[38] Casey, *The Fate of Place*, 293.

[39] Gaston Bachelard, *The Poetics of Space,* trans. Maria Jolas (Boston, MA: Beacon Press Book, 1994), 6 (originally published in French as *La poétique de l'espace*, 1958).

[40] Ibid., 14.

[41] ibid., 15.

[42] Gary Metz, "Quaking Space: Populus Tremuloides", in *Quaking Aspen*, 15.

[43] Bachelard, *The Poetics of Space,* 193.

[44] Ingold, *The Perception of the Environment*, 199.

[45] Casey, *The Fate of Place*, 293.

[46] Sean Cubitt, *The Practice of Light: A Genealogy of Visual Technologies from Prints to Pixels* (Cambridge, MA, and London: MIT Press, 2014), 85-86 (emphasis added).

[47] As Adams famously said, while reaching a landscape "simply look with perceptive eyes at the world around you, and trust to your own reactions and convictions. Ask yourself: Does this subject move me to feel, think and dream? Can I visualize a print—my own personal statement of what I feel and want to convey—from the subject before me". As this statement suggests, for Adams the landscape is in front of him as a picture and in his imagination as a finalised print. Cited in Harvey V. Fondiller, *The Best of Popular Photography* (New York: Watson-Guptill, 1980), 280.

[48] Belting, *An Anthropology of Images*, 60.

[49] Ibid., 46-47.

[50] Ibid., 47.

[51] David Crouch, "Landscape, Performance, and Performativity," in *The Routledge Companion to Landscape Studies,* ed. Peter Howard et al. (London and New York: Routledge, 2013), 123.

[52] Tuan, *Space and Place*, 29.

[53] Maurice Merleau-Ponty, "Eye and Mind", in *The Primacy of Perception and Other Essays on Phenomenological Psychology, the Philosophy of Art, History, and Politics,* ed. James M. Edie et al., trans. Carleton Dallery (Evanston, IL: Northwestern University Press, 1964), 163.

[54] Tuan, *Space and Place*, 28.

[55] Merleau-Ponty, *Phenomenology of Perception*, 116 (emphasis in original).

[56] Unlike in Adams' photograph where, due to the central and elevated perspective, one can say that the mountain is *on* the earth, in Metz' photograph, thanks to the equal attention to the natural and man-made materiality of the world, none of the photographed objects gains superiority over the other ones. For instance, for the flattened and democratic view in the photo, one could even say that the tree in the centre is *on* the mountain in the background.

[57] Leo Stein, *The A-B-C of Aesthetics* (New York: Boni and Liveright, 1927), 44 (emphasis added).

58 Bill Brown, "Thing Theory", *Critical Inquiry*, vol. 28, no. 1, Things (Autumn 2001), 5.

59 Crouch, "Landscape, Performance", 122-123.

60 Jacques Rancière, "Notes on the Photographic Image", in *The Visual Culture Reader*, ed. Nicholas Mirzoeff (New York: Routledge, 2013), 95.

61 Ibid., 94.

62 Jacques Rancière, *The Politics of Aesthetics*, trans. Gabriel Rockhill (New York: Continuum, 2011), 23-24.

63 Ibid., 22-23 (emphasis added).

64 Ibid., 23.

65 Ibid., 22 (emphasis added).

66 Ibid., 34.

67 Ibid., 32.

68 Jacques Derrida, *Copy, Archive, Signature: A Conversation on Photography*, trans. Jeff Fort (Stanford, CA: Stanford University Press, 2010), 43 (emphasis in original) (originally published in German in 2000 under the title "Die Photographie als Kopie, Archiv und Signatur" in *Theorie der Fotografie* IV, 1980-1995).

69 Derrida, *Copy, Archive, Signature*, 44.

70 Jacques Rancière, *The Future of the Image*, trans. Gregory Elliott (London: Verso, 2009), 48.

71 Ibid., 46.

72 Ibid., 47 (emphasis in original).

73 Cubitt, *The Practice of Light*, 94.

74 Derrida, *Copy Archive, Signature*, 43.

75 Vilém Flusser, *Towards a Philosophy*, 27.

The Camera: A Place That Spatialises Time and Temporalises Space

1 The so-called "cameraless photography" refers to the practice of manipulating light-sensitive photographic papers with only chemical materials and without using a camera, thus producing photographic images without the use of a camera. Therefore, it is not always true that the camera is a necessary element in the process of image production, but it is undoubtedly the camera that proclaims that the photographic image is never discovered in the world, in the same way that an archaeologist discovers an artefact from the past.

2 Damisch, "Notes for Phenomenology", 88.

3 Nigel Thrift, "Space: The Fundamental Stuff of Geography", in *Key Concepts in Geography*, ed. Nicholas J. Clifford (Trowbridge: Sage, 2009), 102.

4 Susan Sontag, *On Photography* (London: Penguin Book, 1977), 15 (emphasis added).

5 Flusser, *Towards a Philosophy*, 26-27.

6 André Bazin, "Ontology of the Photographic Image", in *What is Cinema?*, trans. Hugh Gray (Berkeley and Los Angeles, CA: University of California Press, 1967) (originally published in French under the title *Qu'est-ce que le cinema?*, in four volumes between 1958 and 1962).

7 Bazin, "Ontology of the Photographic", 13.

8 Ibid., 14-15.

9 Stanley Cavell, *The World Viewed: Reflections on the Ontology of Film* (Cambridge, MA: Harvard University Press, 1979), 20.

[10] Bazin, "Ontology of the Photographic", 7 (emphasis added)

[11] Ibid., 9.

[12] Walter Benjamin, "A Small History of Photography," in *One-Way Street and Other Writings*, trans. E. Jephcott and K. Shorter (London: Lowe and Brydone, 1979), 243 (originally published in German in 1931under the title "Kleine Geschichte der Photographie").

[13] Bazin, "Ontology of the Photographic", 12.

[14] Walter Benjamin, "The Work of Art in the Age of Its Mechanical Reproduction", in *Illuminations*, trans. Harry Zohn, ed. Hannah Arendt (New York: Schocken Books, 2007), 233 (originally published in German in 1935 under the title *Das Kunstwerk im Zeitalter seiner Technischen Reproduzierbarkeit*).

[15] Christian Metz, "Photography and Fetish", in *The Photography Reader*, ed. Liz Wells (New York: Routledge, 2003), 143.

[16] Ibid., 140-141 (emphasis in original).

[17] Ibid., 141 (emphasis added).

[18] Flusser, *Towards a Philosophy*, 23.

[19] Ibid., 25.

[20] Ibid., 28.

[21] Ibid., 21.

[22] As William J. Mitchell put forward in his book, *The Reconfigured Eye*, the shift from analogue to digital photography was a transition from a photographic era to a "post-photographic era" which, according to him, challenges our "ontological distinction between the imaginary and the real". Although the photographic image has undergone a significant change since its digitisation, the way in which digital cameras interfere with space and time has remained similar to that of analogue cameras. That is, they both cut off the space to which they are exposed and preserve the time at which the photo is being taken. Sean Cubitt offers an extensive study of the historical evolution of digital cameras, noting that although their technology has been evolving through the ages, what has remained the same in cameras is their rigid automaticity and mechanical structure in dealing with space and time: Sean Cubitt, *The Practice of Light: A Genealogy of Visual Technologies from Prints to Pixels* (Cambridge, MA, and London: MIT Press, 2014). William J. Mitchell, *The Reconfigured Eye* (Cambridge, MA: MIT Press, 1992), 225.

[23] Susan Collins, "Unfolding Time: Landscape, Seascape and the Aesthetics of Transmission", in *Spatialities*, ed. Judith Rug and Craig Martin (Chicago, IL: The University of Chicago Press, 2012), 11-25.

[24] Flusser, *Towards a Philosophy*, 47.

[25] Joanna Zylinska, *Nonhuman Photography* (London: The MIT Press, 2017), 69.

[26] Flusser, *Towards a Philosophy*, 21.

[27] Ibid., 25.

[28] Derrida, *Copy, Archive, Signature*, 12.

[29] Ibid. (emphasis in original).

[30] Ibid.

[31] Flusser, *Towards a Philosophy*, 74.

[32] Derrida, *Copy, Archive, Signature*, 9 (emphasis added).

[33] While some of these unidentifiable pixels are suggestive of a stray of pixels connected to each other by their similarity of colour (e.g. the white lines on the sea surface), others simply show an individual pixel differentiated from the others around it, such as the black dot-like pixels.

34 Collins, "Unfolding Time", 22-24.

35 Tom Gunning, "What's the Point of an Index? Or, Faking Photographs", *Nordicom Review* 25, no.1-2 (2004), 47.

36 In the history of photography there has been an ongoing debate about whether the photographic image can be deemed a sign for the reality it represents, particularly whether it is an iconic or indexical sign. If the indexical sign implies that the photo has a causal relationship to its referent (e.g. smoke being an index of fire), the iconic sign suggests that the photograph conveys what it represents only by means of imitation and likeness, (e.g. a painting of fire being an icon of real fire). However, as Gunning argues, indexicality and iconicity of photographs have always been intertwined, since our evaluation of a photograph as accurate depended not only on its indexical basis, but also "on our recognition of it as looking like its subject". Therefore, he contends the "the photograph exceeds the function of a sign" precisely because its "truth value" always depends on its "visual accuracy" (indexicality) to the same extent as it does on its "recognisability" (iconicity): Gunning, "Point of an Index?", 41-48. In his article "Photographs and Fossils", literary theorist Walter Benn Michaels offers a similar critique of seeing the photograph merely as a sign, by arguing that the indexicality of photographs is not a one-to-one relation with the reality they represent, but it is rather "the bypassing of the artist's intentionality": Walter Benn Michaels, "Photography and Fossils", in *Photography Theory: The Art Seminar*, ed. James Elkins (New York: Routledge, 2007), 441.

37 Gunning, "Point of an Index", 46.

38 Cavell, *The World Viewed*, 22 (emphasis in original).

39 Ibid.

40 Siegfried Kracauer, "Photography," in *The Past's Threshold: Essays on Photography*, ed. Philippe Despoix and Maria Zinfert, trans. Conor Joyce (Berlin: Diaphanes, 2014), 34 (originally published in German in 1927 as an essay in *Frankurter Zeitung*).

41 Ibid., 33.

42 Ibid., 37 (emphasis added).

43 Gunning, "Point of an Index", 46.

44 Roland Barthes, *Camera Lucida*, trans. Richard Howard (London: Vintage Books, 2000), 80 (originally published in French in 1980 under the title *La Chambre Claire*).

45 Ibid., 76 (emphasis in original).

46 Ibid., 77.

47 Barthes, *Camera Lucida*, 77.

48 John Lechte, *Genealogy and Ontology of the Western Image* (New York: Routledge, 2012), 128 (emphasis in original).

49 Barthes, *Camera Lucida*, 96.

50 Geoffrey Batchen, *Photography Degree Zero. Reflections on Roland Barthes's Camera Lucida* (Cambridge, MA: MIT Press, 2009), 266.

51 Barthes, *Camera Lucida*, 96.

52 Bernard Stiegler, *Technics and Time 2: Disorientation*, trans. Stephan Barker (Stanford, CA: Stanford University Press, 2009), 19.

53 Lechte, *Genealogy and Ontology*, 127.

54 Barthes, *Camera Lucida*, 23.

55 Ibid., 27-28 (emphasis in original).

56 Ibid., 26-27.

57 Ibid., 51.

58 As art critic Michael Fried has argued, the punctum of detail cannot be perceived by the photographer at the moment the photograph is taken because it belongs to the domain of the photographed thing; thus it can be recognised as the punctum of detail only by the viewer. Here it should be mentioned that, whereas Fried notes that digitisation undermines the punctum of detail since it reduces the unnoticed details captured in photos, historian James Elkins argues that even completely digitally constructed photographs can still bear some accidental features within their frame. Therefore, irrespective of its analogue or digital origin, the punctum of detail is that which remains accidental, incompatible and disparate in the domain of the photographed thing, and can be recognised only by the viewer as that which remains other in the frame: Michael Fried, *Why Photography Matters as Art as Never Before* (New Haven, CT: Yale University Press, 2008), 104; James Elkins, "Critical Response: What Do We Want Photography to Be? A Response to Michael Fried", *Critical Inquiry,* vol. 31, no. 4 (Summer 2015), 947.

59 Jacques Derrida, "The Deaths of Roland Barthes", in *The Work of Mourning,* ed. Pascale-Anne Brault and Michael Naas (Chicago, IL, and London: University of Chicago Press, 2001), 39.

60 Ibid., 39 (emphasis added).

61 Ibid., 41.

62 Roland Barthes, *Camera Lucida,* 27-28.

63 Jacques Derrida, "The Deaths of Roland Barthes", 58.

64 Ibid., 42.

65 In music theory the term "contrapuntal motion" refers to the movement of two melodic lines in parallel to each other while they maintain their independence. Derrida suggests that the two notions of S/P, too, should be conceived as two independent melodies that, although remaining independent of each other, coalesce into a whole: Derrida, "The Deaths of Roland Barthes", 42.

66 Rancière, *The Future of the Image,* 11.

67 Ibid. (emphasis added).

68 Derrida, "The Deaths of Roland Barthes", 53 (emphasis added).

69 Roland Barthes, *Camera Lucida,* 5-6.

70 Derrida, "The Deaths of Roland Barthes", 57.

71 Ibid., 49.

72 Jacques Derrida, *Right of Inspection,* trans. David Wills (New York: Monacelli Press, 1998), np.

73 Geoffrey Batchen, *Each Wild Idea: Writing, Photography, History* (Cambridge, MA: MIT press, 2000), 106.

The Photograph: A Place That Lacks Its Own Emplacement

1 Batchen, *Each Wild Idea,* 74.

2 Ibid., 140 (emphasis added).

3 Eduardo Cadava, "The Itinerant Languages of Photography", in *The Itinerant Languages of Photography* ed. E. Cadava and G. Nouzeilles (Princeton, NJ: Princeton University Press, 2013), 25.

4 Flusser, *Towards a Philosophy,* 49.

5 Cresswell. "Place", 2.
6 Ibid. (emphasis added).
7 Malpas, *Places and Experiences*, 35-36.
8 Allan Pred, "Place as Historically Contingent Process: Structuration and the Time-Geography of Becoming Places", *Annals of the Association of American Geographers*, vol. 74, no.2 (1984), 279.
9 Ibid., 281-282.
10 Flusser, *Towards a Philosophy*, 49.
11 Allan Sekula, "On the Invention of Photographic Meaning", in *Thinking Photography*, ed. Victor Burgin (London: Macmillan Press, 1982), 84-85 (first published as an essay in 1974).
12 Ibid., 90 (emphasis in original).
13 Benjamin, "The Work of Art", 220.
14 However, Benjamin argues that the "cult value" has never been completely eradicated. Because, for example, even the mass-produced photographs can gain "the cult of remembrance of loved ones, absent or dead" offering "a last refuge for the cult value of the picture": ibid., 225-226.
15 Ibid., 221.
16 Ibid., 218.
17 Sekula, "Invention of Photographic", 90.
18 Eduardo Cadava, "Theses on the Photography of History," *Diacritics*, vol. 22, no. 3/4 Commemorating Walter Benjamin (Autumn-Winter, 1992), 96 (emphasis added).
19 Gabriela Nouzeilles, "The Archival Paradox", in *The Itinerant Languages of Photography*, ed. Eduardo Cadava and Gabriela Nouzeilles (Princeton, NJ: Princeton University Press, 2013), 41.
20 Ibid., 41 (emphasis added).
21 Ibid., 38.
22 Batchen, *Each Wild Idea*, 60.
23 Ibid., 114.
24 Casey, *The Fate of Place*, 287.
25 Flusser., *Towards a Philosophy*, 56.
26 Such an understanding of the photograph, as something that is continually affected and affecting, has been given substantial attention in the works of historical anthropologist Elizabeth Edwards, for whom photographs are essentially unfinished because their meaning and value are continually being altered through our multisensorial engagement with them. In several perceptive publications Edwards examines the importance of material practice in anthropological understanding of photography, such as: Elizabeth Edwards, "Photography and the Material Performance of the Past", *History and Theory*, issue 48 (2009), 130-150; Elizabeth Edwards, "Objects of Affect: Photography Beyond the Image", *Annual Review of Anthropology*, vol. 41 (2012), 221-234; Elizabeth Edwards, "Anthropology and Photography: A Long History of Knowledge and Affect", *Photographies*, vol. 8, no. 3 (2015), 235-252.
27 Cadava, "The Itinerant languages", 36.
28 "Archive Noise", Zabriskie Gallery, available at: http://www.zabriskiegallery.com/, accessed 17 April 2016.

29 For instance, among these iconic images was the photograph of the torture scandal in the Abu Gharib prison in Baghdad. It should be said that the artist's choice of iconic images refers to the photographs that had been widely disseminated and discussed throughout the history of photography.

30 "Googlegram: Niépce", Metropolitan Museum of Art, available at: https://www.metmuseum.org/art/collection/search/302283?exhibitionId=%7B2e988323-b8df-496f-b72ae999e567faba%7D&oid=302283, accessed 17 April 2016.

31 Cadava, "The Itinerant Languages", 27.

32 Taken in 1826, Niépce's photograph was moved to London in 1827 where Niépce met Daguerre. Later in 1898, it was exhibited at the Crystal Palace Photographic exhibition in London. Subsequently, it was moved to the Gernsheim Collection at the Ransom Centre at the University of Texas, USA, where the photograph is being preserved today: Cadava, "The Itinerant languages", 27-28.

33 Ibid., 26 (emphasis added).

34 Comparing photographs to the structure of myth, in several instances in *Camera Lucida* Barthes notes that one of the primary functions of photographs is to serve as alibis for photographers: *Camera Lucida*, 28 & 32.

35 Roland Barthes, *Mythologies*, trans. Jonathan Cape (New York: The Noonday Press, 1991), 122.

36 Ibid., 122.

37 Michel Foucault, "Different Spaces", in *Aesthetics, Method, and Epistemology*, ed. James D. Faubion, trans. Robert Hurley et al. (New York: The New Press, 1998), 178.

38 Ibid., 179-184.

39 Ibid., 184-185.

40 Flusser, *Towards a Philosophy*, 51.

41 Ibid., 50.

42 Gilles Deleuze and Félix Guattari, *A Thousand Plateaus: Capitalism and Schizophrenia*, trans. Brian Massumi (Minneapolis, MN: University of Minnesota Press, 2005), 362-370 (emphasis in original)(originally published in 1980 under the title Mille plateaux: Capitalisme et Schizophrénie).

43 Ibid., 370 (emphasis in original).

44 Ibid., 361-364.

45 Ibid., 371.

46 Ibid., 482.

47 Mark Nunes, "Virtual Topographies: Smooth and Striated Cyberspace", in *Cyberspace Textuality: Computer Technology and Literary Theory*, ed. Marie-Laure Ryan (Indianapolis, IN: Indiana University Press, 1999), 61-63

48 Ibid., note 1 (emphasis added).

49 Casey, *The Fate of Place*, 305.

50 Ibid., 304 (emphasis added).

51 Vilém Flusser, "The Photograph as Post-Industrial Object: An Essay on the Ontological Standing of Photographs", *Leonardo* vol. 19, no. 4 (October 1986), 330 (emphasis added).

Photographic Place: Looking at the Photographic Image from Its Edge

1 Thrift, "The Fundamental Stuff", 100.

2 Tim Cresswell, *In Place, Out of Place: Geography, Ideology, and Transgression* (Minneapolis, MN: Minnesota Press, 1996), 150.

3 Tuan, *Space and Place,* 12.

4 Ernst Gombrich, *Art and Illusion* (New York: Pantheon Books,1960), 254. Moreover, American philosopher Nelson Goodman gives a comprehensive account of the way in which perspectival conventions influence our way of seeing in *Languages of Art*. He argues that any pictures in perspective, like photographs, "have to be read; and the ability to read has to be acquired": Nelson Goodman, *Languages of Art: An Approach to a Theory of Symbols* (New York: The Bobbs-Merrill Company, 1968), 14.

5 The transparency discussion of photography, mainly advocated by the American art critic Clement Greenberg, suggests that photography is "the most transparent of the art mediums devised or discovered by man", since it can "put all emphasis on an explicit subject". However, as Ernst Gombrich and Nelson Goodman have argued among others, one way to undermine the transparency discussion is to acknowledge that photographic images are constructed according to the laws of perspective, a convention that is imposed by the camera and has to be learned by the viewer: Clement Greenberg, "The Camera's Glass Eye", *The Nation*, no, 162 (1946), 294-296.

6 Sontag, *On Photography*, 22 (emphasis added).

7 Edward S. Casey, "The Edge(s) of Landscape: A Study in Liminology", in *The Place of Landscape: Concept, Context, Studies,* ed. Jeff Malpas (Cambridge, MA: MIT eBook Collection, The MIT Press, 2011), 91.

8 Joel Snyder and Neil Walsh Allen, "Photography, Vision and Representation", *Critical Inquiry* vol. 2, no. 1 (Autumn, 1975), 149.

9 Victor Burgin, "Looking at Photographs", in *The Photography Reader*, ed. by Liz Wells (New York: Routledge, 2003), 133.

10 Cited in Benjamin, "A Small History of Photography", 249.

11 Szarkowski, *Looking at Photographs*, 100.

12 Snyder and Walsh Allen, "Vision and Representation", 154.

13 Although Porter applies both terms in relation to the photographic frame, the centripetal composition applies more aptly to the painterly frame; because, being a conception of the world, a painting, unless in exceptional cases, rarely refers to what has been left out of its frame: Eliot Porter, *Intimate Landscapes: Photographs by Eliot Porter* (New York: The Metropolitan Museum of Art, 1979), 11.

14 Cavell, *The World Viewed*, 24 (emphasis in original).

15 Although it is usually true that the photographic frame, with less effort than the painterly frame, motivates the viewer to envisage what would be located next to the photographed subject in the world, thus becoming an image *of* the world, it is not always the case. For instance, in the genre of "photorealism" that began in the late 1960s, in which an artist attempts to reproduce a painting based on a photograph and as realistically as possible, the painterly frame can also motivate the viewer to imagine what would lie next to the painted subject in the world, as in the work of John Baeder, Ralph Goings and Chuck Close. A comprehensive documentation of photorealism movement is given by Louis K Meisel and Linda Chase in *Photorealism at the Millennium* (New York: Abrams Books, 2002).

16 Clive Scott, *The Spoken Image: Photography and Language* (London: Reaktion Books Ltd, 1999), 180.

17 Ibid., 39.

18 Ibid., 26.

19 Ibid.,107.

20 In staged photography, rather than capturing a precise moment in real life, the artist make specific choices when artificially constructing the desired scene. By consciously arranging compositions and placing elements in the frame, staging photographers become the directors of their photographs. Although staged compositions became well-known in the 1980s through the work of Cindy Sherman, Jeff Wall and Gregory Crewdson, its origin can be found in "tableau photographs" that have been created since the beginning of photography. For instance, nineteenth-century photographers, such as Oscar Gustav Rejlander and Henry Peach Robinson, made staged photographs based on classical and biblical stories. Marta Weiss, Karen Henry and Ann Thomas, *Acting the Part: Photography as Theatre: A History of Staged Photography,* ed. Lori Pauli (London and New York: Merrell, 2006).

21 Hilde Van Gelder and Helen Westgeest, *Photography Theory: In Historical Perspective: Case Studies from Contemporary Art* (Chichester: Wiley-Blackwell, 2011), 115-117.

22 Joan Fontcuberta and Geoffrey Batchen, *Landscape Without Memory* (New York: Aperture, 2005).

23 Scott, *The Spoken Image*, 180.

24 Metz, "Photography and Fetish", 140-143.

25 Ibid. (emphasis added).

26 Clive Scott, *The Spoken Image*, 180.

27 Metz, "Photography and Fetish", 143.

28 Flusser, "Post-Industrial Object", 291.

29 While the narrow-angle camera could peer into space from several kilometres away to capture the surfaces of the comet, the wide angle camera was intended to capture wide-angle views when the spacecraft was planned to land on the comet: "Rosetta's OSIRIS Camera Instrument", Planetary, available at: http://www.planetary.org/explore/resource-library/data/rosetta-osiris.html, accessed 2 March 2017.

30 "Rosetta Mission", ESA, available at: http://rosetta.esa.int/, accessed 2 March 2017.

31 "OSIRIS Image of the Day", Planet Gate, available at: https://planetgate.mps.mpg.de/Image_of_the_Day/public/OSIRIS_IofD_2016-07-14.html, accessed 20 July 2020.

32 Casey, "The Edge(s) of Landscape", 94 (emphasis in original).

33 Filip Mattens, "The Aesthetics of Space: Modern Architecture and Photography", *The Journal of Aesthetics and Art Criticism* 69, no.1, special issue: The Aesthetics of Architecture: Philosophical investigation into the Art of Building (winter 2011), 112 (emphasis in original).

34 Ibid., 112-113.

35 Patrick Maynard, "Scales of Space and Time in Photography", in *Photography and Philosophy: Essays on the Pencil of Nature,* ed. Scott Walden (Hong Kong: Wiley-Blackwell, 2010), 191.

36 Goodman, *Languages of Art*, 15.

37 Jean Baudrillard, *The Perfect Crime*, trans. Chris Turner (London & New York: Verso, 1996), 58.

[38] Jean Baudrillard and Sophie Calle, *Please follow me: Suite venitienne,* trans. Dany Barash and Danny Hatfield (Seattle, WA: Bay Press, 1988), 86.

[39] Baudrillard, *The Perfect Crime,* 58 (emphasis in original).

[40] Ibid.

[41] "A Bigger, Clearer Picture," Hubble Site, available at: http://hubblesite.org/the_telescope/ nuts_.and._bolts/instruments/acs/#top, accessed 9 March 2017.

[42] "Hubble's High-Definition Panoramic View of the Andromeda Galaxy", available at: https://www.nasa.gov/content/goddard/hubble-s-high-definition-panoramic-view-of-the-andromeda-galaxy, accessed 15 March 2017.

[43] This photograph contains 1.5 billion pixels. Because of its tremendously large size, NASA has provided a zoom tool with which we can peer into every single detail of space that is captured in this image: "Sharpest ever View of the Andromeda Galaxy", Space Telescope, available at: https://www.spacetelescope.org/images/heic1502a/, accessed 2 March 2017.

[44] Yi-Fu Tuan, *Segmented World and Self* (Minneapolis, MN: University of Minnesota Press, 1982), 118.

[45] Casey, "The Edge(s) of Landscape", 94.

[46] To have access to the full size of the image, see "Sharpest ever view of the Andromeda Galaxy," Space Telescope.

[47] Snyder and Walsh Allen, "Vision and Representation", 271.

[48] Ibid., 271-272 (emphasis in original).

[49] Siegfried Kracauer, "Photographed Berlin", in *The Past's Threshold: Essays on Photography,* ed. Philippe Despoix and Maria Zinfert, trans. Conor Joyce (Zurich: diaphanes, 2014), 56 (emphasis added).

[50] Henry Bergson, *Matter and Memory,* trans. Nancy Margaret Paul and W. Scott Palmer (New York: Zone Books: 1991), 102-103 (emphasis in original).

[51] Ibid., 34.

[52] Cavell, *The World Viewed,* 24 (emphasis in original).

[53] Casey, "The Edge(s) of Landscape", 94.

[54] Ibid., 95.

[55] Edward S. Casey, "Keeping Art to its Edge", *Journal of Theoretical Humanities* 9, no.2 (August 2004), 147 (emphasis added).

[56] Following this argument, I also would like to suggest that while a photographic frame functions as a boundary, a painterly frame functions as a border, since, as I have discussed before, a painting is a world in and of itself, which is existentially separated from its origin.

[57] John Tagg, *The Disciplinary Frame: The Photographic Truths and the Capture of Meaning* (Minneapolis, MN: University of Minnesota Press, 2009), 246 (emphasis added).

[58] Edward S. Casey, "Edges and the In-between", *PhaenEX: Journal of Existence and Phenomenological Theory and Culture,* no. 2 (2008), 3.

[59] Jacques Derrida, *The Truth in Painting,* trans. Geoff Bennington and Ian Macleod (Chicago, IL, and London: The University of Chicago Press, 1987), 63.

[60] Ibid., 63.

[61] Ibid., 75.

[62] Ibid., 61.

[63] Ibid., 73.

[64] Jeff Malpas, "The Threshold of the World", in *Funktionen des Lebendigen,* ed. Thiemo Breyer and Oliver Müller (Berlin: De Gruyter, 2016), 161-162 (emphasis in original).

[65] Ibid., 167.

66 Derrida, *The Truth in Painting*, 79.
67 Casey, "The Edge(s) of Landscape", 101.
68 Ariella Azoulay, *Civil Imagination: A Political Ontology of Photography*, trans. Louise Bethlehem (London: Verso Books, 2015), 23.

The Spectator: A Place That Is Sempiternally Taking Place

1 Barthes, *Camera Lucida*, 9.
2 Ariella Azoulay, "What is a Photograph? What is Photography?", *Philosophy of Photography* vol. 1, no. 1 (2010), 11.
3 Ariella Azoulay, *The Civil Contract of Photography*, trans. Rela Mazeli and Ruvik Daieli (New York: Zone Books, 2008), 14 (emphasis added).
4 Cresswell. "Place", 1.
5 Ibid., 2.
6 Charles W.J. Withers, "Place and the 'Spatial Turn' in Geography and in History", *Journal of the History of Ideas*, vol. 70, no. 4 (October, 2009), 653.
7 Ibid., 649.
8 Ibid., 652.
9 Ibid., 653 (emphasis in original).
10 Edward Relph, *Place and Placenessness* (London: Pion, 2008), 43.
11 Cresswell, "Place", 1.
12 Ibid., 9.
13 Andrew Merrifield, "Place and Space: A Lefebvrian Reconciliation", in *Transactions of the Institute of British Geographers,* new series 18, No. 4 (1993), 521.
14 Ibid., 520.
15 Ibid., 527.
16 Ibid., 520.
17 Ibid., 521 (emphasis in original).
18 Tuan, *Space and Place*, 6.
19 Merrifield, "Place and Space", 522 (emphasis in original).
20 Ash Amin and Nigel Thrift, *Cities: Reimagining the Urban* (Cambridge: Polity, 2002), 30.
21 Ibid., 29-30 (emphasis in original, except for the words "variable events").
22 Azoulay, "What is a Photograph?", 12.
23 Azoulay, *Civil Imagination*, 19-21.
24 Azoulay, "What is a Photograph?", 13.
25 Azoulay, *Civil Imagination*, 26.
26 Azoulay, *The Civil Contract*, 23.
27 Azoulay, *Civil Imagination*, 20.
28 Ibid., 23.
29 Ibid., 23.
30 Ibid., 22.
31 Azoulay, "What is a Photograph?", 12 (emphasis added).
32 Slavoj Žižek, *Event: Philosophy in Transient* (London: Penguin, 2014), 3 and& 113. Ibid., 2.
33 Ibid., 150 (emphasis in original).
34 Ibid., 2.

35 Eduardo Cadava, "Lapsus Imaginis: The Image in Ruins", *October* 96 (Spring, 2001), 49-50.
36 Eduardo Cadava, *Words of Light: Theses on the Photography of History* (Chichester: Princeton University Press, 1997), 61 (emphasis in original).
37 Ibid., 60.
38 Jean-Luc Nancy, *Being Singular Plural*, trans. Robert D. Richardson and Anne E. O'Byrne (Stanford, CA: Stanford University Press, 2000), 168.
39 Nancy, *"The Surprise of the Event"*, 175.
40 Ibid., 167.
41 Alain Badiou, *Being and Event*, trans. Olivier Feltham (New York: Continuum, 2007), 68 (originally published in French in 1988).
42 Alain Badiou, *Philosophy and the Event*, trans. Louise Burchill (Cambridge: Polity Press, 2014), 42 (originally published in French in 2010).
43 Ibid., 42, 9, 10.
44 Ibid., 9.
45 Ibid., 42.
46 Fabien Tarby, "Short Introduction to Alain Badiou's Philosophy", in *Philosophy and the Event*, trans. Louise Burchill (Cambridge: Polity Press, 2014), 142.
47 Quentin Meillassoux, "History and Event in Alain Badiou", *Parrhesia*, no. 2 (2011), 2 (emphasis in original).
48 Ibid., 9.
49 Badiou, *Being and Event*, 175.
50 Ibid., 176 (emphasis in original).
51 Ibid., 179.
52 Ibid., 181, 206, 178 (emphasis added).
53 Azoulay, *Civil Imagination*, 26.
54 Kracauer, "Photography", 43.
55 Casey, *The Fate of Place*, 211.
56 Ibid., 212.
57 Azoulay, *The Civil Contract*, 390.
58 Ibid., 391.
59 Ibid., 20-22.
60 Ibid., 28.
61 Azoulay, *The Civil Contract*, 391 (emphasis added).
62 "The Story Behind the 'Napalm Girl' Photo Censored by Facebook", TIME, available at: http://time.com/4485344/napalm-girl-war-photo-facebook/, accessed 21 August 2017.
63 Gerhard Richter, "Between Translation and Invention", in Jacques Derrida, *Copy, Archive, Signature: A Conversation on Photography*, trans. J Fort, ed. Gerhard Richter (Stanford, CA; Stanford University Press, 2010), xxiv (emphasis added).
64 Azoulay, *Civil Imagination*, 27.
65 Amin and Thrift, *Cities*, 30; Merrifield, "Place and Space", 522.
66 Casey, *The Fate of Place*, 339 (emphasis in original).
67 Ibid., 336.
68 Ibid., 232.
69 Ibid., 337.
70 Nancy, *"The Surprise of the Event"*, 173.
71 David Bate, *Photography: The Key Concepts* (Oxford and New York: Berg Publishers, 2009), 16.

The Genre: The Aftermath of Place

[1] John Szarkowski, "Introduction to The Photographer's Eye", in *The Photography Reader*, ed. Liz Wells (New York, Routledge, 2003), 97.

[2] West Brett, *Photography and Place*, 2 (emphasis in original).

[3] Thierry De Duve, "Time Exposure and Snapshot: The Photograph as Paradox", *October*, vol. 5 (summer, 1978), 121.

[4] Edward S. Casey, *Re-presenting Place: Landscape Painting and Maps* (Minneapolis, MN: University of Minnesota Press, 2002), 271 (emphasis in original).

[5] Clive Scott, *The Spoken Image*, 54.

[6] Lucy Lippard, *The Lure of the Local: Senses of Place in a Multicentered Society* (New York: The New Press, 1997), 8.

[7] D.W. Meining, "The Beholding Eye: Ten Versions of the Same Scene", in *The Interpretation of Ordinary Landscapes*, ed. D.W. Meining (New York: Oxford University Press, 1979), 33-47.

[8] Ibid., 45.

[9] Ibid., 46.

[10] Edward Relph, *Place and Placelessness* (London: Pion, 1976), 123.

[11] Edward S. Casey, *Re-Presenting Place*, 271.

[12] Edward S. Casey, "Between Geography and Philosophy: What Does it Mean to be in the Place-World?", *Annals of the Association of American Geographers*, vol. 91, no. 4 (2001), 689.

[13] Ibid. (emphasis in original).

[14] Casey, "A Study in Liminology", 107.

[15] Jeff Malpas, "Place and the Problem of Landscape", in *The Place of Landscape: Concepts, Contexts, Studies,* ed. Jeff Malpas (Cambridge, MA: Ebook Collection: The MIT Press, 2011), 6.

[16] Ibid. 15.

[17] Ibid., 9.

[18] Ibid., 8 (emphasis added).

[19] Meining, "The Beholding Eye", 7.

[20] Crouch, "Landscape, Performance", 121-122.

[21] George Simmel, "The Philosophy of Landscape", *Theory, Culture & Society*, vol. 24 (2007), 26 (originally published in German in 1913 under the title "Die Philosophie der Landschaft").

[22] Ibid. (emphasis added).

[23] Nicholas Entrikin, *The Betweenness of Places: Towards the Geography of Modernity* (London: Macmillan, 1991), 3.

[24] Tim Ingold, "Towards an Ecology of Materials", *Annual Review of Anthropology*, 41 (2012), 431.

[25] Simmel, "The Philosophy of Landscape", 26.

[26] Ibid., 28 (emphasis in original).

[27] Michael Mayerfeld Bell, "The Ghosts of Place", *Theory and Society*, vol. 26, no.6 (December 1997), 815.

[28] Ibid., 815.

[29] Ibid., 831 (emphasis added).

[30] Phill Hubbard, *City* (New York: Routledge, 2006), 159.

[31] Tim Ingold, "The Temporality of the Landscape", *World Archaeology*, vol. 25, no. 2, Conception of Time and Ancient Society (October 1993), 162.

[32] Karren Barad, "Posthumanist Performativity: Towards an Understanding of How Matter comes to Matter", *Signs*, vol. 8, no. 3, Gender and Science: New Issues (spring, 2003), 826-827.

[33] Ibid., 815.

[34] Ernst van Alphen, "Time Saturation: The Photography of Awoiska van der Molen", *View. Theories and Practices of Visual Culture* 8 (2014), 4.

[35] I borrow this term from the sociologist Rob Shields, who states, "photographic 'shooting' kills not the body but the life of things, leaving only representational carcasses": Shields, "A Guide to Urban", 230.

[36] John Berger, *Way of Seeing* (London: Penguin, 1972).

[37] West Brett, *Photography and Place*, 5-6.

[38] Ibid., 77.

[39] "Flooding and Capsize of ro-ro passenger ferry Herald of Free Enterprise with loss of 193 lives", UK Government, available at: https://www.gov.uk/maib-reports/flooding-and-subsequent-capsize-of-ro-ro-passenger-ferry-herald-of-free-enterprise-off-the-port-of-zeebrugge-belgium-with-loss-of-193-lives#summary, accessed 14 November 2016.

[40] In this incident three different individuals who worked for P&O enterprises could have been held equally culpable: "the assistant bosun who was responsible for shutting the doors had fallen asleep and the Chief Officer whose responsibility was to ensure the doors were shut had failed to do so"; and, also, the captain did not "confirm from the bridge whether or not the doors had been shut. This incident became a landmark in what is known today as "corporate manslaughter", a case in which no single individual, but the entire enterprise, P&O in this case, is liable for manslaughter. Only after the investigation into this incident in Zeebrugge did charges against a corporation became recognised in law: Celia Wells, *Corporations and Criminal Responsibility* (New York: Oxford University Press, 2001), 106-107.

[41] Liz Wells, *Photography: A Critical Introduction* (New York: Routledge, 2015), 33.

[42] According to the artist, the location displays the exact location where the incident happened. All of Kocken's photographs were taken in such a way that the focal point of the photograph aims at the precise location of the incidents: personal interview with the artist, 15 January 2017.

[43] Isis Brook, "Aesthetic Appreciation of Landscape", in *The Routledge Companion to Landscape Studies,* ed. Peter Howard, Ian Thompson and Emma Waterton (New York, Routledge, 2013), 108.

[44] Ibid., 111

[45] Giorgio Agamben, "The Original Structure of the Work of Art", in *The Man Without Content,* trans. Giorgia Albert (Stanford, CA: Stanford University Press, 1999), 99 (emphasis added).

[46] De Duve, "Time Exposure and Snapshot", 121.

[47] Ibid., 118.

[48] Ibid. 121 (emphasis in original, except "act of looking").

[49] Victor Burgin, "Looking at Photographs", in *Thinking Photography*, ed. by Victor Burgin (London: Macmillan Press Ltd, 1982), 152.

50 Denis Cosgrove, "Landscape and the European Sense of Sight - Eyeing Nature", in *Handbook of Cultural Geography*, ed. Kay Anderson, Mona Domosh, Steve Pile and Nigel Thrift (London, CA, and New Delhi: Sage Publications, 2003), 253 (emphasis added).

51 Jean-Luc Nancy, "Forbidden Representation", in *The Ground of the Image*, trans. Jeff Fort (New York: Fordham University Press, 2005), 37.

52 West Brett, *Photography & Place, 51*.

53 Ibid., 3.

54 Ibid., 50.

55 Ibid., 3.

56 Ulrich Baer, *Spectral Evidence: The Photography of Trauma* (Cambridge, MA: MIT Press, 2005), 76.

57 Ibid., 63.

58 Ibid., 68 (emphasis added).

59 Ibid., 73.

60 Jacques Derrida and Bernard Stiegler, "Spectrographies", in *The Spectralities Reader: Ghosts and Haunting in Contemporary Cultural Theory*, ed. Esther Peeren and María del Pilar Blanco (New York: Bloomsbury, 2013), 40-41.

61 Ibid., 41.

62 Ibid., 40.

63 Bernard Stiegler, "The Discrete Image", in *Echographies of Television: Film Interviews*, trans. Jennifer Bajorek (Malden: Polity Press, 2002), 152.

64 Jean-Luc Nancy, "Uncanny Landscape", in *The Ground of the Image*, trans. Jeff Fort (New York: Fordham University Press, 2005), 59.

65 In September 2005, after many years, the Spirit Photography exhibition was taken to the public in the Museum of Art in New York City. According to Gunning, while many people treated the exhibition as a joke, the unprecedented attention to this outdated approach can indicate more about "our beliefs about photographs" than our "beliefs in ghosts": Tom Gunning, "To Scan a Ghost: The Ontology of Mediated Vision", in *The Spectralities Reader: Ghosts and Haunting in Contemporary Cultural Theory*, ed. María del Pilar Blanco and Esther Peeren (New York and London: Bloomsbury, 2013), 212.

66 In his compendious study of spirit photography, Louis Kaplan conflates photography theories, the history of science, American cultural history and religious revivalism to shed light on the so-called "spooky theory" of photography from the middle of the nineteenth century up to the present day: Louis Kaplan, *The Strange Case of William Mumler: Spirit Photographer* (Minneapolis, MN: University of Minnesota Press, 2008), 212.

67 Kaplan's most intriguing theoretical insights reside in his chapter called "Spooked Theories", where he links William Mumler's spiritual photography to Derrida's notion of "hauntology", Freudian's formulation of "the uncanny" and the psychoanalytic account of "mourning" and "paranoia": ibid., 211-243.

68 Gunning, "To Scan a Ghost", 213.

69 Baer, *Spectral Evidence*, 71.

70 Mark Twain, *Life on the Mississippi* (Boston, MA: University Press, 1883), 448, available at: https://archive.org/stream/lifeonmississipptwai#page/n7/mode/2up, accessed 20 July 2020.

71 Jean-Luc Nancy, "Distinct Oscillation", in *The Ground of the Image*, trans. Jeff Fort (New York: Fordham University Press, 2005), 75.

72 Siegfried Kracauer, "The Photographic Approach", in *The Past's Threshold: Essays on Photography*, ed. Philippe Despoix and Maria Zinfert, trans. Conor Joyce (Zurich: Diaphanes, 2014), 64 (originally published in *Magazine of Art* in 1951).

73 Ibid., 72.

74 Benjamin, Walter, "Work of Art", 226.

75 As Krauss contends, by coding and numbering his photographs rather than naming them, Atget's work attains the "function of a catalogue" in archiving images, and therefore the authorship becomes an irrelevant term in relation to Atget's photographs. It is because, "the coding system Atget applied to his images derives from the card files of the libraries and topographic collections for which Atget worked", and so his photographs of deserted places in Paris, above all, question the issue of authorship, artistic intention and subjectivity:. Rosalind Krauss, "Photography's Discursive Spaces: Landscape/View", *Art journal*, vol. 42, no. 4, The Crisis of the Discipline (winter, 1982), 316-317.

76 Burgin, "Looking at Photographs", 144.

77 Ibid.

78 Victor Burgin, "Seeing Sense", in *The End of Art Theory: Criticism and Post-Modernity*, by Victor Burgin (London: Macmillan International Higher Education, 1986), 51.

79 Roland Barthes, "Rhetoric of the Image", in *Image Music Text*, ed. Stephen Heath (London: Fontana Press, 1977), 39.

80 Ibid., 38.

81 Ibid., 38 (emphasis in original).

82 Clive Scott, "Title and Caption", 60.

83 Ibid., 48.

84 Ibid., 52.

85 Ibid., 51 and 53.

86 Ibid., 51 (emphasis added).

87 Peter Wollen, "Fire and Ice," in *The Photography Reader*, ed. Liz Wells (New York: Routledge, 2003), 77.

88 The narrative present, also known as "the historic present", is used in order to add dramatic emphasis to recent past events by usually using the simple present tense in news titles: P.H. Matthews, *The Concise Oxford Dictionary of Linguistics*, 3d edition (Oxford online database: Oxford University Press, 2014), available at:. https://www.oxfordreference.com/view/10.1093/acref/9780199675128.001.0001/ acref-9780199675128, accessed 9 December 2016.

89 Wollen, "Fire and Ice", 77.

90 Clive Scott, 'Title and Caption", 47.

91 W.J.T. Mitchell, "The Photographic Essays: Four Case Studies", in *Picture Theory: Essays on Verbal and Visual Representation* (Chicago, IL, and London: The University of Chicago Press, 1995), 281.

92 Ibid., 285.

93 Ibid., 290.

94 This book was the culmination of Evans' collaboration with Farm Security Administration, known as FSA. In it, Evans documented several photographs showing the ordinary lives of people after the Great Depression that took place during 1930. None of the photographs in this photo essay were titled; instead, the entire contextual background of the images was communicated through the accompanying text written by Agee, to explain the devastating state of life the photographed subjects had gone through.

95 Quoted in Mitchell, "The Photographic Essay", 290.

96 Ibid., 300 (emphasis added).

97 Ibid., 295.

98 Nancy, "Distinct Oscillation", 78.

99 Ibid.

100 Giorgio Agamben, "The Author as Gesture", in *Profanations,* trans. Jeff Fort (New York: Zone Books, 2007), 66.

101 Giorgio Agamben, "Notes on Gesture", in *Means Without Ends: Notes on Politics*, trans. Vincenzo Binetti and Cesare Casarino (Minneapolis, MN: University of Minnesota Press, 2000), 56 (emphasis added).

102 Ibid. (emphasis in original).

103 Ibid., 58.

104 Ibid., 57 (emphasis in original).

105 Metz, "Photography and Fetish", 141 (emphasis in original).

106 John Berger, "Uses of Photography: For Sontag", in *Understanding a Photograph*, ed. Geoff Dyer (London: Penguin Books, 2013), 54.

107 Ibid., 57 (emphasis added).

108 Giorgio Agamben, "Uses and Disadvantages of Living Among Specters", in *The Spectralities Reader: Ghosts and Haunting in Contemporary Cultural Theory,* ed. María del Pilar Blanco and Esther Peeren (London and New York: Bloomsbury, 2013), 475.

109 Giorgio Agamben, *The Time That Remains: A Commentary to the Letters to the Romans,* trans. Patricia Dailey (Stanford, CA: Stanford University Press, 2005), 39.

110 Giorgio Agamben, "Poiesis and Praxis", in *The Man Without Content,* trans. Georgia Albert (Stanford, CA: Stanford University Press, 1994), 74 (emphasis added).

111 Walter Benjamin, "The Task of the Translator", in *Walter Benjamin: Selected Writings* vol. 1, 1913-1926, ed. M. Bullock and M.W. Jennings (Cambridge, MA: Harvard University Press, 2002), 260.

112 Giorgio Agamben, "The Melancholy Angel", in *The Man Without Content,* trans. Georgia Albert (Stanford, CA: Stanford University Press, 1994), 113.

References

Agamben, Giorgio. "Uses and Disadvantages of Living Among Specters." In *The Spectralities Reader: Ghosts and Haunting in Contemporary Cultural Theory,* edited by María del Pilar Blanco and Esther Peeren, 473-477. New York and London: Bloomsbury, 2013.

———. "The Author as Gesture." In *Profanations,* translated by Jeff Fort, 61-72. New York: Zone Books, 2007.

———. *The Time That Remains: A Commentary to the Letters to the Romans,* translated by Patricia Dailey. Stanford, CA: Stanford University Press, 2005.

———. "Notes on Gesture." In *Means Without Ends: Notes on Politics,* translated by Vincenzo Binetti and Cesare Casarino, 49-58. Minneapolis, MN: University of Minnesota Press, 2000.

———. "The Original Structure of the Work of Art." In *The Man Without Content,* translated by Giorgia Albert, 94-103. Stanford, CA: Stanford University Press, 1999.

———. "Poiesis and Praxis." In *The Man Without Content,* translated by Georgia Albert, 68-93. Stanford, CA: Stanford University Press, 1994.

———. "The Melancholy Angel." In *The Man Without Content,* translated by Georgia Albert, 104-115. Stanford, CA: Stanford University Press, 1994.

Amin, Ash, and Nigel Thrift. *Cities: Reimagining the Urban.* Cambridge: Polity, 2002.

Azoulay, Ariella. *Civil Imagination: A Political Ontology of Photography,* translated by Louise Bethlehem. London: Verso Books, 2015.

———. "What is a Photograph? What is Photography?" *Philosophy of Photography,* vol. 1, no. 1 (2010), 9-13.

———. *The Civil Contract of Photography,* translated by Rela Mazeli and Ruvik Daieli. New York: Zone Books, 2008.

Bachelard, Gaston. *The Poetics of Space,* translated by Maria Jolas. Boston, MA: Beacon Press Book, 1994. (Originally published in French as *La poétique de l'espace* in 1958.)

Badiou, Alain. *Philosophy and the Event,* translated by Louise Burchill. Cambridge: Polity Press, 2014. (Originally published in French in 2010.)

———. *Being and Event,* translated by Olivier Feltham. New York: Continuum, 2007. (Originally published in French in 1988.)

Baer, Ulrich. *Spectral Evidence: The Photography of Trauma.* Cambridge, MA: MIT Press, 2005.

Barad, Karren. "Posthumanist Performativity: Towards an understanding of How Matter comes to Matter." *Signs,* vol. 28, no. 3, Gender and Science: New Issues (spring, 2003), 801-831.

Barthes, Roland. *Camera Lucida,* translated by Richard Howard. London: Vintage Books, 2000. (Originally published in French in 1980, under the title *La Chambre Claire.*)

———. *Mythologies,* translated by Jonathan Cape. New York: The Noonday Press, 1991.

———. "Rhetoric of the Image." In *Image Music Text,* edited by Stephen Heath, 32-50. London: Fontana Press, 1977.

Batchen, Geoffrey. *Photography Degree Zero. Reflections on Roland Barthes's Camera Lucida.* Cambridge, MA: MIT Press, 2009.

————. *Each Wild Idea: Writing, Photography, History*. Cambridge, MA: MIT Press, 2000.

Bate, David. *Photography: The Key Concepts*. Oxford and New York: Berg Publishers, 2009.

Baudrillard, Jean. *The Perfect Crime,* translated by Chris Turner. London & New York: Verso, 1996.

——, and Sophie Calle. *Please follow me: Suite venitienne*, translated by Dany Barash and Danny Hatfield. Seattle, WA: Bay Press, 1988.

Bazin, André. "Ontology of the Photographic Image." In *What is Cinema?*, translated by Hugh Gray, 9-17. (Berkeley and Los Angeles, CA: University of California Press, 1967). (Originally published in French in four volumes between 1958-1962, under the title *Qu'est-ce que le cinema ?*.)

Bell, Michael Mayerfeld. "The Ghosts of Place." *Theory and Society* vol. 26, no.6 (December 1997), 813-836.

Belting, Hans. *An Anthropology of Images,* translated by Thomas Dunlap. Princeton, NJ: Princeton University, 2011.

Benjamin, Walter. "The Work of Art in the Age of Its Mechanical Reproduction." In *Illuminations*, translated by Harry Zohn, edited by Hannah Arendt. New York: Schocken Books, 2007. (Originally published in German in 1935, under the title "Das Kunstwerk im Zeitalter seiner Technischen Reproduzierbarkeit".)

——"The Task of the Translator." In *Walter Benjamin: Selected Writings: Volume 1 1913-1926,* ed. M. Bullock and M.W. Jennings, 253-263. Cambridge, MA: Harvard University Press, 2002.

————. "A Small History of Photography." In *One-Way Street and Other Writings,* translated by E. Jephcott and K. Shorter. London: Lowe and Brydone, 1979. (Originally published in German in 1931, under the title "Kleine Geschichte der Photographie".)

Berger, John. "Uses of Photography: For Sontag." In *Understanding a Photograph*, edited by Geoff Dyer, 49-60. London: Penguin Books, 2013.

————. *Way of Seeing*. London: Penguin, 1972.

Bergson, Henry. *Matter and Memory,* translated by Nancy Margaret Paul and W. Scott Palmer. New York: Zone Books: 1991.

Brook, Isis. "Aesthetic Appreciation of Landscape." In *The Routledge Companion to Landscape Studies*, edited by Peter Howard, Ian Thompson and Emma Waterton, 108-118. New York, Routledge, 2013.

Brown, Bill. "Thing Theory." *Critical Inquiry,* vol. 28, no. 1, Things (Autumn 2001), 1-22.

Burgin, Victor. "Looking at Photographs." In *The Photography Reader,* edited by Liz Wells, 130-137. New York: Routledge, 2003.

————. "Seeing Sense." In *The End of Art Theory: Criticism and Post-Modernity*, 51-69. London: Macmillan International Higher Education, 1986.

————. "Looking at Photographs." In *Thinking Photography*, edited by Victor Burgin, 142-153. London: Macmillan Press Ltd, 1982.

Cadava, Eduardo. "The Itinerant Languages of Photography." In *The Itinerant Languages of Photography*, edited by Eduardo Cadava and Gabriela Nouzeilles, 24-37. Princeton, NJ: Princeton University Press, 2013.

————. "Lapsus Imaginis: The Image in Ruins." *October*, vol. 96 (Spring, 2001), 35-60.

————. *Words of Light: Theses on the Photography of History.* Chichester: Princeton University Press, 1997.

————. "Theses on the Photography of History." *Diacritics,* vol. 22, no. 3/4, Commemorating Walter Benjamin (Autumn-Winter, 1992), 84-114.

Casey, Edward S. "The Edge(s) of Landscape: A Study in Liminology." In *The Place of Landscape: Concept, Context, Studies,* edited by Jeff Malpas, 91-108. MIT eBook Collection: The MIT Press, 2011.

————. *Getting Back Into Place: Towards a Renewed Understanding of the Place-World.* Bloomington, IN: Indiana University Press, 2009.

————. "Edges and the In-between." *PhaenEX: Journal of Existence and Phenomenological Theory and Culture,* no. 2 (2008), 1-13.

————. "Keeping Art to its Edge." *Journal of Theoretical Humanities*, vol. 9, no.2 (August 2004), 145-153.

————. *Re-presenting Place: Landscape Painting and Maps.* Minneapolis, MN: University of Minnesota Press, 2002.

——"Between Geography and Philosophy: What Does it Mean to be in the Place-World?" *Annals of the Association of American Geographers*, vol. 91, no. 4 (2001), 683-693.

————. *The Fate of Place: A Philosophical History.* Berkeley, CA: University of California Press, 1998.

Cavell, Stanley. *The World Viewed: Reflections on the Ontology of Film.* Cambridge, MA: Harvard University Press, 1979.

Collins, Susan. "Unfolding Time: Landscape, Seascape and the Aesthetics of Transmission." In *Spatialities,* edited by Judith Rug and Craig Martin, 11-25. Chicago, IL: The University of Chicago Press, 2012.

Cosgrove, Denis. "Landscape and the European Sense of Sight – Eyeing Nature." In *Handbook of Cultural Geography,* edited by Kay Anderson, Mona Domosh, Steve Pile and Nigel Thrift, 249-268. London, CA, and New Delhi, Sage Publication, 2003.

Costello, Diarmuid. *On Photography: A Philosophical Inquiry.* New York: Routledge, 2018.

Cresswell, Tim. *Place: An Introduction,* 2nd edition. Chichester: Blackwell Publishing, 2015.

————. "Place." In *International Encyclopedia of Human Geography*, edited by Nigel Thrift and Rob Kitchen, 169-177. Oxford: Elsevier, 2009.

————. *In Place, Out of Place: Geography, Ideology, and Transgression.* Minneapolis, MN, MN: Minnesota Press, 1996.

Crouch, David. "Landscape, Performance, and Performativity." In *The Routledge Companion to Landscape Studies,* edited by Peter Howard, Ian Thompson and Emma Waterton, 119-129. New York: Routledge, 2013.

Cubitt, Sean. *The Practice of Light: A Genealogy of Visual Technologies from Prints to Pixels.* Cambridge, MA, and London: MIT Press, 2014.

Damisch, Hubert. "Five Notes for Phenomenology of the Photographic Image." In *The Photography Reader*, edited by Liz Wells, 87-90. New York: Routledge, 2003.

De Duve, Thierry. "Time Exposure and Snapshot: The Photograph as Paradox." *October*, vol. 5 (summer, 1978), 113-125.

Deleuze, Gilles, and Félix Guattari. *A Thousand Plateaus: Capitalism and Schizophrenia,* translated by Brian Massumi. Minneapolis, MN: University of Minnesota Press, 2005. (Originally published in 1980, under the title *Mille plateaux: Capitalisme et Schizophrénie.*)

Derrida, Jacques, and Bernard Stiegler. "Spectrographies." In *The Spectralities Reader: Ghosts and Haunting in Contemporary Cultural Theory,* edited by María del Pilar Blanco and Esther Peeren, 37-51. New York: Bloomsbury, 2013.

————. *Copy, Archive, Signature: A Conversation on Photography,* translated by Jeff Fort. Stanford, CA: Stanford University Press, 2010. (Originally published in German in 2000 under the title "Die Photographie als Kopie, Archiv und Signatur" in *Theorie der Fotografie* IV, 1980-1995.)

————. "The Deaths of Roland Barthes" In *The work of Mourning*, edited by Pascale-Anne Brault and Michael Naas, 31-67. Chicago, IL, and London: University of Chicago Press, 2001.

————. *Right of Inspection*, translated by David Wills. New York: Monacelli Press, 1998.

————. *The Truth in Painting*, translated by Geoff Bennington and Ian Macleod. Chicago, IL, and London: The University of Chicago Press, 1987.

Edwards, Elizabeth. "Anthropology and Photography: A Long History of Knowledge and Affect." *Photographies*, vol. 8, no. 3 (2015), 235-252.

————. "Objects of Affect: Photography Beyond the Image." *Annual Review of Anthropology*, vol. 41 (2012), 221-234.

————. "Photography and the Material Performance of the Past." *History and Theory*, issue 48 (2009), 130-150.

Elkins, James. "Critical Response: What Do We Want Photography to Be? A Response to Michael Fried." *Critical Inquiry*, vol. 31, no. 4 (Summer 2015), 938-956.

Entrikin, Nicholas. *The Betweenness of Places: Towards the Geography of Modernity*. London: Macmillan, 1991.

ESA, "Rosetta Mission." http://rosetta.esa.int/.

Flusser, Vilém. *Towards a Philosophy of Photography*, translated by Anthony Mathews. London: Reaktion Books, 2000. (Originally published in German as *Für eine Philosophie der Fotografie*.)

————. "The Photograph as Post-Industrial Object: An Essay on the Ontological Standing of Photographs." *Leonardo*, vol. 19, no. 4 (October 1986), 329-332.

Fondiller, Harvey V. *The Best of Popular Photography*. New York: Watson-Guptill, 1980.

Fontcuberta, Joan, and Geoffrey Batchen. *Landscape Without Memory*. New York: Aperture, 2005.

Foucault, Michel. "Different Spaces." In *Aesthetics, Method, and Epistemology*, edited by James D. Faubion, translated by Robert Hurley et al., 178-185. New York: The New Press, 1998.

Fried, Michael. *Why Photography Matters as Art as Never Before*. New Haven, CT: Yale University Press, 2008.

Gombrich, Ernst. *Art and Illusion*. New York: Pantheon Books,1960.

Goodman, Nelson. *Languages of Art: An Approach to a Theory of Symbols*. New York: The Bobbs-Merrill Company, 1968.

Greenberg, Clement. "The Camera's Glass Eye." *The Nation*, no, 162 (1946), 294-296.

Gunning, Tom. "To Scan a Ghost: The Ontology of Mediated Vision." In *The Spectralities Reader: Ghosts and Haunting in Contemporary Cultural Theory*, edited by María del Pilar Blanco and Esther Peeren, 207-244. New York and London: Bloomsbury, 2013.

————. "What's the Point of an Index? Or, Faking Photographs." *Nordicom Review*, vol. 25, no.1-2 (2004), 39-49.

Hardy, Stephen P. "Placiality: The Renewal of the Significance of Place in Modern Cultural Theory." *Brno Studies in English*, vol. 26, no. 1 (2013), 85-100.

Hubbard, Phill. *City*. New York: Routledge, 2006.

Hubble Site. "A Bigger, Clearer Picture." http://hubblesite.org/the_telescope/nuts_.and._bolts/instruments/acs/#top.

Husserl, Edmund. "The World of the Living Present and the Constitution of the Surrounding World External to the Organism." In *Husserl: Shorter Works*, translated by F.A. Elliston and L. Langsdorf. Notre Dame, IN: University of Notre Dame Press, 1981.

————. *The Crisis of European Sciences and Transcendental Phenomenology*, translated by David Carr. Evanston, IL: Northwestern University Press, 1970.

Ingold, Tim. "Towards an Ecology of Materials." *Annual Review of Anthropology*, vol. 41 (2012), 427-442.

———. *The Perception of the Environment: Essays on Livelihood, Dwelling and Skills*. London: Routledge, 2000.

———. "The Temporality of the Landscape." *World Archaeology*, vol. 25, no. 2, Conception of Time and Ancient Society (October 1993), 152-174.

Jurvoics, Toby. "Same as it Ever Was: Re-reading New Topographics." In *Reframing the New Topographics*, edited by Greg Foster-Rice, 1-13. Chicago, IL: University of Chicago, 2013.

Kaplan, Louis. *The Strange Case of William Mumler: Spirit Photographer*. Minneapolis, MN: University of Minnesota Press, 2008.

Kracauer, Siegfried. "Photographed Berlin." In *The Past's Threshold: Essays on Photography*, edited by Philippe Despoix and Maria Zinfert, translated by Conor Joyce, 55-57. Zurich: Diaphanes, 2014.

———. "The Photographic Approach." In *The Past's Threshold: Essays on Photography*, edited by Philippe Despoix and Maria Zinfert, translated by Conor Joyce, 63-78. Zurich: Diaphanes, 2014. (Originally published in *Magazine of Art* in 1951.)

———. "Photography." In *The Past's Threshold: Essays on Photography*, edited by Philippe Despoix and Maria Zinfert, translated by Conor Joyce, 27-44. Zurich: Diaphanes, 2014. (Originally published in German in 1927 as an essay in *Frankurter Zeitung*.)

Krauss, Rosalind. "Photography's Discursive Spaces: Landscape/View." *Art journal*, vol. 42, no. 4, The Crisis of the Discipline (winter, 1982), 311-319.

Lechte, John. *Genealogy and Ontology of the Western Image*. New York: Routledge, 2012.

Lippard, Lucy. *The Lure of the Local: Senses of Place in a Multicentered Society*. New York: The New Press, 1997.

Malpas, Jeff. "The Threshold of the World." In *Funktionen des Lebendigen*, edited by Thiemo Breyer and Oliver Müller, 161-168. Berlin: De Gruyter, 2016.

———. "Place and the Problem of Landscape." In *The Place of Landscape: Concepts, Contexts, Studies*, edited by Jeff Malpas, 3-26. Ebook Collection: The MIT Press, 2011.

———. *Places and Experiences: A Philosophical Topography*. Cambridge: Cambridge University Press, 1999.

Massey, Doreen. "Power-Geometry and a Progressive Sense of Place." In *Mapping the Futures: Local Cultures, Global Change*, edited by John Bird, Barry Curtis, Tim Putnam and Lisa Tickner, 59-69. London: Routledge, 1993.

Mattens, Filip. "The Aesthetics of Space: Modern Architecture and Photography." *The Journal of Aesthetics and Art Criticism*, vol. 69, no.1, special issue: The Aesthetics of Architecture: Philosophical investigation into the Art of Building (winter 2011), 105-114.

Matthews, P.H. *The Concise Oxford Dictionary of Linguistics*, 3d edition. Oxford online database: Oxford University Press, 2014. https://www.oxfordreference.com/view/10.1093/acref/9780199675128.001.0001/acref-9780199675128.

Maynard, Patrick. "Scales of Space and Time in Photography." In *Photography and Philosophy: Essays on the Pencil of Nature*, edited by Scott Walden, 187-208. Hong Kong: Wiley-Blackwell, 2010.

Meillassoux, Quentin. "History and Event in Alain Badiou," *Parrhesia*, no. 2 (2011), 1-11.

Meining, D.W. "The Beholding Eye: Ten Versions of the Same Scene." In *The Interpretation of Ordinary Landscapes*, edited by D.W Meining, 33-48. New York: Oxford University Press, 1979.

Meisel, Louis K., and Linda Chase. *Photorealism at the Millennium*. New York: Abrams Books, 2002.

Merleau-Ponty, Maurice. *Phenomenology of Perception,* translated by C. Smith. New York: Routledge, 2002.

———. "Eye and Mind." In *The Primacy of Perception and Other Essays on Phenomenological Psychology, the Philosophy of Art, History, and Politics,* edited by James M. Edie, translated by Carleton Dallery, 159-193. Evanston, IL: Northwestern University Press, 1964.

Merrifield, Andrew. "Place and Space: A Lefebvrian Reconciliation." *Transactions of the Institute of British Geographers,* new series, vol. 18, no, 4 (1993), 516-531.

Metropolitan Museum of Art. "Googlegram: Niépce." https://www.metmuseum.org/art/collection/search/302283?exhibitionId=%7B2e988323-b8df-496f-b72ae999e567faba%7D&oid=302283.

Metz, Christian. "Photography and Fetish." In *The Photography Reader,* edited by Liz Wells, 138-148. New York: Routledge, 2003.

Metz, Gary. "Quaking Space: Populus Tremuloides." In *Quaking Aspen: A Lyric Complaint,* edited by Alan Metnick and Salvatore Mancini. New York: Shadow Imaging, 2012.

———. "The Landscape as a Photograph." In *Quaking Aspen: A Lyric Complaint,* edited by Alan Metnick and Salvatore Mancini. New York: Shadow Imaging, 2012.

———. *Quaking Aspen: A Lyric Complaint,* edited by Alan Metnick and Salvatore Mancini. New York: Shadow Imaging, 2012.

Michaels, Walter Benn. "Photography and Fossils." In *Photography Theory: The Art Seminar,* edited by James Elkins, 431-450. New York: Routledge, 2007.

Mitchell, W.J.T. "The Photographic Essays: Four Case Studies." In *Picture Theory: Essays on Verbal and Visual Representation,* 281-321. Chicago, IL, and London: The University of Chicago Press, 1995.

Mitchell, William J. *The Reconfigured Eye.* Cambridge, MA: MIT Press, 1992.

Nancy, Jean-Luc. "Distinct Oscillation." In *The Ground of the Image,* translated by Jeff Fort, 63-79. New York: Fordham University Press, 2005.

———. "Forbidden Representation." In *The Ground of the Image,* translated by Jeff Fort, 27-50. New York: Fordham University Press, 2005.

———. "Uncanny Landscape." In *The Ground of the Image,* translated by Jeff Fort, 51-62. New York: Fordham University Press, 2005.

———. *Being Singular Plural, translated by Robert D. Richardson and Anne E. O'Byrne. Stanford, CA: Stanford University Press, 2000.*

NASA. "Hubble's High-Definition Panoramic View of the Andromeda Galaxy." https://www.nasa.gov/content/goddard/hubble-s-high-definition-panoramic-view-of-the-andromeda-galaxy.

Nouzeilles, Gabriela. "The Archival Paradox." In *The Itinerant Languages of Photography,* edited by Eduardo Cadava and Gabriela Nouzeilles, 38-53. Princeton, NJ: Princeton University Press, 2013.

Nunes, Mark. "Virtual Topographies: Smooth and Striated Cyberspace." In *Cyberspace Textuality: Computer Technology and Literary Theory,* edited by Marie-Laure Ryan, 61-77. Indianapolis, IN: Indiana University Press, 1999.

Planet Gate. "OSIRIS Image of the Day." https://planetgate.mps.mpg.de/Image_of_the_Day/public/OSIRIS_IofD_2016-07-14.html.

Planetary. "Rosetta's OSIRIS Camera Instrument." http://www.planetary.org/explore/resource-library/data/rosetta-osiris.html.

Porter, Eliot. *Intimate Landscapes: Photographs by Eliot Porter.* New York: The Metropolitan Museum of Art, 1979.

Pred, Allan. "Place as Historically Contingent Process: Structuration and the Time-Geography of Becoming Places", *Annals of the Association of American Geographers,* vol. 74, no.2 (1984), 279-297.

Rancière, Jacques. "Notes on the Photographic Image." In *The Visual Culture Reader,* edited by Nicholas Mirzoeff, 86-96. New York: Routledge, 2013

———. *The Politics of Aesthetics,* translated by Gabriel Rockhill. New York: Continuum, 2011.

———. *The Future of the Image,* translated by Gregory Elliott. London: Verso, 2009.

Relph, Edward. *Place and Placenessness.* London: Pion, 2008.

Richter, Gerhard. "Between Translation and Invention." In *Copy, Archive, Signature: A Conversation on Photography,* edited by Gerhard Richter, translated by J. Fort. x-xxxvIII. Stanford, CA; Stanford University Press, 2010.

Scott, Clive. *The Spoken Image: Photography and Language.* London: Reaktion Books Ltd, 1999.

Sekula, Allan. "On the Invention of Photographic Meaning." In *Thinking Photography,* edited by Victor Burgin, 84-109. London: Macmillan Press, 1982. (First published as an essay in 1974.)

Shields, Rob. "A Guide to Urban Representation and What to Do About It: Alternative Traditions of Urban Theory." In *Re-Presenting the City: Ethnicity, Capital and Culture in the Twenty- First Century Metropolis,* edited by Anthony D. King, 227-252. New York: New York University Press, 1996.

Simmel, George. "The Philosophy of Landscape." *Theory, Culture & Society,* vol.24 (2007), 20-29. (Originally published in German in 1913, under the title "Die Philosophie der Landschaft".)

Snyder, Joel, and Neil Walsh Allen. "Photography, Vision and Representation." *Critical Inquiry,* vol. 2, no. 1 (Autumn, 1975), 143-169.

Sontag, Susan. *On Photography.* London: Penguin Book, 1977.

Space Telescope. "Sharpest ever View of the Andromeda Galaxy." https://www.spacetelescope.org/images/heic1502a/.

Stein, Leo. *The A-B-C of Aesthetics.* New York: Boni and Liveright, 1927.

Stiegler, Bernard, and Jacques Derrida. *Technics and Time 2: Disorientation,* translated by Stephan Barker. Stanford, CA: Stanford University Press, 2009.

——— "The Discrete Image." In *Echographies of Television: Film Interviews,* translated by Jennifer Bajorek, 143-163. Malden: Polity Press, 2002.

Szarkowski, John. "Introduction to The Photographer's Eye." In *The Photography Reader,* edited by Liz Wells, 97-103. New York, Routledge, 2003.

———. *Looking at Photographs: 100 Pictures from the Collection of the Museum of Modern Art.* New York: Graphic Society, 1976.

Tagg, John. *The Disciplinary Frame: The Photographic truths and the Capture of Meaning.* Minneapolis, MN: University of Minnesota Press, 2009.

Tarby, Fabien. "Short Introduction to Alain Badiou's Philosophy." In *Philosophy and the Event,* translated by Louise Burchill, 131-154. Cambridge: Polity Press, 2014.

Thrift, Nigel. "Space: The Fundamental Stuff of Geography." In *Key Concepts in Geography,* edited by Nicholas J. Clifford, 95-107. Trowbridge: Sage, 2009.

TIME. "The Story Behind the 'Napalm Girl' Photo Censored by Facebook." http://time.com/4485344/napalm-girl-war-photo-facebook/.

Trigg, Dylan. *The Memory of Place: A Phenomenology of the Uncanny.* Athens, OH: University Press, 2012.

Tuan, Yi-Fu. *Segmented World and Self.* Minneapolis, MN: University of Minnesota Press, 1982.

———. *Space and Place: The Perspective of Experience.* Minneapolis, MN: University of Minnesota Press, 1977.

Twain, Mark. *Life on the Mississippi.* Boston, MA: University Press, 1883. https://archive.org/stream/lifeonmississipptwai#page/n7/mode/2up.

UK Government. "Flooding and Capsize of ro-ro passenger ferry Herald of Free Enterprise with loss of 193 lives." https://www.gov.uk/maib-reports/flooding-and-subsequent-capsize-of-ro-ro-passenger-ferry-herald-of-free-enterprise-off-the-port-of-zeebrugge-belgium-with-loss-of-193-lives#summary.

Van Alphen, Ernst. "Time Saturation: The Photography of Awoiska van der Molen." *View. Theories and Practices of Visual Culture,* no.8 (2014), 1-12.

Van Gelder, Hilde, and Helen Westgeest. *Photography Theory: In Historical Perspective: Case Studies from Contemporary Art.* Chichester: Wiley-Blackwell, 2011.

Weiss, Marta, Karen Henry and Ann Thomas. *Acting the Part: Photography as Theatre: A History of Staged Photography,* edited by Lori Pauli. London and New York: Merrell, 2006.

Wells, Celia. *Corporations and Criminal Responsibility.* New York: Oxford University Press, 2001.

Wells, Liz. *Photography: A Critical Introduction.* New York: Routledge, 2015.

West Brett, Donna. *Photography & Place: Seeing and Not Seeing Germany After 1945.* New York: Routledge, 2016.

Westgeest, Helen. *Take Place: Photography and Place from Multiple Perspectives.* Amsterdam: Valiz, 2009.

Whitehead, Alfred North. *Science and the Modern World.* New York: Free Press, 1953.

Withers, Charles W.J. "Place and the 'Spatial Turn' in Geography and in History." *Journal of the History of Ideas,* vol. 70, no. 4 (October 2009), 637-658.

Wollen, Peter. "Fire and Ice." In *The Photography Reader,* edited by Liz Wells, 76-80. New York: Routledge, 2003.

Wylie, John. "Landscape and Phenomenology." In *The Routledge Companion to Landscape Studies,* edited by Peter Howard, Ian Thompson and Emma Waterton, 54-66. New York: Routledge, 2013.

———. *Landscape: Key Ideas in Geography.* London: Routledge, 2007.

Zabriskie Gallery. "Archive Noise." http://www.zabriskiegallery.com/.

Žižek, Slavoj. *Event: Philosophy in Transient.* London: Penguin, 2014.

Zylinska, Joanna. *Nonhuman Photography.* London: The MIT Press, 2017.

Index